UP HERE

EDITED BY JULIE DECKER AND
KIRSTEN J. ANDERSON

UP HERE

THE NORTH AT THE CENTER OF THE WORLD

ANCHORAGE MUSEUM | ANCHORAGE, ALASKA
UNIVERSITY OF WASHINGTON PRESS | SEATTLE & LONDON

© 2016 by the Anchorage Museum
Printed and bound in Canada
Photo preceding title page courtesy of Michael Conti
Design: Dustin Kilgore
Typeset in Trade Gothic Next, a typeface designed by
Jackson Burke, Akira Kobayashi, and Tom Grace
20 19 18 17 16 5 4 3 2 1

University of Washington Press
www.washington.edu/uwpress

Library of Congress Cataloging-in-Publication Data
Names: Decker, Julie, editor. | Anderson, Kirsten (Kirsten J.), editor.
Title: Up here : the North at the center of the world / edited by
 Julie Decker and Kirsten J. Anderson.
Description: Seattle : University of Washington Press, 2016. |
 Includes bibliographical references.
Identifiers: LCCN 2016010342 | ISBN 9780295999081 (hardcover
 : alk. paper)
Subjects: LCSH: Arctic regions. | Arctic regions—Environmental
 conditions. | Arctic regions—Social life and customs. | Arctic
 regions—Pictorial works. | Arctic regions—Environmental
 conditions—Pictorial works. | Arctic regions—Social life and
 customs—Pictorial works.
Classification: LCC G608 .U6 2016 | DDC 909/.0913—dc23
LC record available at https://lccn.loc.gov/2016010342

To Eva

CONTENTS

UP HERE

INTRODUCTION

Julie Decker

The Arctic is a place of activity, investigation, iteration, and risk taking. No longer one of the world's great remote spaces, it is instead pivotal, connected, and spotlighted. At a time when views of the North are conveyed primarily through reality television, tourism, myths, and misperceptions, this publication seeks to start a conversation about an authentic Arctic, to convey a voice of the North—one that rings true for insiders and offers outsiders a glimpse of a vibrant, unlimited place.

Scientists estimate that, within a decade, the Iñupiaq village of Shishmaref, located on the barrier island of Sarichef off the coast of Alaska, will be swallowed by rising seas. In October 2001, a severe fall storm caused the shoreline near the village to move inland by 125 feet. The Iñupiaq people have lived here for over four thousand years but will now be forced to relocate to higher ground at a projected cost of almost $200 million. Along the coast of Greenland, the once year-round sea ice is gone for most of the late spring, summer, and early fall, making the traditional dog-sled transportation—which for centuries sustained the hunter-gatherer lifestyle—impossible. For millennia, the indigenous peoples of Russia, northern Scandinavia, and North America—the Inuit, Iñupiaq, Athabaskans, and Gwich'in, among others—have endured environmental and climatic change. But recent anthropogenic climate change may be their most formidable challenge of all. In the past few decades, average temperatures in the Arctic have risen at almost twice the rate as those in the rest of the world (and in some areas, like Alaska, annual average temperatures are rising at five times the global rates). Sea level is rising, the ice is thinning, and the ranges and availability of the seals, whales, caribou, and fish that have sustained northern cultures are not what have long been recognized.

For Arctic peoples, flexibility and innovation have long been key to adapting to environmental change. Historically, the reindeer-herding communities across Russia and northern Scandinavia have moved their homes with their herds to summer pastures, then back to higher ground for the winter, and then back again. However, today many Arctic peoples cannot simply relocate or change resource use as they could in the past. Most now live in permanent, planned settlements, and their hunting and herding activities are governed by land-use laws, landownership regulations, and resource management regimes. Climate change arrived at a time when the indigenous peoples of the Arctic were already struggling to maintain their cultures in an increasingly regulated world.

Empowerment and adaptation occur at a local level, not a national one. Indigenous societies acutely understand the risks associated with climate change. Arctic peoples are preparing themselves, their societies, and their governments for change. One question

is what adaptation knowledge is available—and the answer is likely a combination of the expertise of the scientific community and on-the-ground, historical experience. Aside from climate change, the economic and social conditions experienced by northern indigenous peoples continue to represent some of the most pressing domestic issues in Alaska and other Arctic territories—alcoholism, depression, abuse, suicide. The challenges are great.

These discussions are not new to the Arctic. While other parts of the world ask whether there is climate change and work on making the case, in the Arctic the case has been made. The discussions of resource extraction are not new to the Arctic, either—the North has long been a place of environmental codependence. In the Arctic, the conversations are about the complexities of place and people. This is not a black-and-white landscape, nor an untouched one. The four

million people of the Arctic are invested in the Arctic and its future. The conversations UP HERE are about future scenarios and how the people of the North will continue to adapt to the environment and its extremes. What the globe is interested in is how technology, along with local and indigenous knowledge, will provide solutions and adaptations that can be applied to other locations outside the region that, after the Arctic, will be affected by rising sea levels, acidic oceans, storms, fires, and changes in the migration of people and animals in search of a welcoming landscape.

Maps have long showed the Arctic at the edge—up at the top, far away from the center of humanity. Today the Arctic is at the edge of discovering the limits and the glory of human resilience. The North is at the center. It is in the North where global discourse, the imagination and innovation of man, and the power of Nature will find its future.

Winter's flaming sky, summer night's sun miracle.
Go against the wind. Climb mountains.
Look North.
More often.

—**Rolf Jacobsen**

Arctic sun dogs, or parhelia,
in Canada's Arctic.
Copyright © Ryerson Clark.

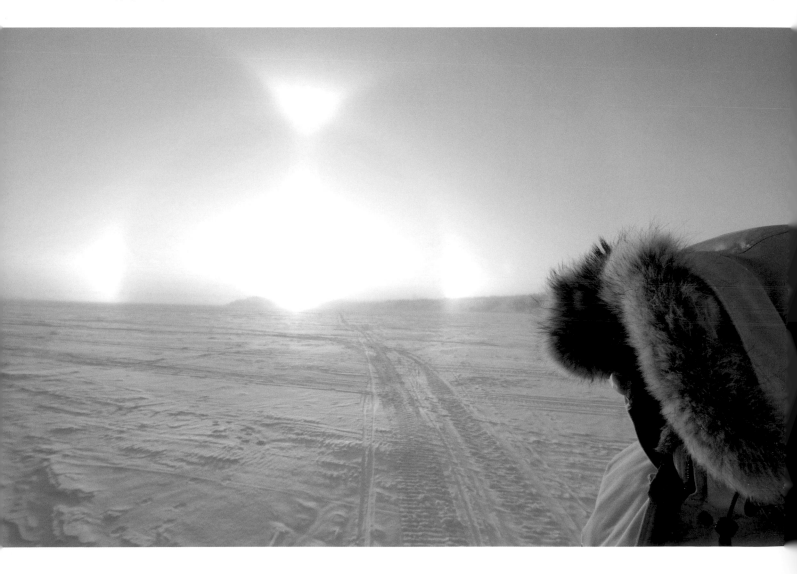

ARKTIKÓS

Barry Lopez

On a winter afternoon—a day without a sunrise, under a moon that had not set for six days—I stand on the frozen ocean 20 miles off Cape Mamen, Mackenzie King Island. The sea ice of Hazen Strait is not completely featureless, but its surface does not show, either, any evidence of severe torture, such as one would find, for example, in the Lincoln Sea. The currents are relatively calm here. During the nine or ten months the water is frozen, this platform hardly moves.

To the south I can see a thin streak of violet and cobalt sky stretching across 80° of the horizon. But the ice and snow barely reflect these colors. The pervasive light here is the milky blue of the reflected moon. It is possible to see two or three miles in the moonlight; but the pale light gives nothing an edge. Except for the horizon to the south, the color of a bruise, the world is only moonlit ice and black sky.

The sky has no depth because of the fullness of the moon, but stars shine brightly. The stars have caused me to pause in the middle of my walk. Polaris, the North Star, is directly overhead. Whenever before I have located the Big Dipper in the sky and followed the imaginary line through its indicator stars to find Polaris, I have been looking to the north, into a northern sky. This afternoon I look straight up.

It is a celestial accident that Polaris is located over the earth's Geographic North Pole (there is no comparable South Pole star). It seems to sit precisely on

an extension of the earth's axis; and it has shifted its position so little in our time we think of it as a constant. It nearly is; it has been steady enough to anchor routes of navigation for people in the Northern Hemisphere for as long as history records. Astronomers call the mathematical point in the sky above the North Pole the North Celestial Pole, and Polaris is within a degree of it.

I look straight up at that anchor now, a yellowish star one hundred times the size of the sun, *Alpha Ursae Minoris*, the only one that never seems to move. Pivoting around it are the seven bright stars and seven fainter ones that can be joined to create the familiar cup with its handle, or to form the hips and tail of Ursa Major, the Great Bear. In the early history of Western civilization the parts of the world that lay to the far north were understood to lie beneath these stars. The Greeks called the whole of the region Arktikós, the country of the great bear.

The Old World regarded the Arctic as an inaccessible place. Beyond a certain gloomy and hostile border country, however, they did not imagine it as inhospitable. Indeed, in Greek myth this most distant part of the Arctic was a country of rich lacustrine soils, soft azure skies, gentle breezes (zephyrs), fecund animals, and trees that bore fruit even in winter, a region farther north than the birthplace of the North Wind (Boreas). The inhabitants of Hyperborea, as it was called, were thought to be the oldest of the human races, and to

8

Bethel, Alaska, 2012.
Courtesy of Brian Adams.

be comparable themselves with the land—compassionate in temperament, knowing no want, of a contemplative bent. In some legends of Hyperborea there are striking images of this blessed atmosphere—white feathers falling from the sky, for example. (The allusion is probably to a gentle lamellation of snow; but the reference is not entirely metaphorical. On the coast of Alaska one summer day, an immense flock of molting ducks flew over my head, and hundreds of their feathers rocked quietly to earth as they passed. In histories of nineteenth-century arctic exploration, too, one finds a correspondence, with descriptions of a kind of hoarfrost that built up like a vaning of feathers on a ship's rigging.)

Perhaps some traveler's story of irenic northern summers reached the Greeks and convinced them of the Hyperboreans' salutary existence. A darker side of this distant landscape, however, was more frequently evoked. The indigenous southern cultures regarded it as a wasteland of frozen mountains, of violent winds and incipient evil. For theological writers in the seventh century it was a place of spiritual havoc, the abode of the Antichrist. During the time when the southern cultures in Europe were threatened by Goths, Vandals, and other northern tribes (including, later, the Vikings), two quintessentially malevolent figures from the Old Testament, Gog and Magog, emerged as the figurative leaders of a mythic horde poised above the civilized nations. These were the forces of darkness, arrayed against the forces of light. In English legend the northern armies are defeated and Gog and Magog captured and taken to London in chains. (Their effigies stood outside Guildhall in the central city for 500 years before being destroyed in an air raid in World War II.)

A gentler ending than this is found with a hill outside Cambridge called Gogmagog. One of the northern giants in that barbaric army, the story goes, fell in love with one of the young women of the South. She spurned him because of his brutish nature. He lay

down in remorse, never to move again. His body became the hills.

In a more prosaic attempt to define the Arctic we have arranged it around several poles.[1] The precise location of the most exact of these northern poles, the North Pole itself, varies (on a small scale). Tectonic activity, the gravitational pull of the moon, and the continuous transport of sediments from one place to another by rivers cause the earth to wobble slightly, and its axis to shift as it does so. If the North Pole were a scribing stylus, it would trace a line every 428 days in the shape of an irregular circle, with a diameter varying from 25 to 30 feet. Over the years, these irregular circles would all fall within an area some 65 feet across, called the Chandler Circle. The average position of the center of this circle is the Geographic North Pole.

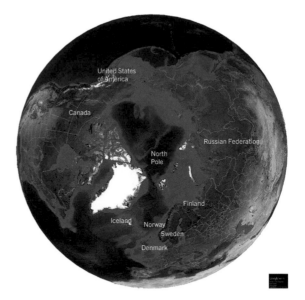

Arctic nations. US State Department, Google Earth/International Bathymetric Chart of the Arctic Ocean, 2015.

Other northern poles are as hard to locate precisely. In 1985 the North Magnetic Pole, around which the earth's magnetic field and its magnetosphere (far above the earth's atmosphere) are organized, lay at 77°N 120°W, some 30 miles east of Edmund Walker Island, at the southern end of the Findlay Group. This is 400 miles farther north and somewhat west of where it was when James Clark Ross discovered it in 1831, on the west side of Boothia Peninsula.

The North Geomagnetic Pole, around which the earth's magnetic field and its magnetosphere are theoretically (mathematically) arranged, lies about 500 miles east of the North Magnetic Pole, in the vicinity of Inglefield Land in northern Greenland. A fifth northern pole, hardly noted anymore, has been made obsolete. In the nineteenth century people believed no point on earth was more difficult to attain than a place in the sea ice north of Alaska, at about 84°N 160°W. The pack ice of the Arctic Ocean was thought to pivot slowly around this spot, making an approach by ship impossible and a journey on foot or by dog sledge too perilous. No more evident to the eye than the Geographic North Pole, this Pole of Inaccessibility has now been "seen" numerous times from the air and even "visited," probably, by Russian icebreakers.[2]

More useful, perhaps, than any set of lines in developing an understanding of the arctic regions is an image of the annual movement of the sun across the arctic sky. To the temperate-zone eye the movement is irregular and unorthodox. The borders that divide periods of light (days) from periods of darkness (nights) seem too vague and the duration of both too prolonged or too short, depending.

It is difficult to imagine the sun's arctic movement because our thought about it has been fixed for tens of thousands of years, ever since we moved into the North Temperate Zone. We also have trouble here because as terrestrial, rather than aerial or aquatic, creatures we don't often think in three dimensions. I remember

the first time these things were impressed on me, on a winter flight to Barrow on the north coast of Alaska. It was around noon and we were flying north. By craning my neck and pressing my face against the cabin window, I was able to see the sun low on the southern horizon. It seemed to move not at all from that spot during the two-hour flight. When we landed at Barrow, it seemed to have set in the same spot. As I walked through the village, I realized I had never understood this before: in a far northern winter, the sun surfaces slowly in the south and then disappears at nearly the same spot, like a whale rolling over. The idea that the sun "rises in the east and sets in the west" simply does not apply. The thought that a "day" consists of a morning and a forenoon, an afternoon and an evening, is a convention, one so imbedded in us we hardly think about it, a convention of our literature and arts. The pattern is not the same here.[3]

To grasp the movement of the sun in the Arctic is no simple task. Imagine standing precisely at the North Pole on June 21, the summer solstice. Your feet rest on a crust of snow and windblown ice. If you chip the snow away you find the sea ice, grayish white and opaque. Six or seven feet underneath is the Arctic Ocean, dark, about 29°F and about 13,000 feet deep. You are standing 440 miles from the nearest piece of land, the tiny island of Oodaaq off the coast of northern Greenland. You stand in each of the world's twenty-four time zones and north of every point on earth. On this day the sun is making a flat 360° orbit exactly 23½° above the horizon.

If we could stay within the limits of this twenty-four-hour day and if you could walk down the 100th meridian, toward Mexico City, you would notice at first very little change in the sun's path around the sky. Soon, however, you would begin to sense that the sun's orbit was tilted, its arc higher in the southern sky and lower in the northern sky. The tilt of the sun's arc would become more and more pronounced

as you walked south. When you reached the vicinity of Garry Lake in the Northwest Territories, where the 100th meridian crosses a line of latitude at 66°33'N (the Arctic Circle), the sun would have dropped low enough to touch the northern horizon behind you for the first time. You would be far enough into a time zone now for it to make a difference, and that moment when the sun touched the horizon would be "midnight." At the same spot twelve hours later, the sun would stand 47° above the southern horizon; it would be "noon," local time. You would say, now, that the sun seemed more to move *across* the sky than *around* in it. It has begun to slip below the northern horizon; from here, still walking south on June 21, you would start to experience "night." Short nights, only prolonged periods of twilight really, at first. But slowly the twilight would start to deepen during the evening hours and to wax in the morning hours. Somewhere on the plains of Manitoba you would finally sense "the middle of the night"—enough of real darkness so you couldn't continue walking without fear of stumbling.

If you carried on, as you could if we held June 21 in suspension like this, you would begin to notice three things: the nights would get noticeably longer; the sun would stand higher and higher in the southern sky at noon (and more clearly seem to "rise in the east" and "set in the west"); and periods of twilight at dawn and dusk would shorten, until twilight would be only a passing phenomenon. The sun rises and sets sharply in Mexico City. Sunshine is a daily, not a seasonal, phenomenon, as it is in the North.

If you stood at the North Pole six months later, on December 21, the winter solstice, the middle of the polar night, you would not see a single star set—they would all pass before you from left to right. If they left behind the light-streak traces they do on time-exposed film, you would see the varicolored rings stacked one atop another, parallel to the horizon, shrinking in diameter, until the last ring, less than 2° across and traced

by Polaris, circled the dark spot of empty space that lies over the North Pole.

If you walked south from the Pole on December 21, you would find the phenomena of six months earlier reversed. It would be utterly dark at the Pole on that day. On the plains of Manitoba the balance of day and night would feel right to you if you were familiar with the short days of winter in the Temperate Zone. In the tropics there would again be days and nights of equal length, with very little twilight.[4]

You would have to walk a very long way south on December 21, 1611 statute miles, all the way to the Arctic Circle, to actually set eyes on the sun. The winter darkness, however, would not be complete. Prolonged periods of twilight penetrate the long arctic night, and the strength of even scant illumination from the stars is enhanced all winter by the reflective surfaces of ice and snow. Too, there is no forest canopy to dim the land and, save in a few places, no night shadow of a mountain range to contend with. The Arctic is like the desert in this way—open, unobstructed country, lit well enough by a full moon to permit travel at night.

It makes little sense in more southerly latitudes to dwell on a consideration of twilight, but it is meaningful in the Arctic, where this soft light lingers for such long periods of time that astronomers distinguish several types.[5] In the Temperate Zone, periods of twilight are a daily phenomenon, morning and evening. In the Far North they are (also) a seasonal phenomenon, continuous through a day, day after day, as the sun wanes in the fall and waxes in the spring. In the Temperate Zone each day is noticeably shorter in winter and longer in summer but, still, each day has a discernible dawn, a protracted "first light" that suggests new beginnings. In the Far North the day does not start over again every day.

In 1597 the icebound and shipwrecked Dutch explorer Willem Barents was forced to overwinter with his crew in wretched circumstances at the northern tip of

11

Novaya Zemlya. They awaited the return of the sun in a state of deep anxiety. More than the cold they hated the darkness; no amount of prolonged twilight could make up for the unobstructed view of that beaming star. They quoted Solomon to each other: "The light is sweet; and it is delightful for the eyes to see the sun." When the sun finally did appear it came twelve days earlier than they expected. They acknowledged a di-

Barrow, Alaska.
Courtesy of George Burba.

vine intervention. They gestured toward it with joy and disbelief, and took courage against their difficulties from its appearance.

What they saw that January day, we now know, was not the sun but only a solar mirage—the sun was still 5° below the horizon, its rays bent toward them by a refractive condition in the atmosphere. Such images, now called Novaya Zemlya images, are common in the Arctic. They serve as a caution against precise description and expectation, a reminder that the universe is oddly hinged.

If, at the termination of this imaginary southward journey through the realms of winter and summer light, you were to turn around and come back, you would notice many changes in the biological life around you. The total number of species of animals and plants (biological diversity) would diminish—strikingly so by the time you reached the arctic regions. Overall biological productivity (annual number of offspring per species) would also fall off. And the timing of the birth of young would be related increasingly to the cycle of the seasons. The various strategies animals use to survive, to procreate, feed, and protect themselves from the climate, would also change. The long-term biological stability of the ecosystems would decrease. You would travel from a land in which the four seasons are phantoms; from jungles of towering hardwood species where water is always a liquid trickling somewhere; and where the list of animals is voluminous but unfinished. You would arrive, finally, in a land of seasonal hibernation, of periodically frozen water and low, ground-hugging trees, where the list of mammalian denizens is short enough to memorize in a few moments.

The overall impression, coming from the South, would be of movement from a very complex world to a quite simplified one—there would come a moment when you passed from the mixed forests of the South, where no one kind of tree stood out, into the coniferous forests where trees of only one or two kinds existed,

imparting a single shade of green to a hillside. But this sensation of simplicity would be something of an illusion. Arctic ecosystems have the same elegant and Byzantine complexities, the same wild grace, as tropical ecosystems; there are simply fewer moving parts—and on the flat, open tundra the parts are much more visible, accessible, and countable. The complexities in arctic ecosystems lie not with, say, esoteric dietary preferences among 100 different kinds of ground beetle making a living on the same tropical acre, but with an intricacy of rhythmic response to extreme ranges of light and temperature. With the seasonal movement of large numbers of migratory animals. And with their adaptation to violent, but natural, fluctuations in their population levels.

In traveling north from the tropics, however, we would still find that broad-scale changes apparent to our eyes suggested an undeveloped country. To the unscientific eye the land would seem to have run out of the stuff of life—running water, light, warmth—to have reached absolute limits. It would seem to offer few niches for animals to occupy. As for the human animal, there would seem to be no such nurturing recesses at all. But there are niches here; and they are filled by animals completely and comfortably at home in them. (The awe one feels in an encounter with a polar bear is, in part, simple admiration for the mechanisms of survival it routinely employs to go on living in an environment that would defeat us in a few days. It is also what impresses someone on an arctic journey with Eskimos. Their resourcefulness, as well as their economy of action, bespeak an intense familiarity with the environment. Of course, they are the people there.)

On our journey north we would notice significant changes in the soil under our feet. Soil is a living system, a combination of dirt (particles of sand, clay, and silt) and decaying and processed organic matter. It is created by erosion, fracture, and the secretion of organic acids; by animals and plants like beetles (sa-

13

prophages) and mushrooms (saprophytes) that break down dead matter; and by the excretions of earthworms. It draws in oxygen like an animal, through myriad tunnels built by ants, rodents, and worms. And it is inhabited throughout by hundreds of creatures—nematodes, mites, springtails, and soil bacteria and fungi.

In the tropics, saprophages and saprophytes break down organic matter quickly. The recycling of nutrients (phosphorus, sodium, and potassium) is so swift that little soil remains behind. In the Temperate Zone, the turnover in organic matter and the recycling of nutrients are much slower, especially in winter, when cold-blooded soil organisms are lethargic or inactive. As a result, rich, deep layers of humus build up over a reddish, sterile clay base familiar from the tropics. To the north these fertile layers of humus give way to firmer, less fertile brown soils, because of a reduction both in the numbers and kinds of saprophages and saprophytes and in aerating and soil-building organisms that can adapt to the loss of solar energy. These acidic podzols of the boreal forests and prairies reach their northern limit at the tree line, where one first encounters the inhospitable soils of the tundra.

Almost everywhere you wander on the open tundra you find whole dead leaves, preserved flower parts, and bits of twig, years of undisturbed organic accumulation. Decomposition in the Arctic is exceedingly slow, work that must be accomplished by even fewer organisms operating for even shorter periods of time—but since overall biological production is not nearly what it is in the Temperate Zone, little humus builds up. Arctic soils are thin, acidic, poorly drained, and poorly aerated. They are rich in neither the nitrogen nor the phosphorus essential for plant growth. (The soil at fox dens and at the slight rises on the tundra that snowy owls and jaegers routinely use as perches while eating their prey is an exception. The concentration of nutrients at these "organic dumps" accounts for the sometimes luxuriant growth of grasses and the bright display of summer wildflowers at these spots.)

So: the soils would change in depth and quality beneath our feet as we came north. And the different kinds of animals and plants living within and upon the soil, less and less able to adapt to the reduction of solar energy, would dwindle. And the ones that remained would work slowly or not at all in the dark and cold. If we kept walking, we would eventually stand in a country without the earthworm or the carrion beetle, a place where earth and decay are almost unknown, on the lifeless gravels of the polar desert.

Traveling north from the equator you could not help but notice, too, the emergence of recognizable seasons, periods of time characterized by conditions of rising, falling, or relatively stable light, in association with certain ranges of temperature. By the time you entered the Temperate Zone you would find a set of seasons distinct enough to be named and easily separated. Farther north, "spring" and "fall" would seem increasingly transitory, until each became a matter of only a few weeks. Winter, you would eventually find, lasted appreciably longer than summer. And together the two would define the final landscape.

The seasons are associated in our minds with the growth of vegetation. Outside of the four primary seasons (a constant referent with us, a ready and seemingly natural way to organize our ideas), we speak of a growing season and of a fallow season, when we picture the earth lying dormant. In the middle of an arctic winter, however, there is such a feeling of a stone crushed beneath iron that it is hard to imagine any organism, even a seed, living, let alone lying fallow. In summer, in the sometimes extravagant light of a July day, one's thoughts are not of growth, of heading wheat and yellowing peaches, but of suspension, as if life had escaped the bounds of earth. In this country, which lacks the prolonged moderations between winter and summer that we anticipate as balmy April mornings

and dry Indian summer afternoons, in this two-season country, things grow and die as they do elsewhere, but they are, more deeply than living things anywhere else, seasonal creatures.

The trees are no exception. The northern limit of the continental forests in North America seems anomalous if you try to make sense of the tree line. The boundary sweeps southwest from Labrador to

pass beneath James Bay, then turns northwest, crossing Canada's Precambrian Shield and paralleling the Mackenzie River Valley nearly to the Arctic Ocean before zigzagging west through the valleys of the Brooks Range and the Kobuk River to Norton Sound. The explanation for the irregularity of the line lies with the seasonal climate—it marks the average southward extension of arctic air masses in summer.

The far northern trees, like the animals, constitute a very few species—willows growing in valleys where they are protected from the wind and a dwarf form of birch. Along the tree line itself, the only successful strategists are species in the pine and birch families. Their numbers thin out over a span of several miles, with trees persisting farther north in isolated patches where there is a fortuitous conjunction of perennially calm air, moisture, and soil nutrients. Islands of trees in the tundra ocean.

The growth of trees in the Arctic is constrained by several factors. Lack of light for photosynthesis of course is one; but warmth is another. A tree, like an animal, needs heat to carry on its life processes. Solar radiation provides this warmth, but in the Arctic there is a strong correlation between this warmth and closeness to the ground. In summer there may be a difference of as much as 15°F in the first foot or so of air, because of the cooling effect of the wind above and the ability of dark soils to intensify solar radiation. To balance their heat budgets for growth and survival, trees must hug the ground—so they are short. Willows, a resourceful family to begin with, sometimes grow tall, but it is only where some feature of the land stills the drying and cooling wind.

Lack of water is another factor constraining the development of trees. No more moisture falls on the arctic tundra in a year than falls on the Mojave Desert; and it is available to arctic plants in the single form in which they can use it—liquid water—only during the summer.

Permafrost, the permanently frozen soil that underlies the tundra, presents arctic trees with still other difficulties. Though they can penetrate this rocklike substance with their roots, deep roots, which let trees stand tall in a windy landscape, and which can draw water from deep aquifers, serve no purpose in the Arctic. It's too cold to stand tall, and liquid water is to be found only in the first few inches of soil, for only this upper layer of the ground melts in the summer. (Ironically, since the permafrost beneath remains impervious, in those few weeks when water *is* available to them, arctic trees must sometimes cope with boglike conditions.)

Trees in the Arctic have an aura of implacable endurance about them. A cross-section of the bole of a Richardson willow no thicker than your finger may reveal 200 annual growth rings beneath the magnifying glass. Much of the tundra, of course, appears to be treeless when, in many places, it is actually covered with trees—a thick matting of short, ancient willows and birches. You realize suddenly that you are wandering around on *top* of a forest.

Virtually all of the earth's biological systems are driven by solar radiation. As the light falls, so must the animals and plants arrange their growth and daily activities. The Arctic receives, strangely, the same amount of sunshine in a year as the tropics, but it comes all at once, and at a low angle of incidence—without critical vigor. The regular rhythm of light-fall in the tropics, that predictable daily infusion of energy, together with its high angle of incidence, are the primary reasons for the natural stability of these ecosystems. The rainy season aside, temperature and humidity on a day in May are not so different from temperature and humidity on a day in December. The animals and plants have evolved breeding and feeding strategies, of course, that depend on this almost uninterrupted flow of light.

In the Temperate Zone, periods of daily light-fall are not equal during the year. The animals and plants must adjust to a seasonal way of life. In the Arctic this

situation becomes much more extreme. Periods of light-fall can't readily be divided into days. The average temperature fluctuates over a period of 365 days, not twenty-four hours; sources of water are frozen; and the dim light puts a special burden on animals that must use their eyes to search. The very rhythm of light itself creates a difficulty. Most animals live lives in biological keeping with the earth's twenty-four-hour period of rotation. They have neither the stamina nor the flexibility, apparently, to adapt to the variable periods of light they encounter in the Arctic's nightless summer and dayless winter.[6]

The adaptive strategies of arctic animals to failing light and low temperatures are varied. In general, they must either develop insulation against the cold or slow down, or halt, their metabolic processes to survive. Warm-blooded animals and flowering plants aside (these must bloom and fruit rapidly in the summer), the most salient, overall adaptive strategy of arctic organisms is their ability to enter a frozen state or a state of very low metabolic activity whenever temperatures drop, and then to resume full metabolic activity whenever it warms sufficiently. Many arctic spiders and insects, along with lichens, ferns, and mosses, lie frozen for the duration of winter. Trees, along with grizzly bears and ground squirrels, carry on their life processes but at a very low metabolic rate. Fish and various beetles use cellular antifreeze agents (glycoproteins) to extend their periods of activity during freezing weather. Other adaptive strategies show parallels with those of desert plants. The leathery leaves of saxifrages and the hairy leaves of Labrador tea, for example, both reduce the transpiration of precious water in the short summer.

Slowing down their rate of growth is another strategy coldblooded animals use. The scant solar energy available to them in the summer is often not enough to complete their development from larval to adult stages, so they must "plan" not to be at a vulnerable point of transition just as winter is coming on. Other

strategies to take advantage of short periods of light for growth and sustenance include the winter carryover of evergreen leaves by the dwarf birch (so it does not have to grow leaves again in the spring to begin photosynthesis); and the very large yolks of arctic cod eggs, which give these embryos a nutritional head start before the return of light in the spring triggers a bloom of plankton, their principal food when they hatch. With this head start they are larger and stronger and better able to survive when the ocean begins to freeze over in the fall.

Scientists believe tropical ecosystems are the oldest ones on earth. Compared with northern ecosystems, where development has been periodically halted or destroyed by the advance of glaciers, they have had many more thousands of years of undisturbed biological evolution. They are also characterized by a special kind of biological stability not found in the North—the finite number of individuals in any given tropical species hardly varies through time. This biological stability is linked to the stability of the climate and is perpetuated by highly intricate food webs and high rates of biological production. Many species, producing many young, exploit a very large number of biological niches. The system is practically invulnerable to most natural disturbances, such as a disease that might wipe out every one of a certain kind of tree. It is too diversified to be affected.

Some biologists believe all ecosystems tend to develop in the direction of stability, that is, toward many types of animals (great species diversity) and very small population surges and declines. Temperate-zone and arctic ecosystems, according to this view, are slowly evolving toward the kind of diversity and stability one sees in the tropics. But they are not liable to develop the complex food webs of the tropics, that kind of resilient diversity, on any scale of time in which we are used to thinking. The northerly ecosystems must contend with significant fluctuations in the amount of

17

solar energy received; their rate of biological evolution, therefore, is much slower. In addition, the northerly ecosystems regularly experience severe biological disturbances related to normal weather patterns (the "unseasonable weather" blamed for the loss of a citrus crop in Florida or the early emergence of hibernating bears in Montana). Arctic climatic patterns are further characterized by unpredictable and violent weather.

The communal alliances of far northern plants and animals we call ecosystems are distinguished from more southerly ecosystems by larger biomasses and lower overall productivity. Instead of many species, each with relatively few individuals in it, we find relatively few species, each with many individuals— large herds of caribou, for example, or vast swarms of mosquitoes. But, generally speaking, these large populations do not include enough surviving young each year to keep their populations stable. The size of the population often changes, dramatically, as a matter of course; the violent weather typical of early and late summer routinely wreaks havoc on some arctic populations, particularly those of warm-blooded animals. On Wrangel Island in the Siberian Arctic, for example, an unbroken, ten-year series of late spring snowstorms prevented lesser snow geese from ever laying their eggs. Between 1965 and 1975 the population fell from 400,000 to fewer than 50,000 birds. In different years in the Greenland Sea where harp seals pup on the ice floes, spring storms have swept hundreds of thousands of infant harp seals into the sea, where they have drowned. In the fall of 1973, an October rainstorm created a layer of ground ice that, later, muskoxen could not break through to feed. Nearly 75 percent of the muskox population in the Canadian Archipelago perished that winter.

Biologists, for these mostly climatological reasons, characterize arctic ecosystems as "stressed" or "accident-prone," underscoring the difference between them and temperate and tropical ecosystems. With their milder climates and longer growing seasons the latter are more forgiving. In the South, the prolongation of spring permits birds to lay two or even three clutches of eggs if the first is destroyed by predation or adverse weather. An arctic nester, by comparison, has only a short period of solar energy available, which it must take swift and efficient advantage of for rearing its young, laying on reserves of fat for its southward journey, and accomplishing its own molt, a fatiguing process that its southern relatives can spread out over several months. (The solar energy upon which it is dependent, of course, is producing more than warmth and light. It is melting water to drink, fueling photosynthesis in the bird's food plants, and bringing to life the insects upon which it depends for protein.)

Because arctic nesters must face unpredictable weather along with an abbreviated period of solar energy, the timing of their arrival on the nesting ground and of their egg-laying and departure is critical. When a June sleet storm or a sudden August freeze destroys an entire generation of young birds, or 10,000 seals, or hundreds of caribou calves, it comes home in the starkest way that this is an environment marked by natural catastrophe, an inherently vulnerable ecosystem. The stress apparent to us, however, is not a sign of any weakness or fragility in arctic ecosystems. In fact, they show a remarkable resiliency. The Canadian muskox population increased dramatically after the winter of 1973–74. The harp seal thrives today in the Greenland Sea. The population of snow geese on Wrangel Island was back to about 300,000 by 1982.[7]

If we finally stood, then, at the end of our journey, looking over the tundra with that short list of arctic creatures to hand, wondering why it had dwindled so, we would need to look no further than that yellow star burning so benignly in the blue summer sky. It is the sunlight, always the streaming sunlight, that matters most. It is more critical even than temperature as a limiting factor on life. The salient reason there are so few

species here is that so few have metabolic processes or patterns of growth that can adapt to so little light. (Secondarily, many warm-blooded creatures can't conserve enough heat to survive in the extreme cold.) Of the roughly 3200 species of mammal we could possibly have encountered on the way north, we would find only 23 or so living beyond the tree line in this cold, light-poor desert.[8] Of some 8600 species of birds, only six or seven—common raven, snowy owl, rock ptarmigan, hoary redpoll, gyrfalcon, Ross's gull, and ivory gull—overwinter in the high Arctic, and only about 70 come north to breed. Of the boundless species of insect, only about 600 are to be found in the Arctic.[9] Of perhaps 30,000 species of fish, fewer than 50 have found a way to live here.

In certain parts of the Arctic—Lancaster Sound, the shores of Queen Maud Gulf, the Mackenzie River Delta, northern Bering Sea, the Yukon-Kuskokwim Delta—great concentrations of wildlife seem to belie violent fluctuations in this ecosystem. The Arctic seems resplendent with life. But these are summer concentrations, at well-known oases, widely separated over the land; and they consist largely of migratory creatures—geese, alcids, and marine mammals. When the rivers and seas freeze over in September they will all be gone. The winter visitor will find only caribou and muskoxen, and occasionally arctic hares, concentrated in any number, and again only in a few places.

All life, of course, cannot fly or swim or walk away to a warmer climate. When winter arrives, these animals must disperse to areas where they will have a good chance to find food and where there is some protection from the weather. A few hibernate for seven or eight months. Voles and lemmings go to ground too, but remain active all winter. Wolves shift their home ranges to places where caribou and moose are concentrated. Arctic foxes follow polar bears out onto the sea ice, where they scavenge the bear's winter kills. Arctic

hares seek out windblown slopes where vegetation is exposed. All these resident animals have a measure of endurance about them. They expect to see you, as unlikely as it may seem, in the spring.

In my seasonal travels the collared lemming became prominent in my mind as a creature representative of winter endurance and resiliency. When you encounter it on the summer tundra, harvesting lichen or the roots of cotton grass, it rises on its back feet and strikes a posture of hostile alertness that urges you not to trifle. Its small size is not compromising; it displays a quality of heart, all the more striking in the spare terrain. Lemmings are ordinarily sedentary, year-round residents of local tundra communities. They came into the central Arctic at the end of the Pleistocene some 8000 years ago, crossing great stretches of open water and extensive rubble fields of barren sea ice to reach the places they live in today. In winter lemmings live under an insulating blanket of snow in a subnivean landscape, a dark, cool, humid world of quiet tunnels and windless corridors. They emerge in spring to a much brighter, warmer, and infinitely more open landscape—where they are spotted by hungry snowy owls and parasitic jaegers and are hunted adroitly by foxes and short-tailed weasels. In most years, in most places, there is not much perplexing about this single link in several arctic food chains. In some places, every three or four years, however, the lemming population explodes. Lemmings emerge from their subnivean haunts in extraordinary numbers and strike out—blindly is the guess—across the tundra.

The periodic boom in lemming populations—there are comparable, though more vaguely defined, cycles affecting the periodic rise and fall of snowshoe hare and lynx populations, and caribou and wolf populations—is apparently connected with the failure of the lemmings' food base. The supply of available forage reaches a peak and then collapses, and the lemmings

19

move off smartly in all directions as soon as traveling conditions permit in the spring. Occasionally many thousands of them reach sea cliffs or a swift-moving river; those pushing in the rear force the vanguard into the water to perish.

Arctic scientist Laurence Irving, camped once on a gravel bar off the Alaska coast, wrote: "In the spring of a year of climaxing abundance, a lively and pugnacious lemming came into my camp . . . [more] tracks and a dead lemming were seen on the ice several kilometers from shore. The seaward direction of this mad movement was pointless, but it illustrates stamina that could lead to a far dispersal." Irving's regard, of course, is a regard for the animal itself, not for the abstract mechanisms of population biology of which it seems to merely be a part. Its apparently simple life on the tundra suggests it can be grasped, while its frantic migrations make it seem foolish. In the end, it is complex in its behavior, intricately fitted into its world, and mysterious.

Whenever I met a collared lemming on a summer day and took its stare I would think: Here is a tough animal. Here is a valuable life. In a heedless moment, years from now, will I remember more machinery here than mind? If it could tell me of its will to survive, would I think of biochemistry, or would I think of the analogous human desire? If it could speak of the time since the retreat of the ice, would I have the patience to listen?

One time I fell asleep on the tundra, a few miles from our camp. I was drowsy with sun and the weight of languid air. I nestled in the tussock heath, in the warm envelope of my down parka, and was asleep in a few moments. When I awoke I did not rise, but slowly craned my head around to see what was going on. At a distance I saw a ground squirrel crouched behind a limestone slab that rose six or eight inches out of the ground like a wall. From its attitude I thought it was listening, confirming the presence of some threat on the other side of the rock, in a shallow draw. After a while

it put its paws delicately to the stone and slowly rose up to peer over, breaking the outline of the rock with the crown of its head. Then, with its paws still flat at the rim, it lowered itself and rested its forehead on the rock between its forelegs. The feeling that it was waiting for something deadly to go away was even stronger. I thought: Well, there is a fox over there, or a wolverine. Maybe a bear. He'd better be careful.

I continued to stare at him from the warm crevice in the earth that concealed me. If it is a bear, I thought, I should be careful too, not move from here until the ground squirrel loses that tension in its body. Until it relaxes, and walks away.

I lay there knowing something eerie ties us to the world of animals. Sometimes the animals pull you backward into it. You share hunger and fear with them like salt in blood.

The ground squirrel left. I went over to the draw beyond the rock but could find no tracks. No sign. I went back to camp mulling the arrangements animals manage in space and in time—their migrations, their patience, their lairs. Did they have intentions as well as courage and caution?

Few things provoke like the presence of wild animals. They pull at us like tidal currents with questions of volition; of ethical involvement, of ancestry.

For some reason I brooded often about animal behavior and the threads of evolution in the Arctic. I do not know whether it was the reserves of space, the simplicity of the region's biology, its short biological history, striking encounters with lone animals, or the realization of my own capacity to annihilate life here. I wondered where the animals had come from; and where we had come from; and where each of us was going. The ecosystem itself is only 10,000 years old, the time since the retreat of the Wisconsin ice. The fact that it is the youngest ecosystem on earth gives it a certain freshness and urgency. (Curiously, historians refer to these same ten millennia as the time of

civilized man, from his humble beginnings in northern Mesopotamia to the present. Arctic ecosystems and civilized man belong, therefore, to the same, short epoch, the Holocene. Mankind is, in fact, even older than the Arctic, if you consider his history to have begun with the emergence of Cro-Magnon people in Europe 40,000 years ago.)

Human beings dwell in the same biological systems that contain the other creatures but, to put the thought bluntly, they are not governed by the same laws of evolution. With the development of various technologies—hunting weapons, protective clothing,

Swarming mosquitos.
Copyright © Patrick Ziegler.

and fire-making tools; and then agriculture and herding—mankind has not only been able to take over the specific niches of other animals but has been able to move into regions that were formerly unavailable to him. The animals he found already occupying niches in these other areas he, again, either displaced or eliminated. The other creatures have had no choice. They are confined to certain niches—places of food (stored solar energy), water, and shelter—which they cannot leave without either speciating or developing tools. To finish the thought, the same technological advances and the enormous increase in his food base have largely exempted man from the effect of natural controls on the size of his population. Outside of some virulent disease, another ice age, or his own weapons technology, the only thing that promises to stem the continued increase in his population and the expansion of his food base (which now includes oil, exotic minerals, fossil ground water, huge tracts of forest, and so on, and entails the continuing, concomitant loss of species) is human wisdom.

Walking across the tundra, meeting the stare of a lemming, or coming on the tracks of a wolverine, it would be the frailty of our wisdom that would confound me. The pattern of our exploitation of the Arctic, our increasing utilization of its natural resources, our very desire to "put it to use," is clear. What is it that is missing, or tentative, in us, I would wonder, to make me so uncomfortable walking out here in a region of chirping birds, distant caribou, and redoubtable lemmings? It is restraint.

Because mankind can circumvent evolutionary law, it is incumbent upon him, say evolutionary biologists, to develop another law to abide by if he wishes to survive, to not outstrip his food base. He must learn restraint. He must derive some other, wiser way of behaving toward the land. He must be more attentive to the biological imperatives of the system of sun-driven protoplasm upon which he, too, is still dependent. Not because he must, because he lacks inventiveness, but because herein is the accomplishment of the wisdom that for centuries he has aspired to. Having taken on his own destiny, he must now think with critical intelligence about where to defer.

A Yup'ik hunter on Saint Lawrence Island once told me that what traditional Eskimos fear most about us is the extent of our power to alter the land, the scale of that power, and the fact that we can easily effect some of these changes electronically, from a distant city. Eskimos, who sometimes see themselves as still not quite separate from the animal world, regard us as a kind of people whose separation may have become too complete. They call us, with a mixture of incredulity and apprehension, "the people who change nature."

I remember one summer evening on the sea ice at the mouth of Admiralty Inlet, lying on caribou skins in my tent, nursing a slight wound I had suffered during the butchering of a narwhal. I was one of two white men in the group of eight and the only one who did not speak Inuktitut, which, far out on the sea ice, increased my feelings of isolation. As I lay there, however, I recalled vaguely some words of Wilfred Thesiger, who traveled among the Bedouin, which I later looked up: "I was happy in the company of these men who had chosen to come with me. I felt affection for them personally and sympathy with their way of life. But though the easy quality of our relationship satisfied me, I did not delude myself that I could be one of them. They were Bedu and I was not; they were Muslims and I was a Christian. Nevertheless I was their companion and an inviolable bond united us."

Lying there in the tent, I knew, as does everyone I think who spends some time hunting with Eskimos, that they are not idyllic people, errorless in the eyes of God. But they are a people, some of them, still close to the earth, maintaining the rudiments of an ancient philosophy of accommodation with it that we have abandoned. Our first wisdom as a species, that unique

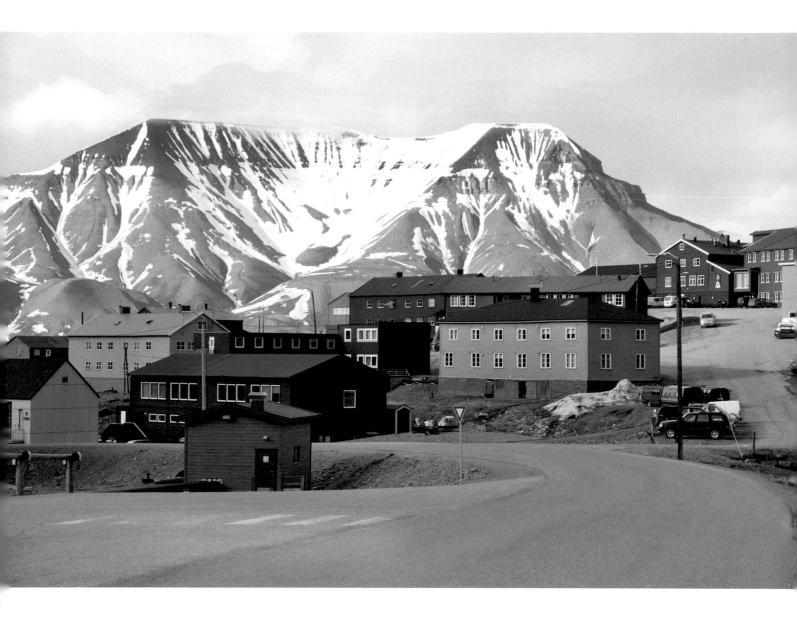

metaphorical knowledge that distinguishes us, grew out of such an intimacy with the earth; and, however far we may have come since that time, it did not seem impossible to me that night to go back and find it. I wanted to enquire among these people, for what we now decide to do in the North has a certain frightening irrevocability about it.

I wanted to enquire, as well, among thoughtful

visitors, people who were taken with the land. Each culture, it seemed to me, is a repository of some good thought about the universe; we are valuable to each other for that. Lying there, I thought of my own culture, of the assembly of books in the library at Alexandria; of the deliberations of Darwin and Mendel in their respective gardens; of the architectural conception of the cathedral at Chartres; of Bach's cello suites, the philosophy of Schweitzer, the insights of Planck and Dirac. Have we come all this way, I wondered, only to be dismantled by our own technologies, to be betrayed by political connivance or the impersonal avarice of a corporation?

I had no idea as I lay on those caribou skins that evening precisely where wisdom might lie. I knew enough of quantum mechanics to understand that the world is ever so slightly but uncorrectably out of focus, that there are no absolutely precise answers. Whatever wisdom I would find, I knew, would grow out of the land. I trusted that, and that it would reveal itself in the presence of well-chosen companions.

I looked out of the tent. It was after one in the morning. A south wind blew, but so slightly. The kind of wind nineteenth-century sailors called "inclinable to calm." Nakitavak lay stretched out on caribou skins and a cotton sleeping bag on his big sled, his qamutiik, watching the still black water between two massive ice floes, the open lead into which narwhals would come, sooner or later. His brother David, both hands wrapped around a mug of tea, was looking to the west, the direction from which he thought they would come. His lips stretched to the steaming, hot surface of the tea, and in the chill air I heard the susurrations of his sipping.

These Tununiarusirmiut men, relatives of the Tununirmiut to the east who had met the whalers 160 years ago, knew beyond a shadow of a doubt, beyond any hesitation, what made them happy, what gave them a sense of satisfaction, of wealth. An abundance of animals.

And so, we waited.

Notes

1 There is no generally accepted definition for a southern limit to the Arctic. The Arctic Circle, for example, would enclose a part of Scandinavia so warmed by a remnant of the Gulf Stream that it harbors a lizard, *Lacerta vivipera*, an adder, *Vivipera berus*, and a frog, *Rana temporaria*. It would also exclude the James Bay region of Canada, prime polar bear habitat. The southern extent of permafrost, the northern tree line, the geographical distribution of certain animals, the southern extent of the 50°F isotherm in July—all have been proposed and argued away by scientists.

2 The Soviet icebreaker *Arktika*, of 23,400 tons displacement and 75,000 shaft horsepower, reached the Geographic North Pole in August 1977.

3 Northern peoples everywhere—Eskimos in Canada, Yakuts in Russia, Samis (Lapps) in Scandinavia—have rearranged their lives in recent years to synchronize themselves with the day/night rhythm of the southern countries, a source of schedules and of patterns of information organization on which they are increasingly dependent.

4 This uneven pattern of illumination in the Arctic is caused by the earth's rotation on its tilted axis and its annual revolution around the sun. See previous note.

5 *Civilian twilight* lasts from the moment after sunset until the sun is 6° below the horizon. The period when it is between 6° and 12° below the horizon is called *nautical twilight*. When the sun is between 12° and 18° below the horizon, the period of *astronomical twilight*, it is getting dark enough, finally, for astronomers to begin their work, which begins with true night, with the sun more than 18° below the horizon.

6 A few arctic animals, possibly auks and other nonpasserine birds, for example, might be "free-running." The rest maintain a twenty-four-hour rhythm, which they synchronize without the benefit of a sunrise or a sunset. Some, apparently, regularly mark the position of the sun over a certain landmark, or respond to fluctuations in the spectral composition (color temperature) of sunlight, which in the Arctic is different at midnight from what it is at noon.

7 The operation of the biological mechanisms responsible for the recovery of arctic species remains largely mysterious. Current research, however, indicates that, unlike their temperate-zone counterparts, arctic animals are apparently unable to tolerate both the inherent stress to which, in an evolutionary sense, they are accustomed and new stresses of man-made origin—oil blowouts, pollution from mine tailings, noise from arctic shipping, and the unnatural patterns of sea-ice disruption associated with icebreakers. They are therefore probably more vulnerable to man-made intrusions than the populations of any animals we have ever dealt with.

8 Grizzly bear, polar bear, short-tailed weasel (ermine), least weasel, mink, wolverine, coyote, wolf, red fox, arctic fox, hoary marmot, arctic ground squirrel, collared lemming, brown lemming, tundra red-back vole, tundra vole, Alaska vole, porcupine, arctic hare, tundra hare, moose, caribou, muskox.

9 They include about 175 species of parasitic wasp, 25 species of sawfly, 40 species of moth, 100 species of root maggot, and 150 species of midge, as well as smaller numbers of species of black and crane flies, blowflies, hover flies, bumblebees, mosquitoes, springtails, fleas, butterflies, and about 60 species of beetle.

Uunartoq, Greenland.
Courtesy of Tiina Itkonen.

ON SEEING THE PACK ICE FOR THE FIRST TIME
AN ELEGY

Eva Saulitis

1. This morning, a cold disc thumbed the sky above the frozen ocean, lower, a smudge marking the edge of seeing, or its beginning. Someone told me it was water sky, clouds low-slung reflecting open leads. I imagined the edge between states of being. I felt compelled to get there, to stand at the brink, to listen to the water lapping ice.

2. An imagined place. Ice edge. Edge of remembering. Knife-edged ridge. Edge of doing and not saying. Poised on that edge. Then, imagination edged out, snow-blinded by the present tense. Trying to make the edges align. Trying another approach angle. Here, a figure like mine, moving herky-jerk on shore-fast ice is visible to an ice seal or polar bear a long way off. Nothing human is concealed. Nothing human is ever safe.

3. Ice polygons: confounded by their endless arrangements and formulae.

4. Edge of cold, a razor blade, too old, familiar. Here I am in mukluks, my thighs pricked as if by frazil ice, walking as fast as I can down the snow-machine trail. Sun just decoration. Snow moiling under boot soles. Air touch-

ing its edge to face skin over and over, leaving its telltale marks. Now I will be seen for what I really am.

5. Figure in green hurrying across a white expanse. Neon snow-machine appears to be bisecting a patch of tundra, which is edgeless, expressionless.

6. Is a field defined by its four edges? Once, there were no fields.

7. Frazil. Nila. Grease. Shuga. Pancake. Floe. New ice to old. Devolving the other way around, now.

8. Ice-age front: creeping, bulldozing, glacial. The warming age is north slamming its cold away. It comes fast, hard, speaks in metaphor, in the abstract. "Polar vortex." *Any child could do that.*

9. She was born near here. And even she calls it *edge of the known world*.

10. She said in her language there are ninety-nine kinds. And she wants to find the hundredth kind.

11. Time runneling out like melt along a fracture. Any description of sea ice already nostalgic—that painting, "Eskimo" in "authentic" garb, staring out across "pristine" floes.

12. I blink back the glare. Here, light minds its business, painting blue shadows between blue bergs. It writhes across a jumble of white. It scrapes across a cheekbone like a knife descaling a fish.

13. The woman from Savoonga said, *I just saw a bird. I don't know what kind.* The guy from Minnesota said, *There are only two kinds.* Juxtaposed against the ice world. Inscribing their non-overlapping circles on the backdrop of Norton Sound.

14. Here, where one kind of knowing abuts against another. Danger. Open lead.

15. His fence was driftwood. Hers, stone. Marking an already marked edge—to what purpose? To discover one plus one equaling two, no more, no less.

16. Prayer at the ice edge: *Lord, let there be _____.* What can I ask? Prayer here useless as a thrust-up berg drained of salt, a sun that blinds but does not heal, my blue shadow, a scarf trailing, my skin rubbed raw with a caribou leg-bone.

17. *Lord, let there be stillness. Let me find it.*

18. Mother ice: there are no colors. Only gradations of transparency.

19. Faces, wind-scraped, cold-darkened. Thick hands pulling a crab pot up from a hole drilled into the sea. These, too, are aspects of mother ice.

20. Break-up is a chair floating away on an ice floe, a woman said. Withdrawal is an empty pail frozen in the snow beside the front step. These are things I learned up north. A shut door and the steps I take, walking backwards, eye on the latch. And the turning away.

21. Turning away, I find the frozen sea behind me, in front of me, beside me, above and below. Here and there, gray billows. At night, pancake floes bump against my limbs, roughening the curves into edges.

22. I pull on skin boots, snow pants, fur hat, moose-hide mitts. I lurch onto the ice, trudge toward the place where the pack begins, wherever that is, sixty miles out, or just six.

23. *The ice*, she said, *is leaving us.*

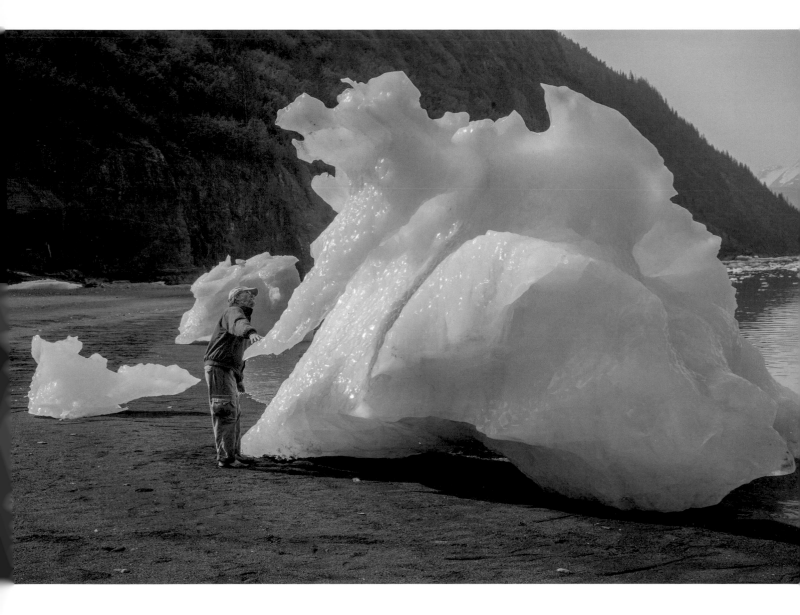

24. I head past the edge of my self-seeing. But the edge of
 the known world, I never reach.

25. Coming back, I pat myself down, to see if any of my
 parts are missing.

Iceberg at low tide.
Prince William Sound, Alaska.
Courtesy of Clark Mishler.

Anchorage, Alaska, 2009.
Courtesy of Brian Adams.

GOING BACK
TO THE ARCTIC

Berit Ellingsen

When the heat wave in Norway has lasted for three weeks I buy a plane ticket to the Arctic to cool down.

On my first trip to Svalbard I was an uninterested teen who went there only to accompany my parents, who were very enthusiastic about visiting the archipelago and had wanted to do so for years. I wondered what all the fuss was about and thought the only good thing about going that far north was to get a few days' respite from the summer-spreading pollen. On the plane up I was bored; it was a long flight with a stop-over at every larger town north along the Norwegian coast. But when we finally spotted land and the white nunataks that pierced though the glaciers of Oscar II Land on Spitsbergen, I realized this was no ordinary place. I had seen plenty of snow and ice before and had vacationed in the mountains, but nowhere as remote and unpopulated as the Arctic. When the plane landed in Longyearbyen I was unsettled. No trees, no grass, almost no houses, and I had the distinct feeling that wandering out of the settlement alone, without proper clothing and defense against polar bears, could most definitely be fatal. In Svalbard I couldn't just call for help or take the next bus home. My protected teenage self had never experienced anything like it.

But then, on a trip to the Von Post Glacier in Tempelfjorden north of Longyearbyen, on a fifty-foot cabin cruiser rented with crew and Zodiac for the day, a large chunk of the glacier slipped from the blue wall of ice and into the sea, with a long slow grace and a swell of ocean I will never forget. I didn't get a word out, just gaped and pointed for my parents to catch the enormous, unexpected sight. But instead my parents turned toward me, thinking I was having some sort of fit, and only saw the small wave the fallen ice sent toward us. That moment did something to me. I was still unsettled by the silence and lack of people and trees and grass, but from then on I was smitten, however dangerous and cold it seemed, or maybe because of it. After that I knew I had go back to the Arctic. And now I'm finally on my way. But will it be the same? Will it feel as risky and pure as it did that time or was it just the imagination of my teenage mind?

When we land at Longyearbyen airport the light is sharper and brighter than anywhere else in the world, the illumination of a sun that does not set but will remain bright as midday until September. The breeze is the gentle wind of summer, yet it has a sharpness to it the air never manages in western Norway, not even in winter. But after the heat and humidity of this summer the chill feels great. I turn around and see the glaciers on the other side of Isfjorden gleam in the sun, like the fabled Soria Moria from Norwegian folktales. My heart jumps and a grin spreads on my face. I haven't felt this about any other place before, not even when I returned to Norway after almost a year in the United States. I'm

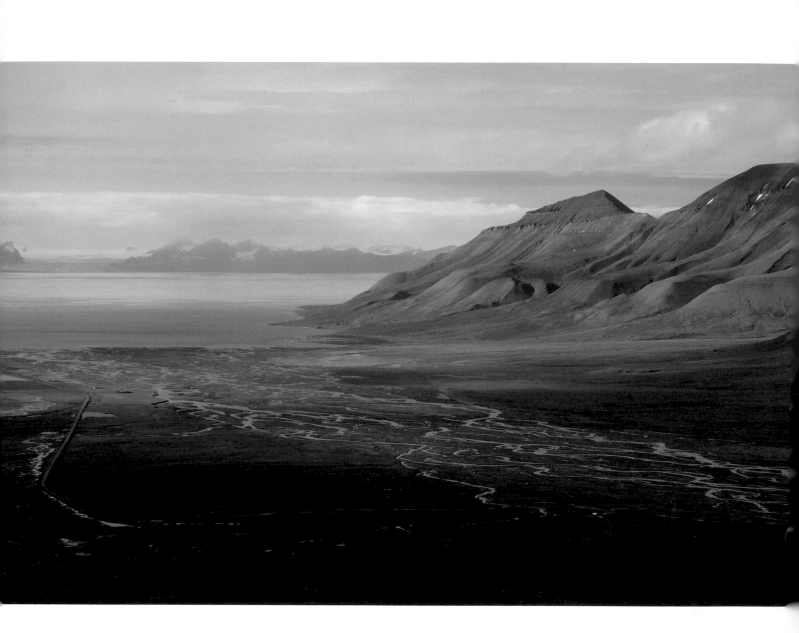

(*Above*) A view from Adventdalen outside Longyearbyen on Svalbard in the Arctic. The photograph was taken at Mine 7, one of the few extant mines on Svalbard, with the Advent River winding down the middle. The fjord is called Isfjorden, and the mountains and glaciers in the distance are part of Oscar II Land. The Advent Valley is named after the explorer ship *The Adventurer.* Courtesy of Berit Ellingsen.

(*Opposite*) And we're back in Longyearbyen, the world's northernmost town with fiber Internet broadband and full 4G phone service, looking up toward the center of town and the Longyear Valley with the Longyear Glacier at the end. Courtesy of Berit Ellingsen.

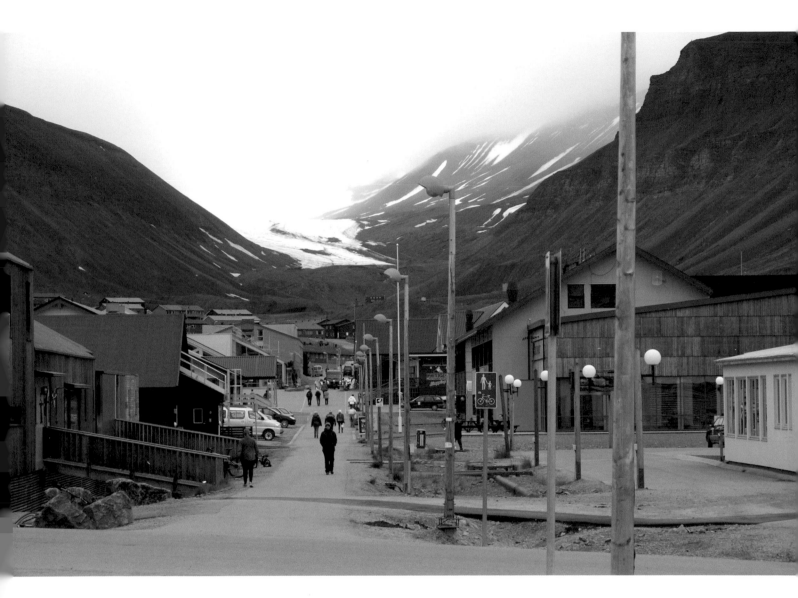

back. I'm finally back. I feel like a polar bear that has come home.

The bus swings out from the airport curb, down the hill, and along the fjord to Longyearbyen, which is named after the American industrialist John Munro Longyear (1850–1922), owner of the coal company that first founded the settlement. The road is almost completely straight. On one side geological strata sit exposed in the cliffside; on the other side the beach

slopes into the surf where vessels varying in size from ferries to rowboats bob at narrow quays and docks. The bus speeds past sheds and storehouses, barracks-like buildings housing businesses and offices. By the low structures are parked snowmobiles, snowplows, buses, trucks, cars, and other heavy machinery. Coils of ship chains, giant wire drums, steel barrels, trawler nets, heaps of tools, and other objects I don't recognize litter the space between the buildings. The lack of

grass and trees makes the mess stand out even more. There's not even soil or mud on the ground, only a dark gravel that resembles the surface of a stone desert. That's the Arctic too. Due to its low amounts of precipitation the Arctic is classified as a desert.

Inside the bus it's silent. Few talk or chat together, even those who are traveling in groups. Instead, we keep our heads turned toward the fjord and the landscape that rushes by outside. During this trip I will see such behavior often—the cessation of talk, discussion, commentary in favor of gazing at the land. The Arctic is so overwhelming it commands silence even from short-time summer visitors.

Dressed like a Seal in Polar Bear Country

The next morning I eat a quick breakfast, pack a small lunch, and run out to the circular driveway of the hotel I'm staying at in Longyearbyen. The modest area is full of tourists, but they're soon fetched by a large bus. A few minutes later another bus comes up the slope, an A4 sheet of paper in its window saying "Barentsburg & Pyramiden." A sizable number of people crowd in front of the vehicle while a guide crosses off our names on a clipboard, before we depart. At Mary-Ann's Polarrigg the bus picks up a few more travelers, then continues to the harbor and a small passenger ferry. It reminds me of the boat I used to take in high school to visit a classmate who lived on one of the many islands in the fjord at home.

Our guide for the day is Jim, a thirty-something northern Norwegian with a beard as big as his personality. The passengers on today's trip are:

A group of Norwegian women in their fifties, on a girl trip, with their men in tow.

Two German-speaking brothers and a woman, all in their fifties.

A German-speaking man and his mother, both dressed as if on a trip to a European metropole.

An American couple in their forties, carrying cameras with enormous objectives.

A Spanish-French family, the parents in their forties, with three kids. The youngest daughter is seven or eight and named Inez, or "Ineeeeeeez!," as they keep yelling.

A Norwegian man in his early twenties traveling alone.

A group of tall muscular Finns in their thirties, with ninety-liter backpacks stuffed to the brim and a neon-yellow satellite phone.

A family group of Brits in their forties.

An elderly Australian woman and her daughter, who looks to be in her early sixties. The daughter is wearing an expedition cruise jacket that says she has been to Antarctica.

A Japanese woman in her thirties, traveling alone, like me.

After another name check to make sure we're not missing anyone, the leaves the Longyearbyen harbor, giving us a sun-filled view of the airport, and on the mesa above it, the white antenna domes of SvalSat, one of the world's largest satellite stations.

As we head east toward Sassenfjorden, the middle-aged female friends set up camp in the plastic

chairs on the top deck and bring out strawberries and dark cherries bought at the grocery store. One of the women, a small, squat, brown-haired lady, pulls on a parka made of mottled seal fur. If a polar bear does appear, I now know who to outrun.

As the Arctic settlement shrinks behind us and we enter the Sassenfjorden proper, the wind picks up and cools down. In Longyearbyen it was about 5°C with a light breeze, but not out here.

"We might catch some waves today," Jim says, "but fear not, we do carry seasick pills onboard; they only cost 500 kroner each."

We all laugh, but a few do look as if they're not entirely sure the exorbitant price was a joke. We sit on the top deck for a while, with people moving back and forth to take pictures of the fjord and the shore. At regular intervals the four big Finns check the reception of their satellite phone. After about half an hour or so, most people retreat inside, to the comfortable seats and the warmth there. Only a few people, including the male half of the American camera couple, the Japanese woman, Inez's father, and me, linger outside, taking pictures of the barren cliffs and geographical strata that rise up along the fjord. Little Inez is also here, with no hat or hood on. After a moment Inez's mother and older sister come running, pulling the hood of the girl's jacket down on her head. She immediately removes the hood.

After twenty more minutes I realize that the softshell pants I bought for the trip and my down jacket, which has served me well at home for several winters, are failing spectacularly. I'm so cold I have to go inside. I sit down at the table with the Japanese woman and we nod and smile at each other. Outside, a strange-looking sandbank comes into view and I really want to go outside and photograph it since I've never seen anything like it before, but the only part of my body that isn't screaming with cold are my feet, which the old sheep fur–lined boots I've only traversed city streets with actually manage to keep warm.

But the lure of the Arctic is too strong, chill or no chill. As soon as I've heated up a bit, I'm outside again, photographing the towering stone formations that bare their jags and slopes of sediment at us. Inez's father, the American guy, and I are now the only ones out on the deck to catch the alien-looking landscape and sharp geological formations. The debris cones and crests of gravel and sand resemble those on photos from Mars. I understand why the archipelago is used as a Mars analogue, a place where the world's space organizations test equipment and experiments that are bound for the red planet.

The strata in the stone are visible as layer upon layer of minerals of different colors and densities. Jim has several stories of companies who came here to mine these riches but were thwarted by the harsh climate or other aspects of the Arctic that they didn't foresee and probably had no chance to. Gypsum and marble, coal and clay. But today it's the region's oil and gas reserves that pull people and companies, along with the expectation that new technology and rising energy prices will overcome the extreme conditions and the high costs of drilling here. I hope not, as the Arctic is more sensitive to environmental disruption than the South.

After an hour or so the ferry reaches a bird mountain, but it's empty, save for streaks of guano down the stone. The chicks have long since tumbled into the sea for their first swim, but a few little-auks and fulmars are still about. The little-auks glance at us over their shoulders as they flap along the waves. According to Jim they're so full of fish they can't get into the air. The fulmars ride the wind and hover around our heads, checking us out. Are we food or not? On top of the bird mountain sits a trapper's cabin. Jim relates its story and we take pictures of the cabin and the cliffside, before most of us return to the warmth inside, even the four big Finns.

On the way across Sassenfjorden and into Billefjorden there is a bit of wind and waves and I half expect

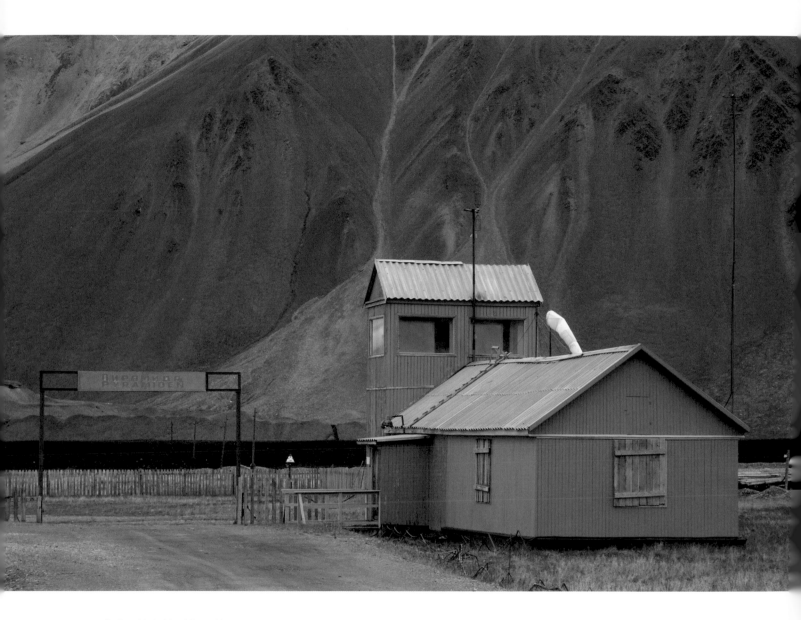

By the old airstrip at Pyramiden
on Svalbard in the Arctic, the
world's northernmost abandoned
town. View across Mimer Bay to
the mountain Yggdrasilkampen.
Courtesy of Berit Ellingsen.

to get seasick, but it doesn't happen. It seems that my brain is so busy processing all the information coming from my eyes that there are no resources left to produce nociception from the inner ear. Once we're inside the narrower Billefjorden the waves stop. I'm outside again, freezing and taking pictures. On one side of the inlet there is a strange duckbill shape sticking out of the hill, with a void beneath it that looks like it was formed by material falling out, but I can't see a mound below it. The opening yawns darkly and both the Australian woman who has been to the Antarctic and I take photos of the geological formation. Jim has told us that a young polar bear roams the fjord, hunting geese at the bird colony at the inlet. We look for the bear, but there is no white head in the water, no large shape shuffling along the beach.

As announced in the tour description, at noon the crew, which counts several Thai sailors, light the barbecue on deck and fry whale meat and salmon for lunch. To my surprise there is also a large pot of rice and Thai sauce and salad. I hadn't expected Asian food here, but I'm very happy for it. I had whale meat as a kid and think it tastes like liver.

After the welcome hot lunch, we reach the end of Billefjorden, where the cliffs rise into mountains proper and narrow into a bay with long moraines on each side. In front of us sits the Nordenskiöld Glacier, named after the Finnish-Swedish explorer Adolf Erik Nordenskiöld (1832–1901). The glacier face is only a few meters high, but its back slopes far inland, where it's split by a nunatak so tall its peak is hidden in the low-lying clouds. When a katabatic wind rushes off the glacier and onto the ship, making it even colder, it feels like we have reached an Arctic nirvana.

I stare at the blue wall, intensely hoping some ice will drop. I have never forgotten the calving of the Von Post Glacier the first time I was here. Jim tells us the ice lost a big chunk yesterday and that the great amount of floes in the water means that it calved also during the

night. Hence, we might be lucky now. The ferry crawls toward the glacier, turning first one side to the blue wall and then the other so the passengers on both sides of the vessel can have good pictures of the glacier. This is after all what we've come to the Arctic from the entire rest of the world to see.

Suddenly, there is a sound like wire snapping and a modest amount of ice falls from the wall and into the water. It's just a small section close to the surface and barely counts as calving. I wish for more, but only some powdery ice follows after that.

"Seal!" someone yells, and everyone turns to where they are pointing, a small opening in the rock exposed by the glacier. There, a seal is lounging on the stone, seeming oblivious to our close presence. One of the women in the large group of friends turns toward the lady in the seal fur coat and says:

"So we actually did get to see a seal, well, not counting you, of course!"

The Northernmost Abandoned Town in the World

Before we leave the Nordenskiöld Glacier, the ship crew pulls a chunk of the ice that is floating in the water on board and hacks it into ice cubes for drinks. I accept one of the plastic cups, but not being a fan of either whiskey or coke, I lick the several-thousand-year-old ice a few times. Then I think of the fulmars and seals that live in the bay and stop.

After the drink it's just a short distance to our real destination for the trip, Pyramiden. The abandoned Russian mining town is tucked inside Billefjorden, almost directly across the bay from the Nordenskiöld Glacier. Our ferry lands at Pyramiden's massive wooden dock. Above it an enormous rusting crane that seems to embody the industrial essence of the Soviet Union itself flies the Russian and the Norwegian flag at

the top. On the fuzzy, unpainted wood stands a small man in a dark coat and a tall round hat. An old rifle is slung over his shoulder. On Svalbard, all activities outside Longyearbyen, even going to the bathroom, must be undertaken accompanied by weaponry against polar bears. However, the gun is first and foremost meant for warning shots. Only if the polar bear actually attacks are you allowed to fire in self-defense, and even then the shooting will be investigated by the Norwegian governor and the local police. In Svalbard all wildlife is protected and humans are only guests.

"There he stands, the little czar," someone in the German group comments. But to me the sight of the guide in his antique-looking Russian clothes is quaint instead of threatening. It catches our attention and gives a sense that we are now indeed in a Russian settlement and going back in time. Both the Japanese traveler and I surreptitiously take photos of the Russian guide while sharing giggles over the pictures. The tall Finnish men take their ninety-liter backpacks, rifles, and satellite phone and leave us to start on their overland journey back to Longyearbyen.

The Russian guide introduces himself in English as Sasha. Jim instructs us to follow Sasha closely, take the pictures we want while he is talking, and always keep up with the group. Sasha is young, in his thirties, and looks a little nervous.

"We met a polar bear inside the town yesterday and it took many shots before he gave up and left," Sasha says. "I'm so tired of this bear." Apparently, this is the same bear that has been living off the seals at the glacier and the geese at the fjord's inlet.

"It's a young male that was too late to follow the ice north in the spring and instead opted to stay at the glacier, where there is at least some food, instead of trying to reach the ice and die in the attempt," Jim says. Polar bears live in one of the world's harshest environments, which selects them harshly for intelligence, navigation, and patience. They are stealth hunters who sneak up on prey as close as they can before they charge. They weigh from three hundred to eight hundred kilograms and are definitely not the kind of animal you want to surprise as you turn a corner. I wonder what I should do if a polar bear does attack, but knowing it can't be outrun and does not scare from human voices or movements as southern bears do, I don't come up with anything better than to stick close to the guy with the gun.

Sasha herds us onto a small bus that drives us the two hundred meters to the settlement proper. There, in front of the old city sign and a symbolic mining cart, Sasha introduces us to the town and its history: Pyramiden started life as a Swedish settlement in 1910, hence its Swedish name, which means "The Pyramid" in English. In 1927 the Soviet Union bought the settlement and expanded its coal-mining capabilities. Coal, extracted high in the mountainside, and bricks made from local clay in the town's coal-powered factory, were Pyramiden's biggest products, shipped south to the Soviet Union. This production and export was interrupted when the town was burned down during the Second World War to prevent the Allies from taking the settlement, well protected at the heart of the archipelago as it was. After the war the town rose to a certain prominence in the Soviet Union due to the higher salaries in the remote community, and with them followed a hospital and doctors considered very high quality for the time. But after the fall of the Iron Curtain and the drop in coal prices on the world market, Pyramiden was no longer profitable. In 1998 the settlement was shut down and became the northernmost abandoned town in the world. Today, Barentsburg is the main Russian settlement in the Svalbard archipelago. However, since 2013 one of Pyramiden's many apartment buildings has been open as a hotel.

In the barren mountainside above us gleams the roof of the funicular that was used to transport coal from the mine down to the settlement. In the slope

The world's northernmost piano. Visitors are allowed to play it, but it is of course very much out of tune. From inside the sports hall in Pyramiden on Svalbard in the Arctic. Poster to the right says "Jazz." Courtesy of Berit Ellingsen.

there is also a word in white Cyrillic script. One of the travelers asks what the word means.

"It says *miromir*," Sasha explains. "It's a play on the word *mir*, which means both 'world' and 'peace,' to mean 'world peace.'"

We continue up a broad road of concrete that follows the stream that winds down the valley. On the way we stop at a yellow wooden shack with a two-story tower and an old, faded wind sock. This is the helipad, still used to bring supplies in from Barentsburg. A little farther up is a farm where cows, sheep, and chickens provided milk and eggs for the settlement, an unbelievable luxury in a place where no food comes fresh. According to Sasha, it was also a scientific experiment to see how ordinary livestock managed Arctic conditions. It turned out that with a warm barn and pasture grown on rich black soil shipped up from the Ukraine, livestock managed very well. Today, the grass still grows thick in the middle of the settlement, but it is now enjoyed only by the local reindeer.

Along the road we pass the brick factory, workshops, apartment buildings, and the hospital, all made from local brick that has the same ocher hue as the mountains around us. At the top of the town square a bust of Lenin gazes out over the Soviet Union's northernmost town, beneath the triangular peak that gave the settlement its name. Above us the clouds have nearly vanished, and we have a fantastic view of the town that slopes gently down toward the sea and the Nordenskiöld Glacier across the fjord. Away from the drone of the ferry engine and the car noise in Longyearbyen, a deep and primeval silence envelops us. In it even the sound of our footsteps on the concrete is loud and piercing. It's the same quiet as last time I was in the Arctic and it is unforgettable. The silence of an undisturbed place, a world that is still unconquered by humans. I feel an exhilarating sense of freedom knowing that such places still exist.

Our group is calm, talking quietly. Even little Inez and her siblings speak in semi-hushed tones and walk unhurriedly back and forth to take pictures. I thought it might get annoying to be in such a large group, but it's so quiet it doesn't bother me at all. We even see another group of tourists farther up the street, but they vanish quickly and we don't run into them again.

Sasha lets us into the town's sport and community center, which because of the slow decay of the Arctic looks like it has been abandoned for only a few years, instead of decades. Inside, the foyer is spacious, but dark. The air is cold and dank and smells of dust. A staircase in wrought iron with steps of speckled stone curves up to the second floor mezzanine. Above us a huge chandelier with multiple bulbs, all dead, stretches its mirrored base out on the ceiling. The glass surfaces are still shiny. Soviet-era posters cover the wooden carved walls and beneath the staircase a lump of dust the size of a tumbleweed has collected.

Sasha leaves us to our curiosity and says we have ten minutes to explore the building. We walk calmly from room to room, taking pictures as we go. On the second floor is a storage room with row upon row of rusty, empty shelves, another where the ceiling has started to collapse. In one room is a mural of the Nordenskiöld Glacier, showing that its tongue of ice once reached much farther out in the fjord and was large enough to cover its flanking moraines. A larger space contains a living room chair set in front of a floor-to-ceiling window with a panoramic view of the barren valley on one side and the cliff on the other. On the sill above the radiator the dry remnants of a potted plant still stands, while in the corner a chest of drawers spills dust and ancient index cards. In yet another room are a drum set, several balalaikas and guitars, and a small piano. Sasha has recommended that we try the piano and several do. The poor instrument sounds exactly like it hasn't been tuned in twenty years.

40

On the first floor the beautiful pattern in the parquet has been disrupted by tiles that have come loose. The ancient-looking circuit board in the hallway sprouts exposed wires and cracked ceramic switches. Down here the air contains noticeably more dust, maybe because gravity has collected it here and our presence in the narrow hallway whirls up more of it. One door leads into the gymnasium, with handball goals and bleachers and the town's name in the floor. A plywood sheet with an Olympic torch painted on it, the colors still bright, leans against a wall.

Being here feels like stealing into a house right after the owners have left. The relative lack of decay gives the impression that the building is just waiting for people to come back, to fill its halls and rooms again with art and sport and community, here, halfway between the North Pole and the nearest strip of land. But instead of new inhabitants, there are now only transients—tourists and travelers who stay for a few hours before returning to the comforts of the South.

After a surprisingly long time, Sasha calls us by banging on a cymbal in the foyer and we file out beneath the beautiful carvings in the entrance and out into the fresh Arctic air. From there we continue down Pyramiden's main street: past the oldest buildings of the settlement, red wooden structures with white carvings and window frames; past the school and the mess hall where every meal was free; and down to the building where a few floors have been reincarnated as a hotel.

Outside, we spot two polar foxes, curled up on the pipes that once transported hot water between the buildings. The gray animals are almost invisible against the concrete. Most of our group enters the hotel while a few remain outside to tempt the foxes closer for pictures. Knowing that foxes are the main host for rabies in the Arctic, I do not stay. Inside the hotel we buy shots of vodka and warm pastry from the surprisingly staid la-dies that work the bar. I had expected other world travelers like Sasha, who's told us he lived in New Zealand and Australia before coming here, but I think these people are employees of the Russian mining company in Barentsburg that owns the town. The staff looks uneasy as we enter, but the mood lightens considerably when it turns out we're buying not only the food and drink on offer, but also the Soviet and Russian memorabilia displayed in glass cases along the walls. I'm tempted to buy a bottle of Soviet champagne, Sovetskoye Shampanskoye, in the bar as celebration for a story I wrote with the same title that will be reprinted in an international anthology, but decide against it because of the weight. Then the small bus arrives and drives us the two hundred meters back to the quay and the ferry. As we file out of the bus and back onto the boat for our return to Longyearbyen, Sasha looks relieved. No shots fired against polar bears today.

Leaving the Arctic for Now

On the way back down Billefjorden and Sassenfjorden, we pass two trapper shacks and Jim relates their story to the few people who are still on deck: Inez's father, the American cameraman, the Australian mother and daughter, the Japanese traveler, the young Norwegian guy, and me. The rest are eating or sleeping in the warmth inside. I use the quiet time to ask Jim what it's like to live in Svalbard.

"The Arctic has a way of getting under your skin," Jim says. "People tend to either hate it or love it here. I know people who were supposed to stay for years but couldn't handle it and left after a few days, and people who came up on a short visit and ended up living here."

I'm starting to see why. I can't imagine leaving or not coming back next year. I know it will be some time

41

before I want to go anywhere else. When I disembark the bus, Jim tells me: "See you next summer!"

"Most definitely," I say.

Before I go to bed I phone the hotel reception to call me in the morning, an hour before the airport bus leaves.

I sit up in bed. The sun is as bright as when I went to sleep, so it's impossible to say what time it is. I scramble for my phone. Six a.m. I asked the desk to call me at five, because with the constant light it didn't seem to matter when I got up. I rush into my clothes. Fortunately, I packed everything yesterday, so all I have to do is brush my teeth, collect my charging phone, and be off.

"You were supposed to call an hour ago," I tell the receptionist while he checks me out.

"I'm terribly sorry," he says. "We mixed your room up with someone else's."

"Can you call a taxi for me?" I ask. "I have to be on the eight o'clock plane."

"Of course. Feel free to sample the breakfast in the meantime," the receptionist says.

But the last thing I want to do now is lather a sandwich with brown cheese and strawberry jam while the taxi arrives and leaves again. I go outside to wait. After five minutes a black taxi van rushes up the driveway. The chauffeur glares at me like he's about to roll down the window and shout "davai-davai!," so I climb into a seat in the back, dragging the suitcase with me. Before I manage to pull the door shut, the driver's off the curb and on his way. I close the door and buckle up.

The driver rattles up a narrow street to one of the smaller hotels, a two-story wooden building with a bar attached to it. I wonder how it is to stay here with the bar so close. A man and a woman in their early thirties are waiting with an enormous hard-shelled suitcase. As the taxi stops, kicking up dust, another man comes out of the hotel with a large backpack. I try to read the relationship between the three. Are the two men broth-

ers and the woman is a girlfriend or wife? Or is she a sister and the two men are friends? Or are all three of them lovers in a ménage à trois? As they squeeze together in the back they stare at me as if they think they must pay for my ride. I don't feel particularly guilty, as we're far from the capacity of the van. The last guy climbs in and before he's closed the door, we're off.

"Jesus!" the man barks and pulls the door closed. I bite back a laugh and instead gaze out the window, at the sunny early morning that is as bright as midday.

My co-passengers are Norwegians—from Oslo, judging by their dialects—and look as if they're severely hungover, or had a big fight, or both. The woman is wearing an elegant coat and handbag, but beneath her city clothes peeks a thick fleece jacket. As the taxi pulls up by the terminal, the Russian driver gives me a sum. I have the cash ready, hand it to him, no tip, and grab my suitcase before he speeds off.

On the plane home I ponder what fascinates me so much about the Arctic. The silent, open landscape, the desolation, the purity are all stunningly beautiful. But more importantly, the Arctic seems to offer another kind of life than the South, something less comfortable, but perhaps more real. Here, you obey nature or die, which is how the rest of the planet also works, we only think it doesn't, removed from it as we are in our cities.

Yet the moment that first acquainted me with the Arctic, the calving of a glacier, also characterizes the strong change in climate that has happened here and that is starting to make itself known in the rest of the world. Currently, all the world's major ice sheets—the Arctic sea ice, Austfonna in Svalbard, the east and the west coast of Greenland, and glaciers not only on the west but also on the east coast of Antarctica—have gone past their tipping points and are melting. The summer of 2015 or 2016 may be the first year of virtually no sea ice during the summer before it starts to increase again in the fall.

With the vanishing of the ice, the sea routes toward the east and the west, as well as industry and human activity, look to be increasing in the Arctic. Already, the US Navy talks about a near-polar route, a northern sea route that doesn't just follow the ice-free coast, but cuts right across the North Pole. Climate scientists warn that the loss of the great Arctic shield of ice that reflects sunlight back into space, and the release of methane into the atmosphere from stores on the sea bed and beneath the tundra, are two tipping points that may lead to climate change that will affect every living being on the planet. Nobody knows, because never in the 200,000-year existence of humanity has the Arctic been ice free. But what is clear is that none of these factors will serve to stabilize the already-perturbed climate systems on Earth. Thus, the future—not only for the Arctic, but for the whole world—may be determined in the polar regions.

Barrow, Alaska, 2013.
Courtesy of Brian Adams.

MISS ARCTIC CIRCLE (RUNNER-UP)

Carol Richards

I was Miss Arctic Circle. Runner-up. First runner-up.

Bea Ballot won. Yvonne Salinas was second runner-up.

There were other Eskimo girls who competed, long-haired girls from Kotzebue and the surrounding villages. We pulled off our windbreakers and sneakers—and, over my Wrangler bell-bottoms, I pulled on a borrowed parka (made from ground-squirrel pelts with a wolf ruff) and kamiks (boots made from caribou hides with sealskin soles). Porcupine quills dangled from our ears. We lined up on a plywood stage, smiled, and waved to the Fourth of July crowd.

The tourists voted.

The tourists came from places like Ohio and New Jersey. Back home, they might have been orthodontists or gym teachers. They came to see the northern lights, polar bears, and Eskimos. But in summer, twenty-six miles above the Arctic Circle, the sun doesn't set; it just skips along the horizon. So, no northern lights. And polar bears were farther north. But they saw Eskimos.

To commemorate their journey, the tourists received Arctic Circle certificates, dated and signed by pilots like my dad. Pilots made the planes bounce a little when they crossed over that imaginary line.

Since the '70s, the face of an Eskimo reindeer herder named Chester Seveck has appeared on the tail fins of all Alaska Airlines' planes. When the tourists stepped onto the runway in Kotzebue, Chester was there to greet them—his wife Helen on one side and a reindeer on the other.

The tourists wore Crayola-colored parkas, thick-soled shoes, and wrinkle-free khakis. Instamatic cameras dangled from their necks. Their cameras were pointed toward us, fur-clad Eskimo girls.

Back then, Miss Arctic Circle contestants didn't have to do much. No interview questions. No dictums on how we're going to keep our Iñupiaq culture alive. No displays of talent: no Eskimo dancing or Eskimo yo-yo demonstrations. Tourists judged us just on the look of our smiles.

Their guidebooks said, "Eskimos are a friendly people."

Bea Ballot smiled broadly, without embarrassment or shyness, without ambiguity or irony. She smiled like she was happy to be there. After a crown was placed on her head, Bea's smile radiated even brighter. She was like that Jack Black song: "I only wish that I was you looking at me!"

Yvonne played it cool, coolly distant, almost feline, as if, at any moment, she might yawn and stretch and walk away. Yvonne, serene and regal, was taller than both Bea and me. Thinner, too. She might have won, had she smiled more.

I was eighteen, but acted younger. Self-conscious and giddy, I hid behind the ruff of my pulled-up hood. I wore my goofy smile, the one that breaks out in giggles.

Barrow, Alaska, 2014.
Courtesy of Brian Adams.

On the smile spectrum, from, say, Mona Lisa to *Mad Magazine*'s cover boy, Yvonne was Mona Lisa and I was a grinning Alfred E. Neuman. Yvonne looked like she'd rather be anywhere else.

I looked like I didn't know how I got there, but I might as well enjoy it.

48

Kivalina, Alaska, 2012.
Courtesy of Brian Adams.

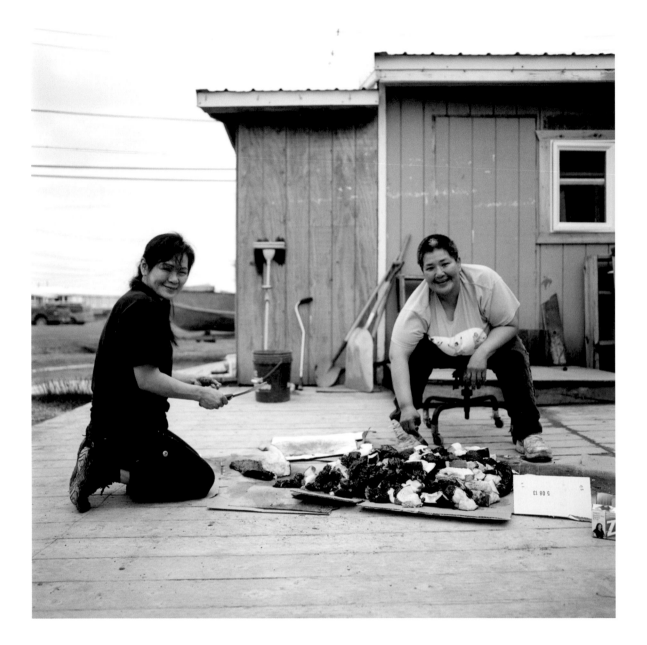

Barrow, Alaska, 2013.
Courtesy of Brian Adams.

. . . but it surely has to do with
the paradox of thaw figured as
restraint or retention, and the wintry
notion that cold, frost and snow
might themselves be a form of gift—
an addition to the landscape that will
in time be subtracted by warmth.

—Robert Macfarlane

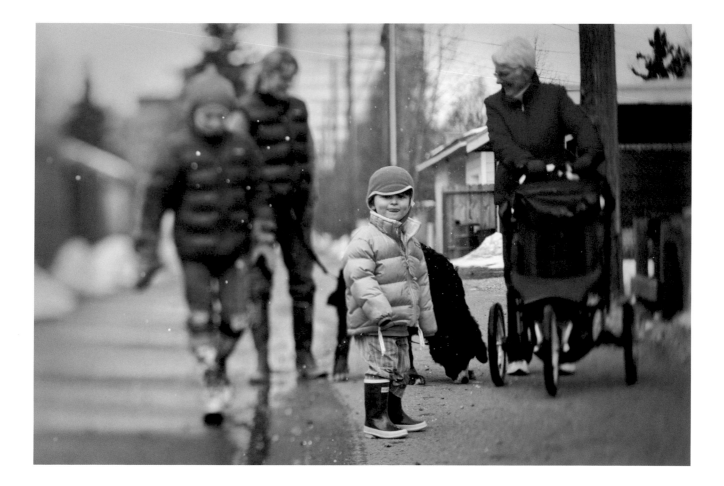

(*Opposite*) Anaktuvuk Pass,
Alaska, 2013. Courtesy of
Brian Adams.

(*Above*) Von Hippel family.
Anchorage, Alaska.
Courtesy of Clark Mishler.

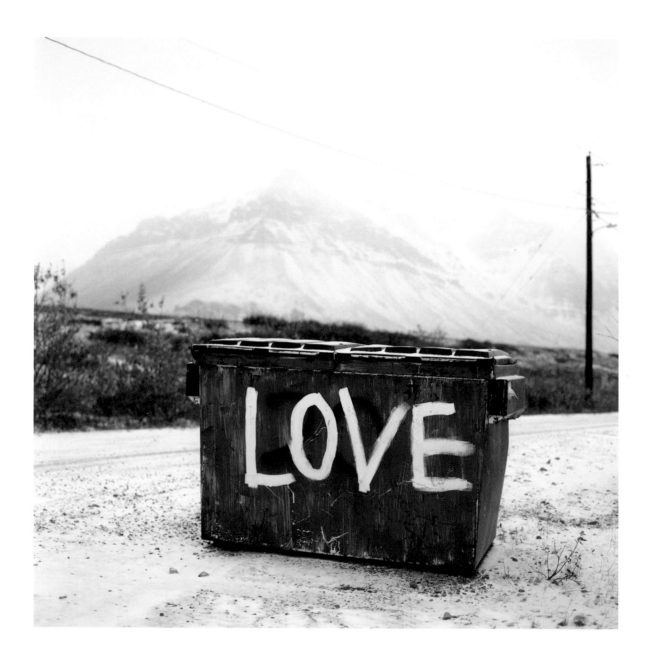

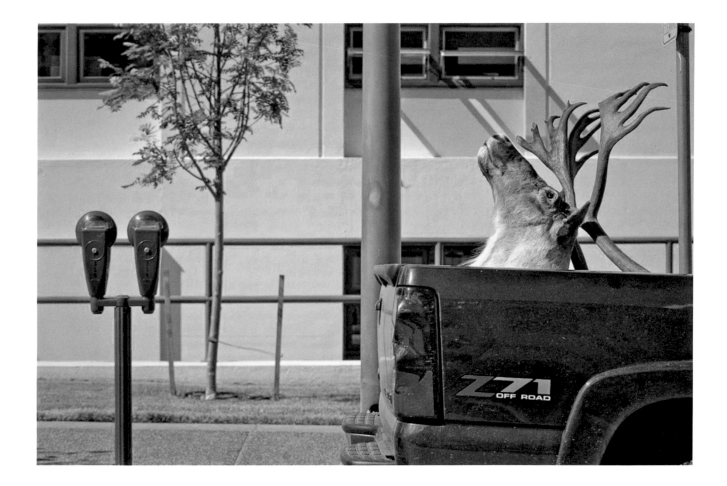

(*Opposite*) Anaktuvuk Pass,
Alaska, 2013.
Courtesy of Brian Adams.

(*Above*) Caribou and pickup truck.
Anchorage, Alaska.
Courtesy of Clark Mishler.

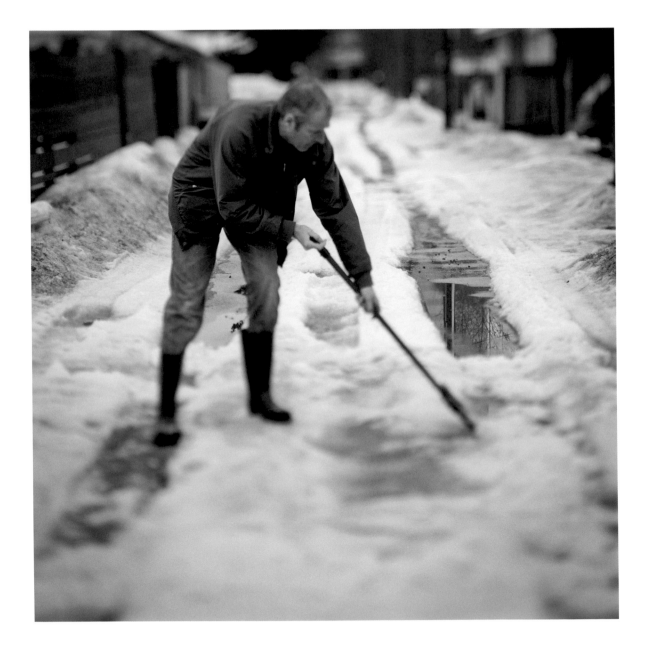

(*Above*) Rick Zimmer.
Anchorage, Alaska.
Courtesy of Clark Mishler.

(*Opposite*) Attorney
Moshe Calberg Zorea.
Anchorage, Alaska.
Courtesy of Clark Mishler.

(*Opposite*) Tim Lewis. Anchorage, Alaska. Courtesy of Clark Mishler.

(*Above*) Distribution of hand warmers to participants in the Big Fat Bike Festival. Homer, Alaska. Courtesy of Oscar Avellaneda-Cruz.

Winfred Obruk.
Shishmaref, Alaska, 2010.
Courtesy of Brian Adams.

Brown bear sow with cub on an
Alaskan camper. Anchorage, Alaska.
Courtesy of Oscar Avellaneda-Cruz.

(*Below*) Siku 1.
Courtesy of Tiina Itkonen.

(*Opposite*) Bingo Night.
Newtok, Alaska, 2008.
Courtesy of Brian Adams.

Fairbanks, Alaska, 2012.
Courtesy of Brian Adams.

"Santa" with his dog Fire in Nome, Alaska. Courtesy of Oscar Avellaneda-Cruz.

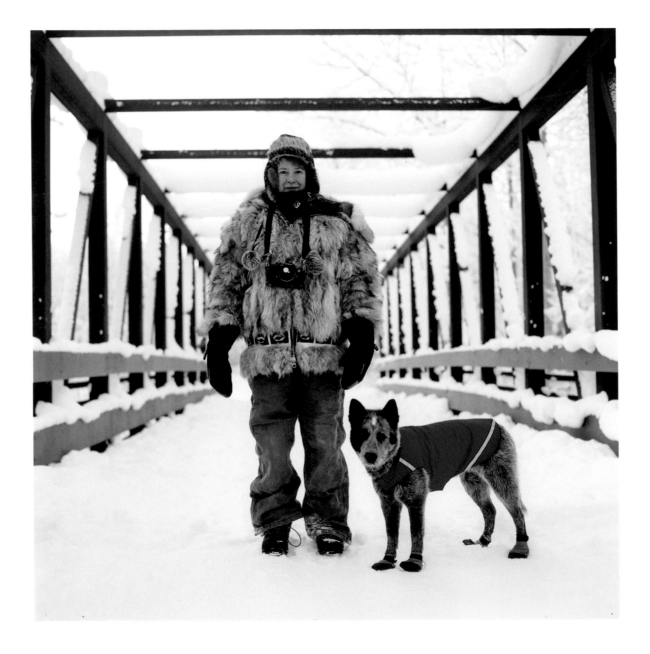

(*Opposite*) Wolf coat and dog coat in the Far North Bicentennial Park in Anchorage, Alaska. Courtesy of Oscar Avellaneda-Cruz.

(*Below*) A pair of women cyclists riding along the shore of Kachemak Bay during the Big Fat Bike Festival. Homer, Alaska. Courtesy of Oscar Avellaneda-Cruz.

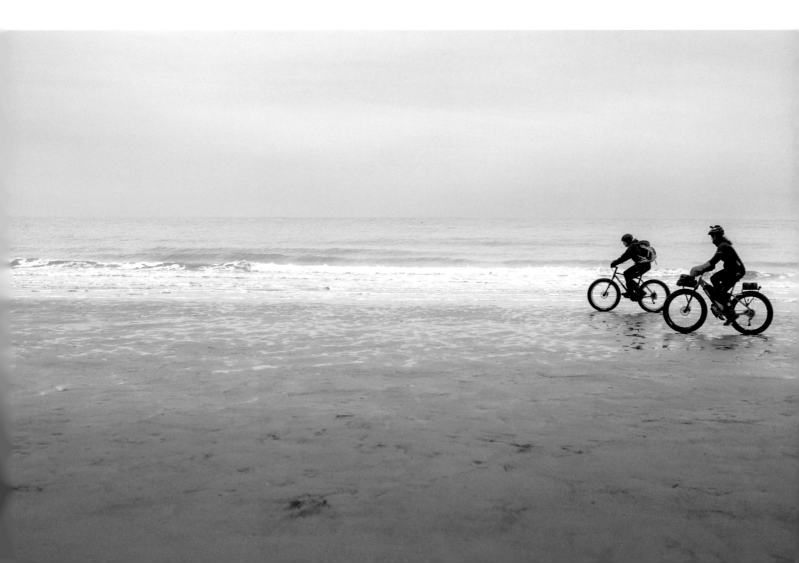

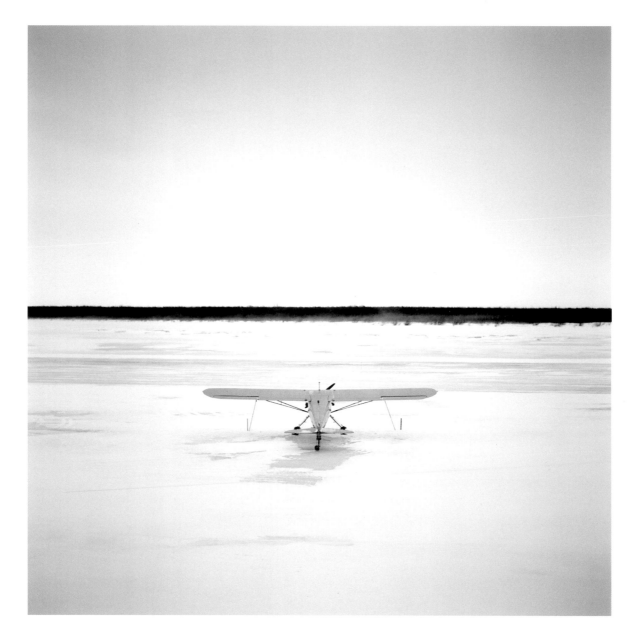

Bethel, Alaska, 2013.
Courtesy of Brian Adams.

UNMIKSOK

Ted Mayac Sr.

My name is Ted Mayac Sr., and I am the eldest son of Peter and Theresa Mayac. I was born in the spring of 1936 at King Island, where I lived with my parents and siblings until 1950, when I was sent away to get an education. I spent my first fourteen years at Ukiovok witnessing the daily routines of an island village. King Island was a hunter-gatherer society totally linked to and dependent on the bounty of the Bering Sea. I have unforgettable and vivid memories of how the Ukiovokmiut (literally, "people of Ukiovok") survived seemingly unaware of the truly harsh environment their island home gave them.

In this essay, I share the Ukiovokmiut perspective on the great white bear, which, given the bear's great strength, large size, and uniqueness as one of the few harvested sea mammals, was considered by the King Island hunters as a rare and special creature.[1] The great white bear, or polar bear, is highly regarded, respected, feared, and admired by the King Island people. The Ukiovokmiut originated and developed a ritualistic and refined song and dance tradition to express their attitudes toward and perspectives on the polar bear (*tughukhok*).

Ukiovokmiut perceptions of the polar bear's nature and significance are historically, fundamentally, and culturally complex and integrated into the society; the protocols for speaking, hunting, and treatment of polar bears are complicated. This essay is the first con-

certed effort to record a definitive history of the King Island belief system regarding the great white bear.

The King Island custom of paying tribute to the polar bear through song and dance is traditional, performed each time a polar bear is harvested. The polar bear dance is a custom closely adhered to and should not be categorized as part of the non-ceremonial dance repertoire.

When a King Island hunter harvests a polar bear, it is believed that he has fulfilled his greatest ambition, the highest achievement of his hunting abilities. This is a singular and privileged accomplishment. Countless stories going back many generations about the polar bear's character and demeanor have been handed down and must be learned by the hunters so that they can avoid becoming the bear's victims. That the white bear is extremely powerful, strong, dangerous, and unpredictable, and thus must be feared, is emphasized in these stories.

The King Island people, aware of these attributes of the polar bear and in deference to its power and prowess, have developed certain rituals that must be strictly followed. The polar bear, or *tughughok*, must never be offended, and appeasements are always necessary. Additionally, the *tughughok* must never be called directly by its name, and stories about the bear must never refer directly to its name.[2] Instead, hunters refer to the great bear simply as "someone." This

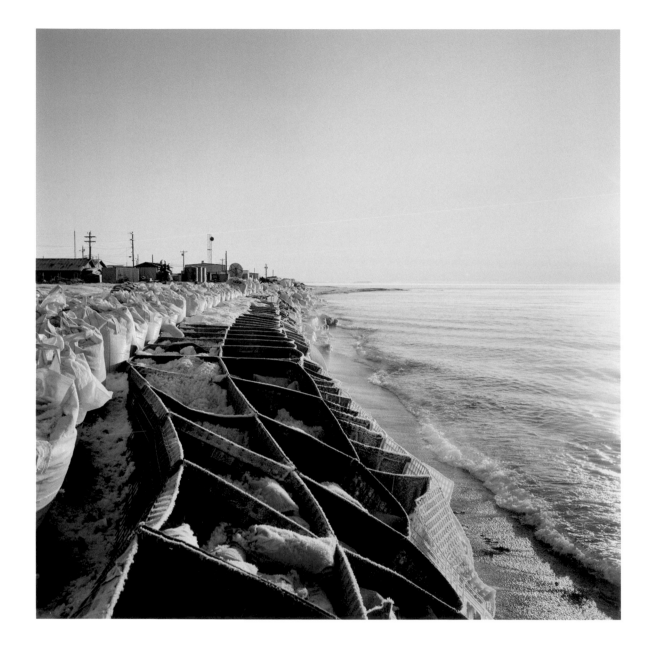

Seawall. Kivalina, Alaska, 2007.
Courtesy of Brian Adams.

illustrates the deference that King Island people have for the polar bear.

Furthermore, the common name of a hunter who has successfully harvested a polar bear must never be mentioned in the presence of the harvested bear, in order to prevent retaliation and reprisals from the animal's spirit. The first hunter who sees or encounters a bear is understood to have the right to harvest the animal, a privilege honored by the other hunters.

The sharing of the edible meat is highly ritualized as well. The first man who comes to help the hunter is entitled to the right front quarter; the second hunter gets the left front quarter; the third gets the rear right quarter; and the fourth gets the left rear quarter. The remaining men who come get the ribs. When the butchering is done, the cut-up meat is tied together and placed inside the bearskin, and the hunters form a single line of seven or more to pull the carcass to the village. After the distributed meat shares are packed, certain rituals and taboos are set in motion. For example, as a precaution to avoid offending the bear spirit, the hunter who bagged the polar bear is not allowed to commingle with his wife for three days.

Two long-forgotten traditions mandated the time when the *umniksok*, or bear dance, ceremonies were to take place, and depended on the gender of the polar bear. The mandated time for a male bear was four days. The mandated time for a female bear was five days. The *umniksok* ceremonies were joyful feasts that emphasized the spirit of Ukiovokmiut solidarity, family kinship, gift giving, sharing, gratitude, and respect for the village members. The skulls and pelts of the harvested bear were always soaked in seawater until the time came for the song and dance celebrations. A male skull was hung in a prominent location. A man's tools and hunting gear were displayed for the male bear. Likewise, a female skull was also hung prominently, adorned with a woman's clothing, her *ulus*, and her seal-oil lamp.

The successful hunter's family and clan hosted the celebrations by distributing the best foods, skin, rawhide ropes, and hunting or fishing implements, which were saved for the occasion. In this way, the Ukiovokmiut expressed their gratitude and friendship to the great bear for having given of itself to sustain the islanders. A hunter's first polar bear pelt is still always dried, cut into wide strips, and given to the hunters to be utilized chiefly as a pad for sitting on the sea ice.

Although the Ukiovokmiut essentially fear the polar bear and its spirit, the King Islanders many generations ago found it honorable and respectful to pay tribute in song and dance to commemorate the thoughtfulness, kindness, and concern of the great white bear for the Ukiovokmiut and their Iñupiaq relatives. The King Island people went to great lengths to properly acknowledge their gratitude and friendship for the polar bear. It is assumed that the Ukiovokmiut may be the only people with such a refined and monumental tradition to admit their close affiliation with the white bear.

The King Island polar bear songs, the *umniksoteet*, are the oldest and most sacred Ukiovokmiut songs. Many years ago, I compiled a list of King Island polar bear songs, which numbered close to twenty. One of the reasons that there is not a large number of these ancient and sacred songs is that previous King Island generations mandated that they be sung only during *umniksok* celebrations. Sadly, this practice has had detrimental unintended consequences, which kept the later generations of singers and drummers from learning the repertoire and words to these important songs.

The polar bear song theme is always narrative. The words of each polar bear song denote who harvested the white bear and the relevant circumstances pertaining to each successful harvest. The successful hunter's common name is never used. The hunter's given name is used instead to prevent the bear from retaliating against the hunter.

73

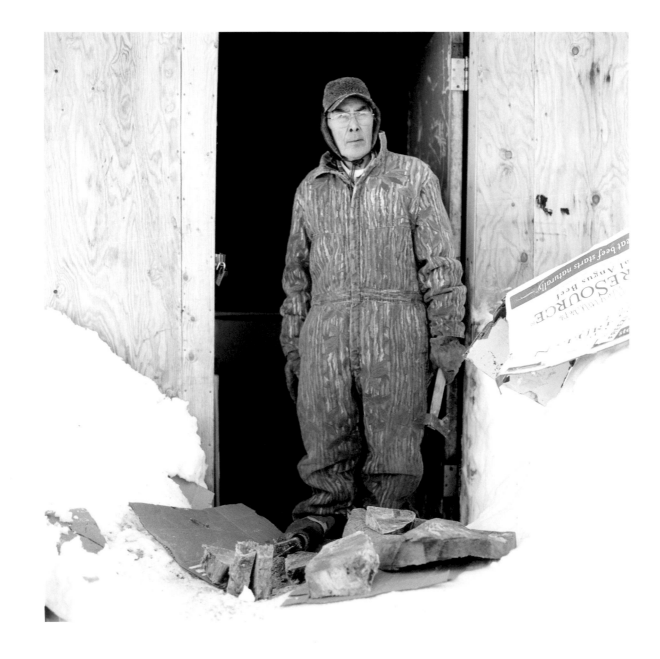

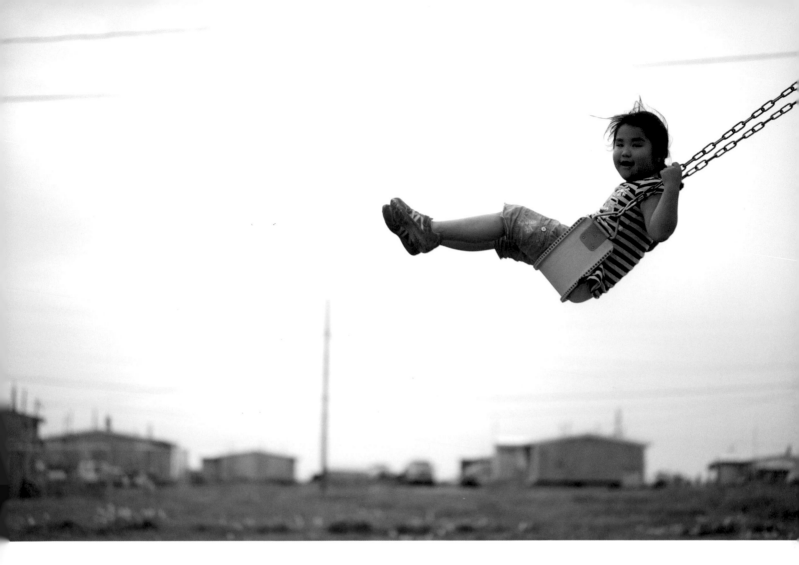

The successful hunter dances two or more songs belonging to him or his clan or family line. The men who came to help dance in the order in which they reached the hunter. The wives, children, and relatives are permitted to dance later on. The *unmiksoteet* songs and dances differ from the more commonplace women's, fixed motion, welcome, and invitation songs. These polar bear songs are generally slower and more somber, respectful, and peaceful.

The pursuit of the *tughoghok* of the sea ice at Ukiovok was always a cooperative adventure for the hunters. In the event that the hunters were required to run after the bear, they jettisoned their hunting bags to lighten their weight. These jettisoned bags were then

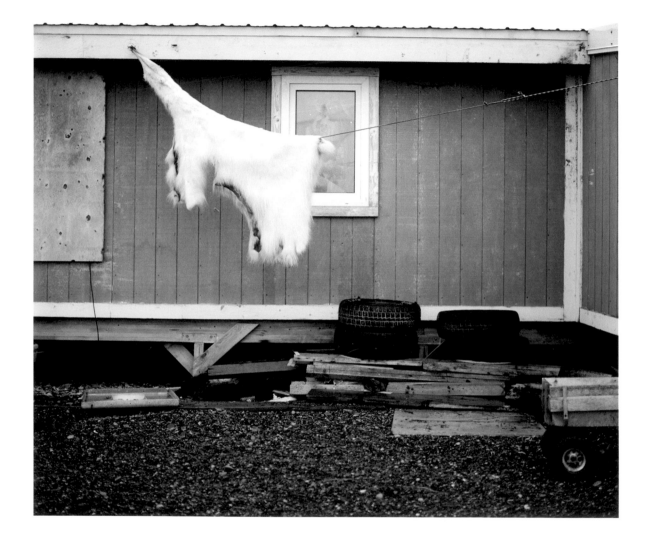

76

Point Hope, Alaska, 2013.
Courtesy of Brian Adams.

retrieved by other men who knew by tradition that it was their responsibility to return the bags to the owners whose survival gear was in those bags. Each hunter, by tradition and necessity, had one or two dogs that were used to harness the harvested bears and drag them home, giving the hunter the needed time to catch up.

There are also stories told about a giant white bear, larger than those we see today. This bear is extinct but lives on in the King Island tales. The characterization attributed to this giant bear by the Ukiovokmiut is that it was often seen sliding on its belly on the ice rather than walking. In our oral traditions, the pursuit of this giant bear was discouraged.

The King Island hunters had only bows and arrows and spears before the fairly recent advent of firearms. There are stories that the hunters devised a baiting ball consisting of coiled baleen inside some seal blubber. There had to be many of these baited balls to achieve visible successes where some wounded bears were found. The successful harvest of a polar bear in the ancient times was a closely cooperative effort requiring multiple hunters with bows and arrows and spears to overpower a bear.

The cardinal rule of avoiding the left forepaw of the bear has always been stressed. The hunters know that the polar bear is left-handed. Hunters, even up to the present time, are taught to confront a charging bear preferably from behind a piece of ice big enough to prevent personal injury. The hunter knows that any sudden movement will momentarily distract the angry bear. A harpoon rawhide line is tossed upward to draw the bear's attention upward, exposing its frontal area for the fatal impalement or shot. The skulls of harvested polar bears were traditionally hung under the houses of the hunters as proof of their skill and achievement.

I distinctly remember the story of three King Island hunters who went after a polar bear on January 6,

1949. Both the sea currents and the winds changed suddenly, preventing the three men from returning to Ukiovok. These men could not reach the stationary shore ice before dark. They could not be rescued, because of unstable ice. The drifting ice took them north. Then a blizzard enveloped everything, reducing visibility to zero. The oldest of these men could no longer keep up with the two younger men. He convinced the other two that he could no longer walk because his feet were frozen. He knew that he could not last much longer. The younger men buried him in snow up to his head and left him to die, as was customary. The sole surviving member of this trio was found on January 18, 1949, near Shishmaref by a man traveling by dog team. They tried to locate the third member, but he was never found, because he may have been buried by the moving offshore ice. The polar bear escaped its pursuers, as it had countless times before this particular confrontation. These three King Island men knowingly risked their lives that fateful day in 1949, each hoping to harvest the great bear. Two men died on the drifting ice; one survived.

The Ukiovokmiut were safe living on the island because they were in their natural environment. On the other hand, the hunters were obliged to harvest their subsistence foods from the sea world, essentially a foreign setting, each time they ventured out on the moving sea ice. They had no choice except to risk their lives in an environment in which they, as humans, did not belong. The weather and the sea ice movements were unpredictable at best. The fatalities on the ice always remained within the scope of occurring intermittently. The King Island hunting culture on the moving sea ice is full of danger and unpredictability. Each day spent pursuing the sea mammals is never the same. Nevertheless, this is the way the Ukiovokmiut survived.

King Island has been vacated and abandoned since the 1960s. Few families would return to spend

77

Joe drives home (last sun for
ninety-four days). Baffin Island,
Nunavut, 2014. Courtesy of
Acacia Johnson.

the winters on the island and circumstances beyond their control eventually forced the King Islanders off their ancestral homeland. The cessation of this lifestyle has adversely affected the King Island people in countless ways. The simple act of surviving on a small island with few outside influences gave way to a finely and intricately planned society, promoting and continuing a way of life filled with the very best interpersonal relationships, full of respect, cooperation, kinship, and love. The precepts governing this age-old lifestyle have now been diverted, turned upside-down, abandoned, and disregarded by contemporary Western American society. The Western worldview is based on individualistic, rather than collective, actions.

The Native peoples of Alaska and the circumpolar regions have been negatively influenced and affected by the Western world, whose goals are to make a profit, without due consideration of the potentially dire consequences. The indigenous peoples are be-

ing co-opted by a consumer-based economic system. There is nothing that can be predicted, but the exploitation of the circumpolar regions is here; the original inhabitants of these regions, including the polar bear, are losing their lifestyles because of global climate change; and very little real action is taking place. The ways of the Ukiovokmiut and the polar bear are disappearing, along with our ice. Perhaps there is a parallel, as the Arctic is literally on thin ice, and in the traditional Ukiovokmiut knowledge system, that means death is approaching.

Notes

1 The Iñupiaq language is gender neutral—there is no "he" or "she."

2 A hunter could never say: "I saw a polar bear/*tughughok* today" or "I killed a polar bear/*tughughok* today." The hunter would say: "I saw *someone* today."

79

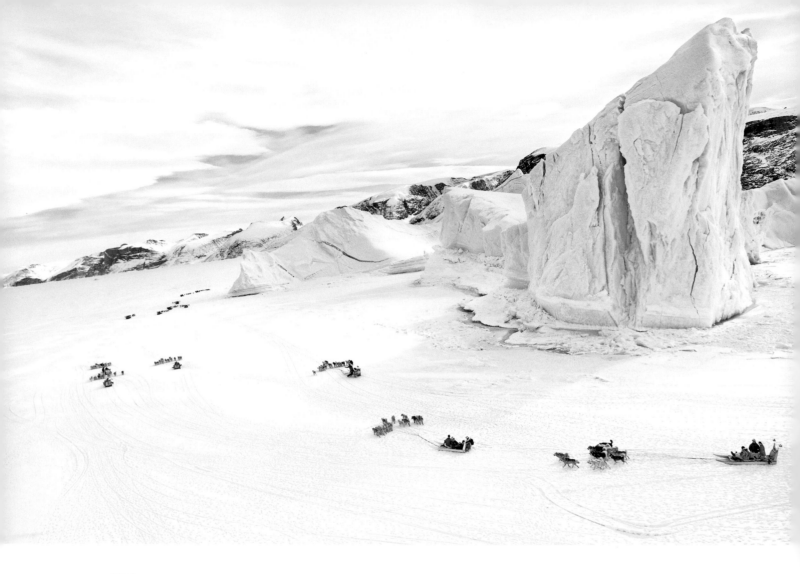

Siku 2.
Courtesy of Tiina Itkonen.

NANOQ AND THE INDETERMINATE NORTH

Bryndís Snæbjörnsdóttir and Mark Wilson

Around 1929 the anthropologist Knud Rasmussen recorded the following Inuit quote:

> The greatest peril of life lies in the fact that human food consists entirely of souls. All the creatures that we have to kill and eat, all those that we have to strike down and destroy to make clothes for ourselves, have souls, like we have, souls that do not perish with the body, and which must therefore be propitiated lest they should avenge themselves on us. We do not believe. We fear.[1]

The essay below draws predominantly from one of our art projects, *nanoq: flat out and bluesome* (2001–6). It also references our art research activity in the Arctic and near-Arctic North (specifically Greenland, Iceland, and Svalbard) more generally. Our objective is to articulate the relations and notional distances between the polar North, the imagined and metaphoric North, and the relative "UK North," focusing principally on interspecific tensions and the paradoxes of representation. One of the prevailing themes in our artwork is "fear"—not necessarily in the "gothic" sense but more in the manner of disquietude, which arises as a response, for instance, to the unfamiliar and the displaced. Uncertainty all too often provokes feelings of disquiet and anxiety in people, presenting them with a choice to go forward or to retract. In this sense, we suggest how fear might be reconsidered and repurposed in the context of a postcolonial position, prompting a new attitude of respect toward those things—places, beings, environments—that have never been ours to conquer or possess.

nanoq and the Indeterminate North

Between 2001 and 2006, we undertook an artists' survey of taxidermic polar bears in the British Isles for our project *nanoq: flat out and bluesome*. Each specimen was photographed in storage, on display, or undergoing restoration, and with the assistance of the keepers of those collections among others, we researched the histories of each. Wherever possible we identified the date, place, and individual associated with each specimen's death or capture.

A novel historical document and an artists' configuration, this project charted the constructed relationship between the northern "wilderness" and its historical and contemporary representation within UK museums and galleries that, incrementally and quietly permeated the collective unconscious. The title *nanoq: flat out and bluesome* references the pace and scope in the development of the project, the significance of the skin or veneer in methods of zoological taxidermic

display, and a mix of nostalgia and pathos triggered by the experience of these relics, once snatched from their natural habitat in the service of knowledge and machismo.

From a position of safety and familiarity there is often within us a longing and attraction toward what is either unknown or simply beyond our control. The conditional preface, however, is crucial—before such imaginary flights, human beings instinctively will do everything they can in order to establish and insulate themselves within conditions of safety and familiarity. The relative fixedness of far North and far South by means of the magnetic poles and the earth's axis, together with (for humans at least) their intrinsically

inhospitable climates, makes them special, in that they are geographically determined and determinate. But they are special also psychologically, as places intrinsically distant, extreme, and inaccessible. We know they are there and, in the case of the North, with the aid of technology and funds, well within our reach; however, as a rule, we tend to imagine intrepid others going there—not ourselves. Introducing his seminal radio work (*The Idea of North*) in 1967, Glenn Gould remarked:

> Like all but a very few Canadians I've had no real experience of the North. I've remained, of necessity, an outsider. And the North has remained for me, a convenient place to dream about, spin tall tales about, and in the end, avoid.[2]

During the research for another of our art projects, *Trout Fishing in America and Other Stories*, based in large part in the Grand Canyon, we asked the simple question, "How is a [national] 'park' a 'wilderness'"?[3] Is not the conflation of the two terms oxymoronic? There is something deeply troubling about this apparent conundrum and, strangely, it points to or awakens in us the same kind of discomfort as, for instance, we felt when we attended the Arctic Circle Conference in Iceland (2013 and 2014), by far the greatest thrust of which we witnessed as a naked and unashamed expression of the global, multinational corporate rush for new trade routes and mining and drilling rights across the Arctic Ocean floor, in light of the evidence and forecasts of exponential reductions in summer sea ice cover. Both seeming dissonances are indicators of lessons not learned from a colonial history, which tended to conflate ownership with a license—or simply the reduced sensibilities that allow speculators—to oppress, exploit, abuse, and ultimately, destroy.

The ancient fear that prompts us to protect our-selves—to pull the wagons into a circle and create shelters, homes, settlements, and cities—can also be seen as one of the drivers behind the acquisition and sustenance of dependable knowledge—of fixing and defending the parameters of our collective experience. But the historic need to bring everything into the realm of what is understood and "known" has led us proportionately to cut ourselves adrift from exposure to things that, while perceived anthropocentrically as "problematic," might otherwise—from an environmental and ecological perspective—be enriching. Insofar as our accretion and redistribution of knowledge is intrinsic to culture, so in attempting anthropocentrically to "culturalize" our experience of the world in ways that are both manageable and dependable, important threads are dropped and the game is lost. Georges Bataille radically describes the consequences of our wilful and historic disembodiment from nature thus: An open wound is produced by humans' separation from animality, and this is what it means to be a human being.[4]

Our insulation from environments beyond urban or agrarian control has robbed us of the know-how of how to be, not only in the world but also—tellingly and in ecological terms—*with* the world. In the seminal collection *Animal Places, Beastly Spaces*, Griffiths, Poulter, and Sibley discuss the respective and contradictory attractions for urban dwellers of domestic stasis and safety and the attendant, notional romanticism of nomadism along with its associated threats:

> The desire to eliminate nature, nature as abject and inimical to domesticity, is still there in the (post) modern city. At the same time, though, wild nature is desired. Its absence in the city figures as loss, and there is a need to reconnect, if only vicariously or in the imagination. Just as nomads transgress and disturb the urban order but, at the same time, represent a romanticized freedom, so uncon-

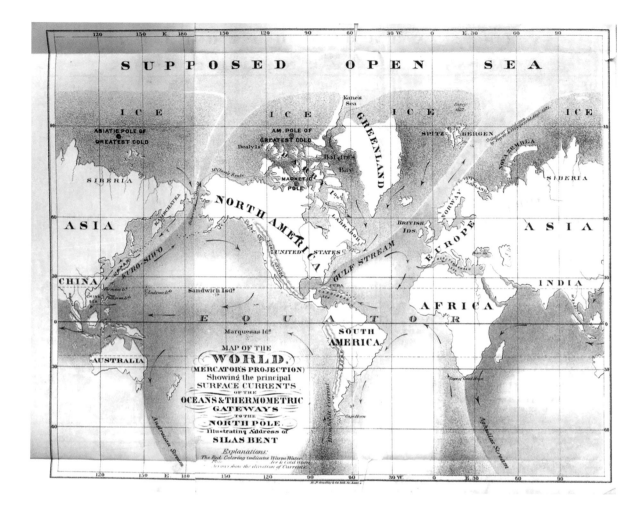

84

trolled nature is a source of both anxiety and desire. Thus, people "need" to imagine marginal places, both as abject spaces to which feral cats, Gypsies and other elements of the "the wild" can be consigned and as spaces of desire where wildness can be recovered.[5]

In the imagined North and particularly in the extreme North, for virtual visitors, that tension between fear and desire is always present.

In his official report to the Navy after returning from the Arctic in the early 1850s, Elisha Kent Kane errone-

(*Above*) Silas Bent's 1872 map of the open Polar Sea. Public domain.

(*Opposite*) Cubs eat mother, 1897, from *nanoq: flat out and bluesome*. Courtesy of Bryndís Snæbjörnsdóttir and Mark Wilson.

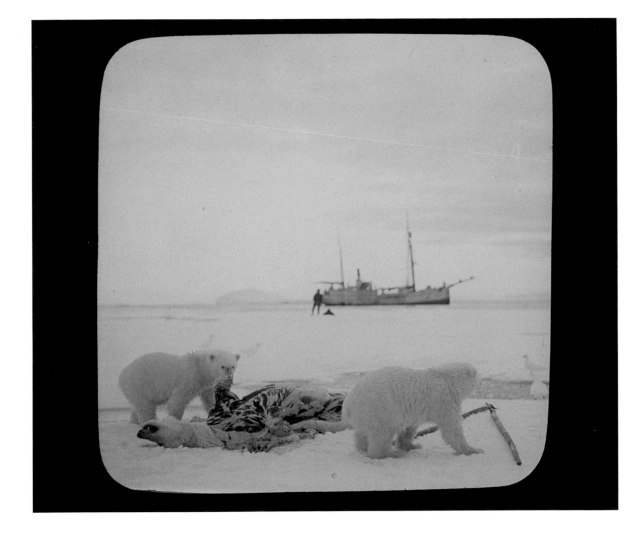

ously proclaimed success in his discovery of an "open and iceless area, abounding with life, and presenting every character of an Open Polar Sea."[6] The romance of this discovery flooded even the most scientific of accounts that followed. Just a few months after Kane's return, Matthew Maury, the father of modern oceanography, dedicated an entire chapter of his groundbreaking scientific work *The Physical Geography of the Sea and Its Meteorology* to Kane's "Open Polar Sea." Maury was poetic in his exuberance, declaring that "seals were sporting and waterfowl feeding in this open sea

of Dr. Kane's. Its waves came rolling in at his feet, and dashed with measured tread, like the majestic billows of old ocean, against the shore."[7] In *Arctic Dreams*, Barry Lopez describes the rather more realistic and disorienting effects Europeans endured in the Arctic:

Thousands of miles from familiar surroundings, genuinely frightened, and perhaps strained by the grim conditions of shipboard life, Europeans took to killing any polar bear they saw. They shot them out of pettiness

and a sense of rectitude. In time, killing polar bears became the sort of amusement people expected on an arctic journey. Travelers regularly shot them from the ship's deck, for target practice.[8]

He continues:

> One idle summer afternoon in 1896, a whaling captain in Amundsen Gulf with nothing else to do shot thirty-five, for sport. . . . Europeans were ill at ease in the Arctic. The polar bear was for them a symbol of the implacable indifference of an inhospitable landscape.

The danger for humans was and is, however, real. Between 1978 and 1981 eighty-four polar bears were killed in the Canadian Arctic as threats to human life.

Following the closure of a military air base at Churchill, Manitoba, in 1957, the pressure of hunting on polar bears was reduced and their population rose accordingly:

> By the mid-sixties, polar bears were turning up [there] in large numbers at garbage fires . . . , frightening people. The people, in turn, began tormenting the bears by shooting them with small-caliber weapons and chasing them with cars.[9]

Of the thirty-three taxidermic bear specimens we tracked down for *nanoq: flat out and bluesome*, the majority had been taken during the nineteenth and early twentieth centuries. Only one remaining in a UK collection predated this. Our survey work involved removing them from the environments of their respective collections and re-presenting them, both photographically and actually, in a series of strategic reconfigurations among polar and zoological collections within mu-

seums across the United Kingdom and Scandinavia. These acts of removal, re-assemblage, and intervention intensified and gave further meaning to our exploration, mirroring and interrogating the original act of hunting, the practice that many now regard as destructive and entirely transgressive. In the photographic archive, in each case, we conflated the image and the provenance of each respective specimen. From the biographical information we gathered in this pursuit, it was clear that some specimens were acquired to be symbols of status. Unsurprisingly, therefore, it was the case that many were shot by members of the aristocracy. As a consequence, these were brought as trophies to private estates and there, as in the museums, we photographed them as we found them, very often among a disparate collection of historical and colonial artifacts.

Most public zoology collections, if they have a polar bear at all, have one or two specimens, thus providing an implicit (rather than an explicit) suggestion of a history of their killing, but also, importantly, an attitude toward predators that Western colonists cultivated and carried all over the world—of suspicion and machismo, of implicit superiority, and (in their conquest) of "vanquished" fear and threat. Part of the ambition of *nanoq* was in the unpacking of what it is to project and exoticize notions of "the North" and of "wilderness"—to dwell with their difference in distance and danger, as something opaque and impenetrable, asking no questions and seeking only to confirm the stereotypes we are conditioned to cherish. Even in the five intervening years between the project's outset and its various manifestations, we saw old stereotypes pale and new ones coalesce. In that short time we saw the rise—and fall—of the polar bear as a reliable symbol of environmental decline.

In all the specimens we saw the hollowness of souvenirs, their intrinsic sadness, and the ultimate futility of collecting things by which we seek to remember places and events. We wrote at the time:

Perhaps nothing is more poignant than that which is plucked from "nature"—that thing that once was living and now is dead or redundant—a shadow of what it once was in life. . . . So if we handle or knock expectantly on the surface of something stolen or displaced long ago, we might expect to hear the dull thud of its disembodiment, its unmediated physicality—in short, what it is—not what it was or what we think, or thought, it was. . . . Or if we listen more closely we may hear the ring and

Blair Athol, *nanoq*.
Courtesy of Bryndís
Snæbjörnsdóttir and
Mark Wilson.

echo of a much larger set of truths, carrying a
multitude of narratives and interlocking frag-
ments, redolent not only of what has trans-
pired, the dislocation of the object, its journey
and its second life, but inevitably, if only by
implication, of what else might have been.[10]

So *nanoq: flat out and bluesome* explored this in-
stability of our regard for objects to which symbolic
value and work have been assigned. The specimens
were gathered in the far North and brought here to sig-
nify one or several symbolic functions—but time has
a knack for exposing these functions as impermanent
and fragile conceits. It is not new to think of the prac-

tice and collection of taxidermy as the fetishization of ruins. But ruins and wastelands—and their symbols—can be construed and misunderstood in many ways.

In an article entitled "Down in the Dumps," dating from 2001, writer Rachel Attituq Qitsualik wrote:

It has always been a popular political view to see the Arctic as a great wasteland, a "safe" dumping ground for the most virulent of pollutants, a "practical" place for nuclear tests. But we are already beginning to see that Arctic ecosystems—and remember, human communities are certainly a part of the ecosystem—are affected even by airborne waste from as far away as Argentina. My mind hesitates even to contemplate overlong upon such horror.

We no longer have to go to the dump; the dump has come to us. Waste is inevitable, but are we destined to live with, or within, our dump sites?[11]

Ironically, as we discovered by walking them during a three-month residency in Greenland, the longest roads in the necessarily coastal towns and settlements there lead to the town dumps, invariably crowding the shore and spilling almost wantonly into the sea. It is an extraordinary and graphic paradox to find the evidence of such entropy in the very place one has imagined (naïvely or not) to be exempt, untainted, and—somehow—perfect. And yet here again the colonial mind is at mischief—and, as always, we should be cautious of reiterating and believing such projections. The very visible local detritus is literally the tiniest tip of an invisible and insidiously distributed berg of global human waste that has found its way fatally into the ecology of the Arctic.

As humans travel farther and farther north, the plethora of signs, which shape our lives, increasingly diminishes. Those things that are recognizable, those indicators of familiarity, those things that remind us of home are encountered less and less frequently as we are delivered into an increasingly sparse and sparsely populated territory. Accordingly, our sense of survival preoccupies us and our thoughts turn inward. The sheer reduction in signs and signifiers of culture induces a sense of liberation, perhaps, but also—for those unprepared—a sense of panic. To quote the Inuit again: "We do not believe. We fear." Perhaps we might usefully see this as an environmental manifesto or blueprint, where fear is absolutely synonymous with the concept of respect, necessitating, therefore and at last, a revision of human behavior.

Since *nanoq: flat out and bluesome* and in the years since 2006, not least for reasons of perceived eco-political manipulation, the polar bear's comparatively recent iconic status as a symbol of environmental deterioration has already tired and mutated into a problematic cliché. The resultant vacuum remains unfilled—the image depleted and not yet replaced. One wonders indeed how that gap could ever be filled. As an environmental icon, the polar bear seemed ideal; on the one hand, it occupied an unchallenged position at the top of the Arctic food chain, and on the other, because of increasingly short winters and increased exposure to heavy metal pollutants, it now struggles to survive—in short, it is a paradoxical mix of awesome strength and pathetic fragility. We find it interesting that even before the animal represented—itself a symbol of a habitat—has become truly endangered or close to extinction, the potency of this representation has already expired. Even in matters of pressing importance, our representations, it seems, have limited shelf lives, the duration of which is determined by sometimes-fickle twists of fad and fortune or, indeed, perceived abuse.[12]

89

Healing the Wound

As we've indicated, the Arctic is an area upon which we find it all too easy to project imaginatively; it is a predominately white and (to us) inclement habitat with relatively few inhabitants, and in relative terms it is still rarely visited. In this context, we propose that the ultimate challenge to representation, and simultaneously the symbol that consequently may yet prove to be most durable, is that of a negative space—a void. Our speculative art project *Matrix,* which at the time of this writing is as much a tool for thinking as a material manifestation, focuses on an oblique evocation of the

(*Top*) 2012 wire-frame 3-D visualization of polar bear den from Kongsøya, Svalbard, 1979. Courtesy of Bryndís Snæbjörnsdóttir and Mark Wilson.

(*Bottom*) Original drawing by biologists. Kongsøya, Svalbard, 1979. Courtesy of Bryndís Snæbjörnsdóttir and Mark Wilson.

species *Ursus maritimus* by making specific reference to the environment that is its point of individuated entry into the world—the bear's maternity den. Our wish is to evoke—through a carefully constructed and poetic balance between site, data, material, and light—a presence that addresses the inseparability of "being" and "world."

A wonderful series of diagrammatic drawings of polar bear dens (and their locations), made during a research expedition in Kongsøya, Svalbard, in 1979 (Polar Institute, Tromsø) has provided us with fixed measurements, data, and visualizations of transient phenomena that once existed, but, inevitably, are no more. The drawings constitute a reliable document made by biologists in the field and in part have informed the development of our art project by allowing us to clothe an idea, rooted necessarily in the imagination of distance, with the data of findings by those who searched for and uncovered the dens, who ventured inside (probably with some trepidation) and meticulously measured their very specific and diverse architectural complexity. From this and similar fieldwork and observations, dedicated biologists have pieced together the ergonomics of these constructions, how they are sited by the bears and periodically adapted during their occupation in response to specific local conditions.

Through art, elements of fact and fiction, as well as of data and affect, may realistically and productively be combined in assemblage, using art itself as a perceptual petri dish. Our approach in researching *Matrix* is to call into being a network of associated traces—a system of bricolage using a variety of media by which it becomes possible for a viewer both consciously and unconsciously, physically and psychologically, to connect with a personalized reading of this very specific but ultimately unfathomable complexity. The ambition of the project is to balance a highly charged (and, for some, contentious) complex reality, founded

on historic and contemporary research data, on the one hand, with the provision of a personal interactive mapping and meaning-navigation opportunity, on the other. From the two-dimensional Bjørnoya field drawings, we have carefully extrapolated wire-frame visualizations using contemporary 3-D software. Some dens are complex, with multiple chambers. Some are simply an entrance tunnel and a main chamber. The den in the illustration at left, for instance, is scaled from an original that measured eighteen meters in length.

The word *matrix* signifies a substance, situation, or environment in which something has its origin, takes form, or is enclosed. The importance of this to our thinking here is how it constitutes a displaced agency of potential and a locus for imaginative projection. The subterranean burrow has no external shape. The entire world, in fact, is its matrix. In its interiority it is quintessential—it is a space, an emptiness into which new life is introduced. As a structure it declares, in very loaded terms, an absence. The absence suggests the recent departure of the maternal family. Before too long, vacated dens are liable to melt or collapse. The den of a polar bear is a white space in a white field. Its presence is announced discreetly at its entrance—as a faint darkening in the snow. Even experts in the field find polar bear dens remarkably hard to spot.

The prospect of entering or staring into a space, legitimized or given agency by the qualities of the absence it embodies, is powerful and compelling. By doing so, we hope to probe our own precarious constructions of the world—in this instance, our cultural conceptualization of its possible or inevitable demise. So in considering these spaces and what they might rekindle and challenge in our projections upon them, central is the idea of shelter or refuge as being a natural extension, expression, and embodiment of the ontology of all living things. Further to this, in the context of Jane Bennett's material vibrancy, the instability of the physical constitution of things and beings as tempo-

91

2014 process photograph.
Courtesy of Bryndís Snæbjörns-
dóttir and Mark Wilson.

rary, organic assemblages is foregrounded—in short, the tantalizing relationship between materiality and impermanence for us all.

Using the journey north and our minimalist perceptions of how it is constituted to carry the idea of a possible, incremental liberation from the jaded meaning-sets that we've come to accept in our daily lives seems promising as a way by which to contemplate a new approach to environment—a notional clean slate. The least we can do is reciprocate by giving due weight in all our work to its deceptive complexity and its mysterious and compelling lightness. But if fear should be our guide, how is it possible to feel again—enough to fear—when we have, by and large successfully, done everything in our power to blind and anaesthetize ourselves? We are remote creatures on a distant planet—we have borrowed, stolen, and squandered. How should we pierce the screen, to step outside—to understand nothing once again?[13]

Notes

1 Jarich G. Oosten, "The Prime Mover and Fear in Inuit Religion: A Discussion of 'Native Views,'" in *Continuity and Identity in Native America: Essays in Honor of Benedikt Hartmann,* edited by Maarten Jansen, Peter van der Loo, and Roswitha Manning (Leiden: E.J. Brill, 1988), 76.

2 Glenn Gould, *The Idea of North* (CBC—Radio Canada, 1967), transcription available at http://polarcosmology.com/blog/idea-north/.

3 B. Snæbjörnsdóttir and M. Wilson, *Trout Fishing in America and Other Stories* (installation at Arizona State University Art Museum, Tempe, 2012–14).

4 Georges Bataille, "Letter to X, Lecturer on Hegel," in *The Bataille Reader*, edited by Fred Botting and Scott Wilson (Oxford: Blackwell, 1997), 296–300.

5 Huw Griffiths, Ingrid Poulter, and David Sibley, "Feral Cats in the City," in *Animal Spaces, Beastly Places: New Geographies of Human-Animal Relations*, ed. Chris Philo and Chris Wilbert (London: Routledge, 2000), 69.

6 *Proceedings of the Royal Geographical Society* 4 (1860): 239.

7 Matthew Fontaine Maury, *The Physical Geography of the Sea and Its Meteorology* (New York: Harper and Brothers, 1868), 209.

8 Barry Lopez, *Arctic Dreams: Imagination and Desire in a Northern Landscape* (New York: Scribner, 1986), 111–115.

9 Ibid.

10 B. Snæbjörnsdóttir and M. Wilson, *nanoq: flat out and bluesome: A Cultural Life of Polar Bears* (London: Black Dog Publishing, 2006), 14.

11 Rachel Attituq Qitsualik, "Down In the Dumps," June 8, 2001, http://www.nunatsiaqonline.ca/archives/nunavut010630/nunani.html (accessed April 2, 2014).

12 Recently, for instance, in the world of representation, some minor cultural tremors have occurred. In 2007, video footage was screened depicting a polar bear "clinging" to a tiny iceberg. The footage was to become controversial when its meaning was called into question, but for a moment it captured the imagination and pricked the conscience of a watching world who saw in this struggle the embodiment of environmental decline. In 2011 the legendary wildlife documentary filmmaker Sir David Attenborough unreasonably became the target of unprecedented hostility when it "came to light" that, during his latest epic series *Frozen Planet* (2011), the birthing of a polar bear had been filmed not in the Arctic at all, but in a zoo.

13 The visual material and data informing the project thus far have arisen from primary research that we have undertaken in Svalbard or that has otherwise been made available to us through our discussions with biologists in the field, by correspondence with polar scientists, and by means of secondary research in the archives of the Scott Polar Research Institute in Cambridge and the Norwegian Polar Research Institute in Tromsø.

93

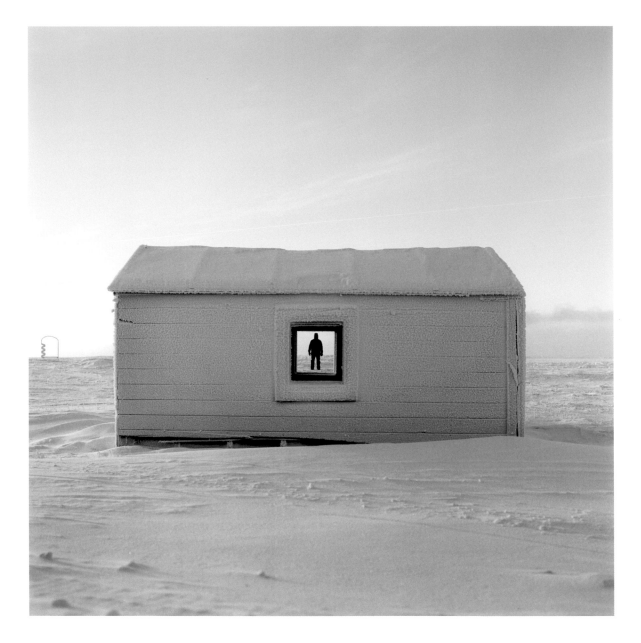

David Taylor.
Barrow, Alaska, 2013.
Courtesy of Brian Adams.

LAST SNOWMAN

Simon Armitage

He drifted south
 down an Arctic seaway
 on a plinth of ice, jelly tots

weeping lime green tears
 around both eyes,
 a carrot for a nose

(some reported parsnip),
 below which a clay pipe
 drooped from a mouth

that was pure stroke-victim.
 A red woollen scarf trailed
 in the meltwater drool

at his base, and he slumped
 to starboard, kinked,
 gone at the pelvis.

From the buffet deck
 of a passing cruise liner
 stag and hen parties shied

Scotch eggs and Pink Ladies
 as he rounded the stern.
 He sailed on between banks

of camera lenses
 and rubberneckers,
 past islands vigorous

with sunflower and bog myrtle
 into a bloodshot west,
 singular and abominable.

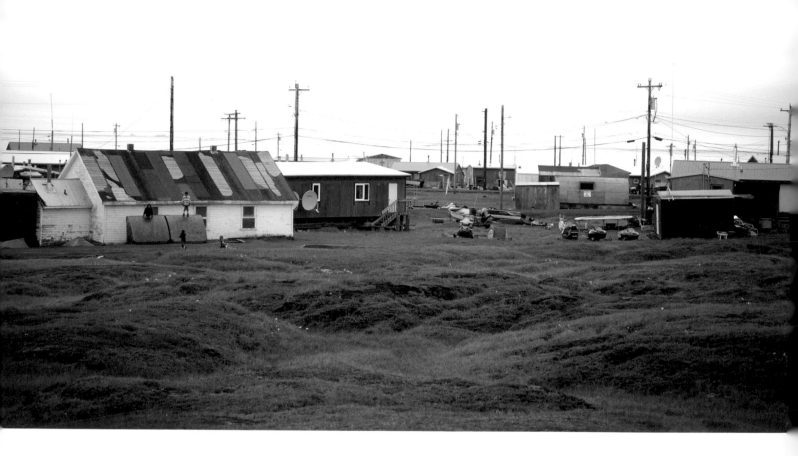

Wainwright, Alaska, 2013.
Courtesy of Brian Adams.

INLAND EMPIRE

Craig Medred

On the seemingly endless journey along the Iditarod Trail, which traverses the foreboding emptiness between the Kuskokwim and Yukon Rivers in the vast Interior, the nothingness of everything creeps into a man's soul. There is a feeling not so much of a time long lost but of time abandoned and all hope of civilization gone.

The spindly black spruce forest and barren, windswept hills mix with the fire-ravaged white spruce and birch, and the absence of fellow travelers, along with the occasional remains of failed human efforts at occupation, leave the feeling that the wilderness has not so much reclaimed this land from humankind as thoroughly and totally defeated the human species.

Once this was a land of golden hopes, golden dreams, and booming communities. Once this was Alaska's Inland Empire. It was the economic Prudhoe Bay of the Alaska Territory circa 1915. Iditarod Trail dog teams hauled gold south to tidewater the way the Trans-Alaska Pipeline now moves oil. Millions of dollars flowed south. And then it all ended.

Global realities invaded even the most remote corner of the North. The world went to war for almost half a decade in 1914, and within little more than ten years, the Great Depression had begun. The residents of the Inland Empire who hadn't trickled away to war fell victim to economic decline.

One by one they left, never to return. Soon there was no one. And little was left behind.

The Iditarod Trail built to serve the goldfields went silent. It remains today a quiet and usually deserted route, both northbound and southbound. The northern route from the deserted mining camp of Ophir snakes past communities that no longer exist for almost 150 miles to meet the Yukon at the village of Ruby, a bustling home to three thousand in 1915, now down to 170 and still fading.

Ruby sits at the northern end of what is today the most heavily traveled highway in the old Inland Empire. The northern Iditarod route welcomes each year the short, noisy passing of the Iron Dog snowmobile race and every other year the now world-famous Iditarod Trail Sled Dog Race.

The southern Iditarod route from Ophir, which travels 135 miles west through the remnants of the ghost town of Iditarod to the fading community of Shageluk, population 85, sees the passing of the dog race only in odd-numbered years. In even-numbered years, there isn't even a trail. It hides somewhere beneath the snow that blows across a land home in winter only to moose, wolves, wolverines, marten, hibernating bears, and the voles that live beneath the whiteness.

Halfway across the route, the hills rolling on and on to the west of Ophir with no hint of civilization marking the horizon, rest the remains of the city of Iditarod,

Wainwright, Alaska, 2013.
Courtesy of Brian Adams

Old Point Hope school.
Point Hope, Alaska, 2013.
Courtesy of Brian Adams.

once home to as many as five thousand people. Hints of what once was are present in the wreckage of old houses sinking into permafrost, in the bunker-like concrete vault of the long-gone bank not far off the edge of the Iditarod River, in the remnants of Tootsie's once-famous bathhouse, and in the hulk of the Northern Commercial Company Store, which somehow remains standing. Off in the brush, you can find old riverboats rotting and the rusting hulks of steam machinery that once powered commerce. When the winds of winter blow, the scattered remains serve as a troubling reminder.

One hundred years ago, Iditarod was a thriving port. Riverboats lined the banks in front of the warehouses. A boomtown bustled along the riverfront. There were crowds in Applebaum's Store, the shop opened by Sam Applebaum, a Polish Jewish immigrant destined to find more success than most miners in the North. Over at Tootsie's, Matty Crosby was purported by some to be the "only colored woman in Alaska," and some first-rate whiskey trickled out of her still.

Crosby would eventually go to jail in Fairbanks in 1925 for bootlegging, but she later returned to the Iditarod country, where she was a beloved member of a rather roguish society. An old-timer interviewed by the U.S. Bureau of Land Management for an oral history in 1993 described her as "a very decent prostitute."

Crosby wasn't the only one in a community that boasted all the comforts of the frontier of the time. Female companionship was high on the list. So was liquor. Iditarod was a rough place, but it was not uncivilized. There were three newspapers at one point, as well as electricity, telephones, hotels, cafés, and a branch of the Miners and Merchants Bank. Automobiles drove the streets. A narrow-gauge railway connected the Iditarod to Flat, an even larger community eight miles southwest.

Flat was home to an estimated six thousand people

by 1914. The local jail was there, and the elementary school. The U.S. Postal Service opened an office in Flat early in the 1900s. It hung on as a remnant operation, serving a handful of people scattered across the country for fifty miles around, until even the Postal Service gave up on the Inland Empire in 2000.

By then, there were whole communities—Dikeman, Dishkakat, and Poorman among them—not just turned to ghost towns but gone. Their history only adds to the remoteness that makes this corner of Alaska feel more forsaken than the wildest of the state's vast and never-occupied wildernesses.

At the Sulatna River fifty miles outside Ruby on the northern route of the Iditarod, a long-abandoned steel bridge in the latter stages of decay rises eerily out of the wilderness twenty or thirty feet above the icy riverbed of winter in the region's dominant season. On the north side of the bridge runs the Ruby-Poorman Road, but it, like everything else now, has been abandoned to the encroaching alders of summer, and the snows and glaciating overflow ice of winter.

Twenty years ago, the Iditarod dog race maintained a checkpoint at a place it called Sulatna Crossing near the bridge so that mushers could take a break on the long run to Ruby from Cripple, a seasonal encampment of portable shelters along the frozen banks of aircraft-friendly Wolf Lake. But the Iditarod abandoned Sulatna before the start of the new millennium as too hard to supply and maintain.

In the Sulatna legacy is the story of the Inland Empire: Too hard to supply and maintain. Too far from anything. Too cold in winter when the thermometer often drops to −50°F and stays there for weeks on end. Too overwhelmed with summer swarms of mosquitoes reported to have sucked the life out of moose. Too tough for modern humans.

Sulatna is a godforsaken place that humans visited only to rip the riches out of the earth before retreating. It is a chilling reminder of Alaska's gold mining past in a

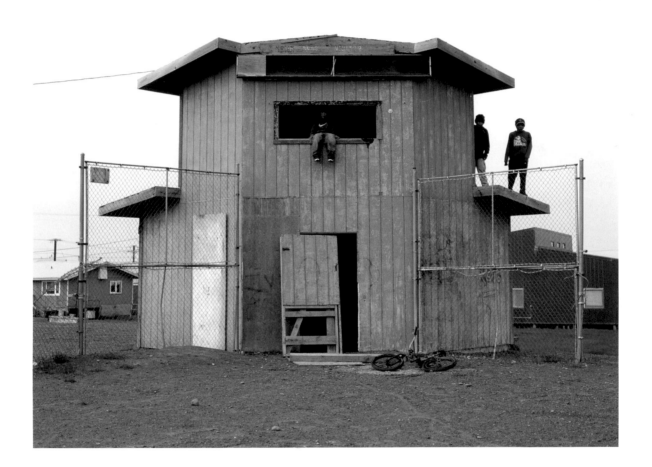

Barrow, Alaska, 2013.
Courtesy of Brian Adams.

state where some are starting to wonder if it might be a harbinger of Alaska's oil production future.

People rarely realize how good things are until they're gone.

Anchorage, Alaska, 2012.
Courtesy of Brian Adams.

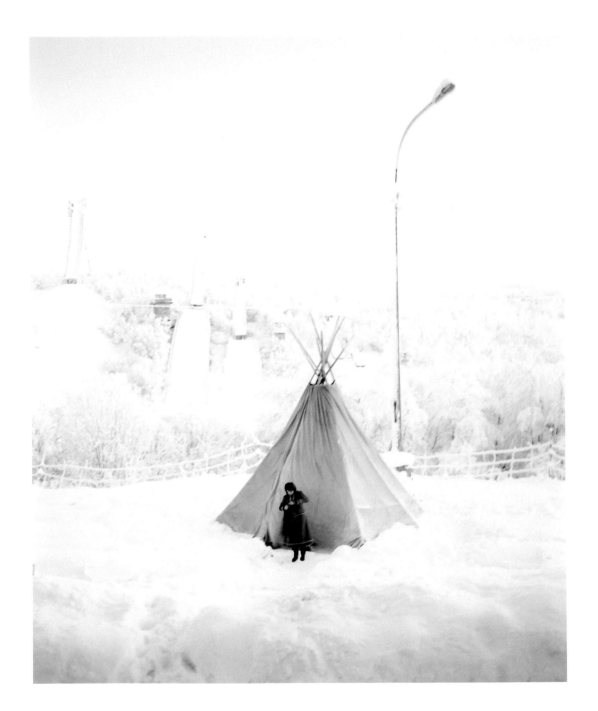

Untitled.
Courtesy of Jeroen Toirkens.

THE ALLURE OF HARSH PLACES

Judith Lindbergh

I sit on the edge of nowhere, looking out at nothing at all. Nothing that is everything, all-encompassing, surrounding, with a wild breathlessness sweeping between rigid cliffs and quivering, windswept fields. The water that falls, the dust that blows, have existed since the beginning of what humans foolishly call time. Here there is no time, only constancy. A waiting that endures and abides.

I seem to be inextricably drawn to formidable places, harsh landscapes where survival is always a question of if, and very rarely how. I have set my novels in such environs: Viking-age Greenland and the Central Asian steppes. My fascination is more than the simple lure of opposites, the chance to escape a busy, crowded life to be silent and alone. Something deeper presses me to venture where most other people shun. These places have been my preoccupation, transforming my understanding of what it means to be part of a culture and community, and of how choices made in a landscape fraught with challenge cannot be measured by any modern, comfortable scale.

I have, in fact, never been comfortable in harsh places, certainly not in lands covered in ice and snow. I cringe through New Jersey winters and unfurl from my clench only with the first melting trickles of spring. The frozen earth is to me a shiver, my shoulders hunched as all life happens in secret hollows under snow, under water, far under root where I wish I could also huddle.

Yet amid true wilderness, my discomfort becomes meaningless. The wind howls as if lonely, alive. Quiet is palpable as a veil of petrified lace frost. I reach out and grasp, but cannot quite touch this harshest essence in my never-bared palm.

Yet people survive here—have always survived—and evolved a culture and relationship with their bitter surroundings both more sober and more sanguine than I can conceive. Should we temperate-climed people be asked to exist in such places, would we find ourselves significantly lacking? Would we have the fortitude to accept circumstances we cannot change, to make choices where sacrifice is not a luxury withdrawn, but a life-or-death decision that cannot be erased once it is made?

Ephemerality

I have never lived in the Arctic. I have been there only twice—once in Finland, and once crossing the North Atlantic in search of Viking ghosts.

It was in Greenland that I first took my seat on the edge of mostly forgotten history. At the homestead called Brattahlid—now a slab of broad, flat rocks sunken into a mat of rough root tangles—I sat on that stone rectangle, thinking: once the clasp of these six-foot walls held in warmth, a door opening to let life in

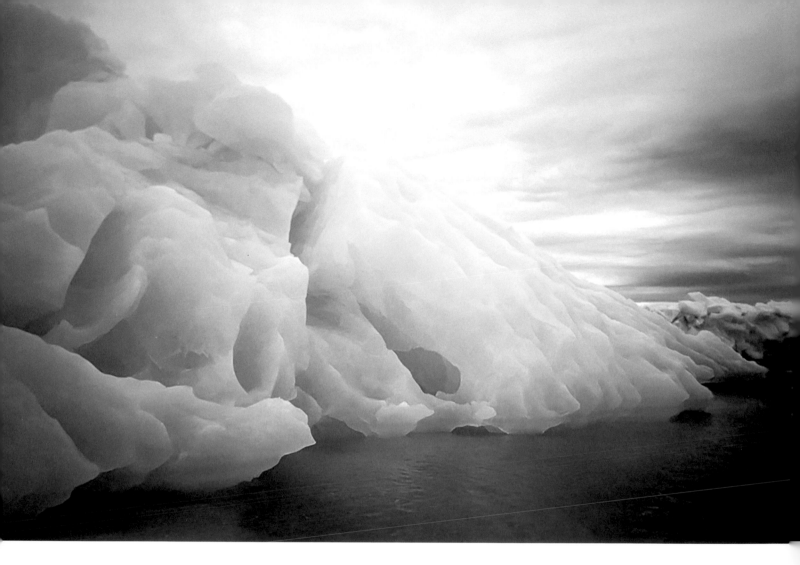

and an earthen roof to let smoke out, while within, dull sunlight, the scent of oily wool, sod coals, the sounds of voices. The name Erik the Red once meant something here. His household. His chieftaincy. His boldness to venture, to turn banishment to legacy. His stubbornness to believe that Thor guided and protected him, that Odin determined his fate. His wife Thjoldhilde's church—the first Christian church built on the North American continent—still sits high on the hill just above these bare remains, a place Erik refused to enter.

The drama of those days is long lost. On this day, his Greenland pastures are dotted with sheep and ruins. Little is left of the Viking settlers but rock, bones, and tales. Their reputation for fierceness and indomitability

(*Above*) Blue ice.
Courtesy of Judith Lindbergh.

(*Opposite*) Buttercups.
Brattahlid, Greenland.
Courtesy of Judith Lindbergh

was betrayed by a climatic cold snap so subtle and insinuating that the settlers did not adapt, eventually simply disappearing a mere five hundred years after they'd landed here. Their optimism had failed them, as had their presumption to claim a landscape that seemed utterly familiar, yet that they barely understood.

This lack of understanding intrigued me: this presumption of their own resilience—so much like our own—and their implicit expectation of their gods' favor. I set my story's time frame on the cusp of Christian conversion to emphasize the fleeting sense of permanence and how quickly it would be dashed, eroded like stones beneath a glacier's foot, scraped to pebbles and leaking into the sea.

Isolation

My first landing in Greenland came just a few days before, at the tiny village of Ikateq outside Tasiilaq on the east coast. We'd reached it by Zodiac boat and then a high climb up a rounded, grassy hill. We had failed to sail around the tiny peninsula to find the proper harbor, too impatient for what we'd come to see. At the top of that hill stood a house and its owner—an Inuit villager who had watched our approach with stony amusement, his face half skeptical and subtly resigned. No doubt he had seen such intruders before, and knew we would come and go quickly, like the tide, with the place he called home little changed by our trespass.

Hvalsey, Greenland.
Courtesy of Judith Lindbergh.

What he would never know is what he would give to me—that I have carried with me for all the years since that brief encounter.

There was litter on the ground—scattered all around that beautiful, isolated village in the empty, wild landscape of my dreams. So I asked him why, in the least presumptuous, least judgmental, least American-tinged perspective I could muster, holding back my outrage and surprise.

"It is so that someone else passing will know we were here."

I had never thought of that before.

Impermanence

I have always lived in cities or suburbs, in the company of people within shouting range or reach, where the sounds of human industry drown out the cries of birds. As a young person, these places energized me. I too would make my mark here, and for many years I strived in a landscape built of the potential that only human hubris could conceive. But in time, I saw impressive constructs that had filled city blocks and pages of veneration grow tattered and tired and then simply slip away. All the sturdiness and substance that I'd admired and sought was friable, more insubstantial than I'd imagined. And what of my own strivings? Did they—would they—ever matter? Of all that we create—through the entire course of human history—so little in the end remains.

I began looking for durability in little islands of nature—in vacant lots, admiring the stubborn strength of scraggly sumac breaking through cracked cement, or counting the dangling larval casings of just-hatched moths left on a chain link fence. Evidence perceived as ugliness, requiring uprooting and tarring over, symbolized a resilience that contradicted ephemerality. Humans would build, overshadow, dominate, but nature in the end would endure.

There was odd comfort in it. To yield to wildness is to be absorbed into the stream. The concrete must succumb to roots and weeds and crumbling. The Inuit I had met in Greenland would have understood. His ancestors' culture was more yielding and attuned to the harsh Arctic environment and its demands—even as the Vikings condemned them. They called the Greenland natives *skraelings*—an Old Norse term laced with superiority. Yet, while the Vikings continued as they always had—relying on wooden longships in a land without wood, grazing their herds on the fragile Greenland grasses as if they'd never left their Nordic homelands—the Inuit adapted, moving south to follow their prey as the climate declined at the beginning of the fourteenth century. The Little Ice Age brought them into direct contact and conflict with the settlers. Relying on hunting and gathering, with no culture, technology, or beliefs that the Vikings could understand, the Inuit survived—and continue to exist in Greenland—long after the settlements disappeared.

Constraint

I remember years ago I was invited to a private home with a group of enthusiastic readers. They discussed my novel, and one finally asked what several had clearly wondered about. "Your slave character—Katla—why didn't she just run away?"

I answered, "She is a woman without freedom, education, property, or any other means. She lives in a small pocket of thawed sod at the edge of the Greenland ice cap beside an ice-plated sea. There's no one around for hundreds—thousands—of miles, no neighbors who don't know to whom she belongs, no other villages or towns beside these two tiny settlements, no

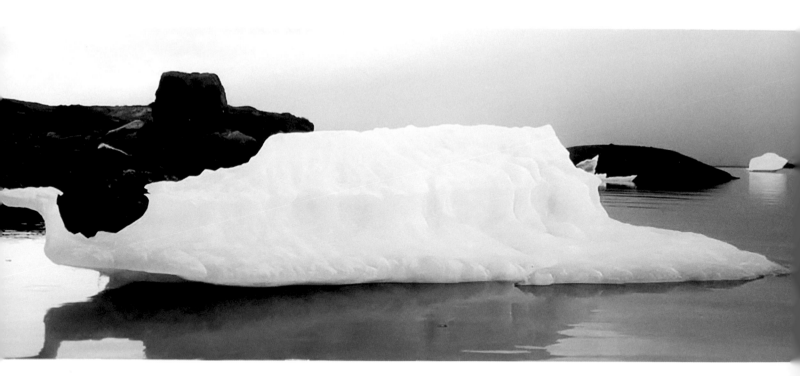

Ikeq, Greenland.
Courtesy of Judith Lindbergh.

place she can walk or run that doesn't involve freezing, starving, drowning, or being eaten alive. Where exactly would she go?"

I said it, perhaps not quite so harshly, because at the core of the question lay my own essential quest: to discover what my characters would do when pressed to the very edge. Life was risky then and there as it cannot be here and now. If we hunger, we go to the refrigerator or the grocery store, get fast food or food stamps or dumpster dive. There are people around to feed us—at a friend's house or a soup kitchen. We do not starve alone on a fjord when the snow locks us away in ice and boreal darkness. People starve now in many places, even (perhaps especially) in dense urban landscapes in the United States. But the wolf is not at the door in quite the same way. The means are withheld by human constraints, not by nature. The threat of the Arctic, especially in Greenland—so removed, at the very edge of the then "known" world—was utter

and complete. By forcing my characters to the edge, I write to face my own fear.

Presumption

The presumption of Western culture is that the individual matters. Our desires and achievements, our social constructs and plans, our values, judgments, impressions, and creations, are all lionized and lauded. But this conceit is perhaps rooted in deep insecurity and subconscious terror of our own fleeting existence. In our endless striving to craft a permanent manifestation of our existence on earth, we deny that death is ever present and essential, no matter how hard we press it away.

In my story, the quintessence of nature is the erasure of the ego. In nature, everything dies. I have been known to say, to the dismay of many urbane compatriots, that the earth wouldn't care if humanity ceased to exist. That our mark here is insubstantial—even as we destroy our environment with our hubristic overreaching abuse and neglect. We are easily erased. And the earth would go on just fine without us.

If our singular objective is to be remembered—to make our mark—then our actions take precedence over the wishes of others, over our roles in our communities and in society, and over our place in the clan, and even nature itself can be bent to our whims. But here lies the danger, as the Greenland settlers experienced. They forgot that their very existence was at nature's sanction.

This edge of Greenland—the southwesternmost tip—was in the tenth century A.D. as green and grassy as on the July day when I visited there. Buttercups speckled the fields and sheep grazed placidly. The water was iron, fixed and hard, but the icebergs were sparkling brilliant blue. Still, what the eye could see, then as now, was not the truth. The late tenth century

was the waxing of the Medieval Warm Period. The Vikings had unknowingly chosen the optimal time to migrate. Only a few centuries later, the climate would cool just a handbreadth of degrees, and the advantages they had sought—uninhabited grazing lands and ice-free harbors—would be lost beneath a layer of rime just thick enough to choke off their livelihoods, European connections, trade, and support, all the necessities that kept the settlements alive.

Mortality

In mythological terms, the forces of fate are equivalent with the forces of nature. Nature's acts cannot be explained; they are the purview of the gods. In such daunting landscapes, we are forced to recognize our own ephemerality, to embrace it, question it, conform with or rail against it. But in the end, all our struggling barely leaves a trace in the inevitable flow of eternity.

I write to toy with this dichotomy: human significance—desire—in the face of insurmountable forces. The need for a character to survive and thrive despite all the powers of fate moving against them. Even in their greatness, my characters are doomed. Not because they are flawed but because they are alive. Only those who accept their mortality and the futility of their own importance come to a deeper understanding of their place in the world.

Significance

Not long after my visit with the Inuit in Ikateq, we sailed to Tasiilaq (then known as Ammassalik to some, though the name had recently changed because someone named Ammassalik in the village had died. We were told that it is forbidden to speak the names of the dead). We followed our young tour guide

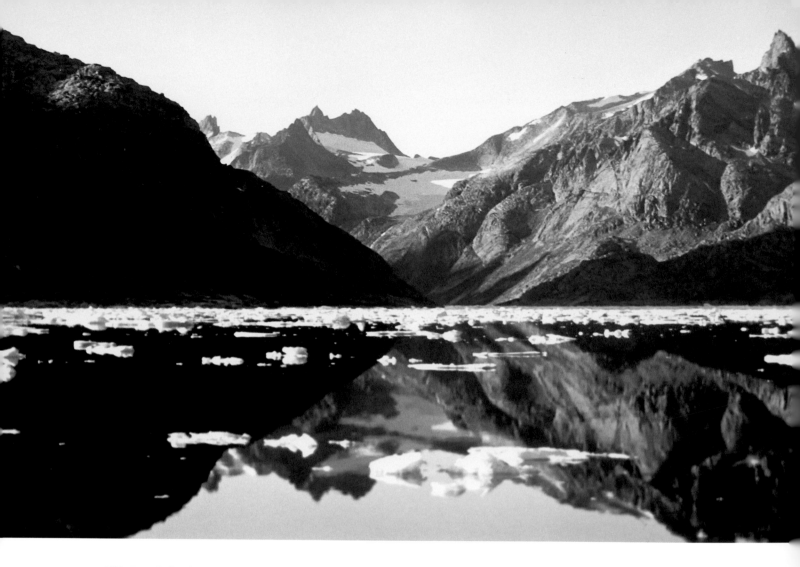

Vikingberg, Svalbard.
Courtesy of Judith Lindbergh.

to the Valley of Flowers, expecting no doubt what any temperate-clime native might think to see. But when one of our group complained about the field of wafting low grasses between ashy cliffs, our guide patiently begged us to get down on our knees.

"Look closely," he murmured.

Indeed, among the green stems were small white and purple buds, barely bigger than seeds.

What I have come to understand is that nature doesn't think we matter—if nature thinks at all. It is we ourselves who leave scattered bits of dross as evidence—litter in a tiny Greenland village, a dotting of rock cairns in Central Asia. In Mongolia they're called *ovoo* and are places of sacrifice, offering, and prayer. It is said that a traveler must circumnavigate the *ovoo* three times and place a rock or other offering on the pile. By adding evidence of his own passing, the traveler gains protection for his journey and "windhorse"—spiritual energy. Similarly, the ancient Inuit made *inuksuk* some ten thousand years ago, stone beacons of piled stones set on high hills to guide travelers or give hunters information about game. At their core, each of these markings—the litter, the *ovoo*, and the *inuksuk*—simply state one of the most basic human cries: "I was here."

Existence

This is the start and the end of everything: to be centered in the smallness. The pebble slipping at the glacier's foot. The threat of ego erased. Harsh landscapes scream with the howl of death. When we step outside the circle of human safety into wildness and wilderness, into a place where a single wrong step could mean our end, how do we mark that place? Do we leave a small scratch on a wall of stone? Do we form a confederacy? Our footsteps are swept by tides, by winds, by shifting sands that forever change the shape of these places, yet remain forever the same.

The sense of wilderness in Greenland is so vast and so visceral that simply sitting on the edge of the crumbling homestead at Brattahlid makes me feel utterly and completely small. Insignificant. If I rise again, or freeze in that place, it would not matter. If I never write another word, the stones would not care. But I would care. The rocks bear within them all the layers of infinitude, while my eyes seep with the knowledge that my passing here, in this place, at this time, means something only to me. And there is comfort in that meaninglessness. It is a humbling experience, one that I embrace. I have spent too much time thinking that my wants and needs matter. I have come here to learn that my life is a mayfly's blink and I have written my way to understand that I am nothing. And that that is better.

I write about harsh places to honor and embrace evanescence. Though we might not survive, or even be remembered, our singular existence matters, at least to ourselves. Each of us may be no more than an individual flower in that Arctic field, or a redwood destined to rise and tower and then one day fall.

It does not matter, only to me—to us—and that is enough. That we are. That we were here.

I'm thinking about the aurora borealis.
You can't tell if it really does exist or if it just
looks like existing. All things are so very uncertain,
and that's exactly what makes me feel reassured.

—Tove Jansson

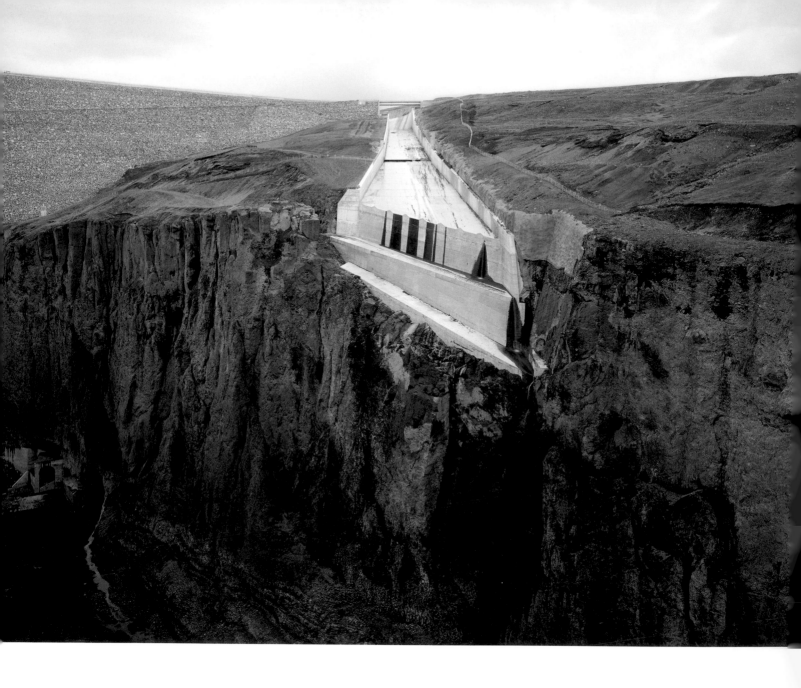

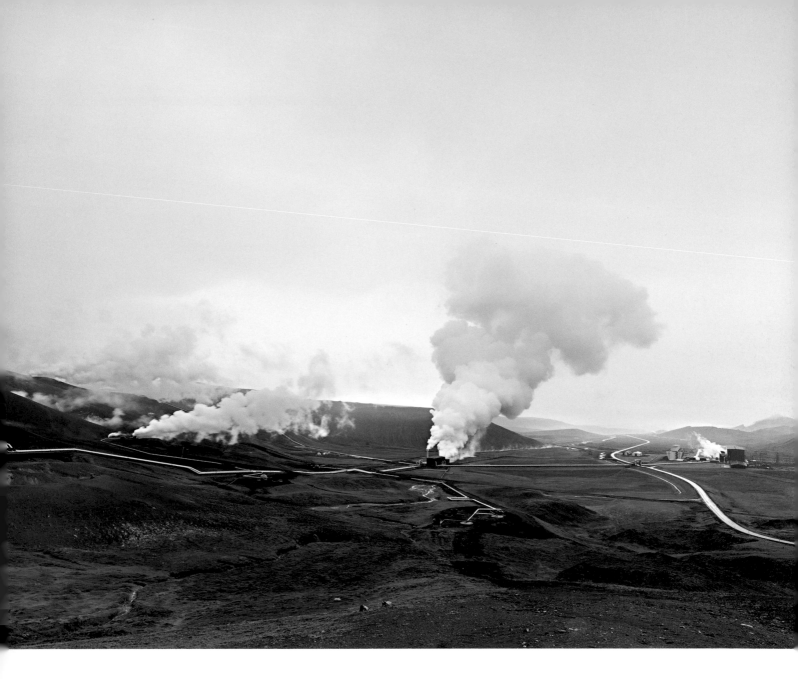

(*Opposite*) Concrete spillway chute, Kárahnjúkar Dam, Iceland, 2010. Courtesy of Olaf Otto Becker.

(*Above*) Myvatn, Iceland, 2010. Courtesy of Olaf Otto Becker.

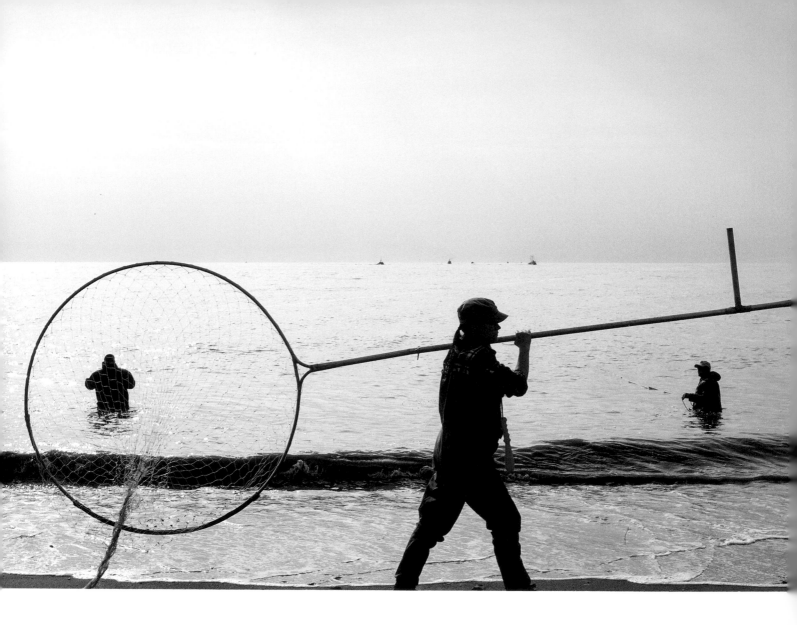

(*Above*) Commercial fishing boats
on the horizon of Cook Inlet, as
seen from the banks of the Kenai
River. Kenai, Alaska. Courtesy of
Oscar Avellaneda-Cruz.

(*Opposite*) Taxidermy trophy
at the Elks Lodge no. 2127.
Homer, Alaska. Courtesy of
Oscar Avellaneda-Cruz.

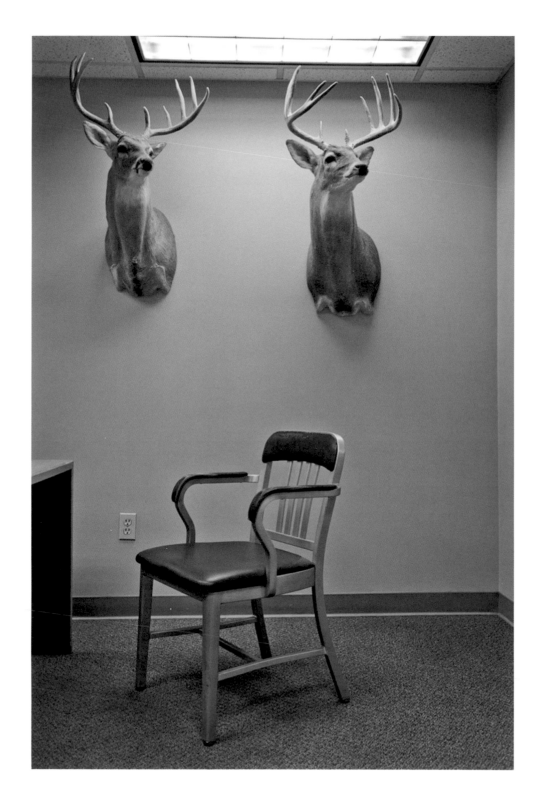

(*Above*) A tailgate kitchen counter
on the Kenai River. Kenai, Alaska.
Courtesy of Oscar Avellaneda-Cruz.

(*Opposite*) Taxi. Seward, Alaska.
Courtesy of Clark Mishler.

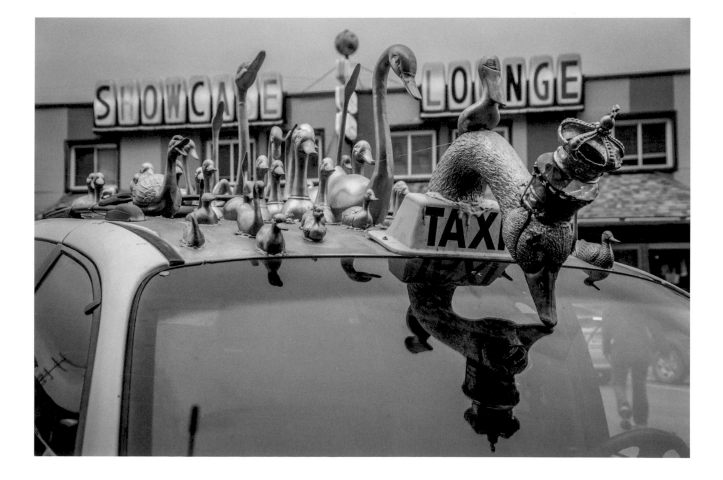

(*Below*) Gutting and processing sockeye
salmon on the Kenai River. Kenai, Alaska.
Courtesy of Oscar Avellaneda-Cruz.

(*Opposite*) Bushpilot's barbershop
at the Ted Stevens International
Airport. Anchorage, Alaska.
Courtesy of Oscar Avellaneda-Cruz.

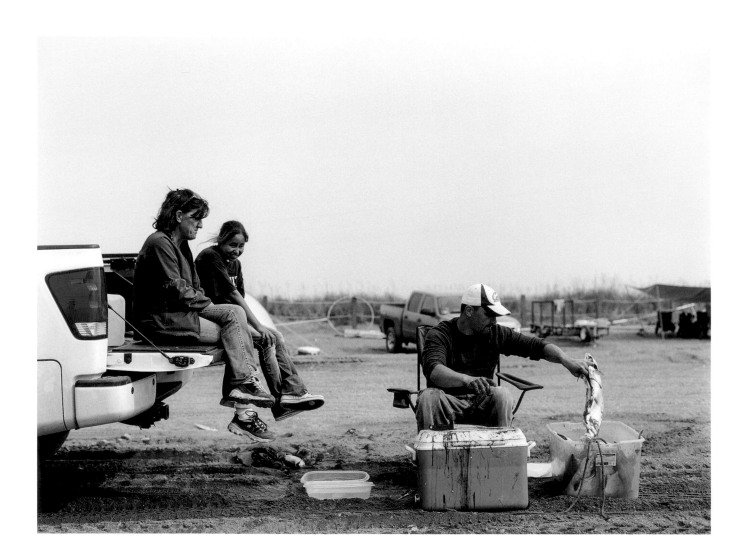

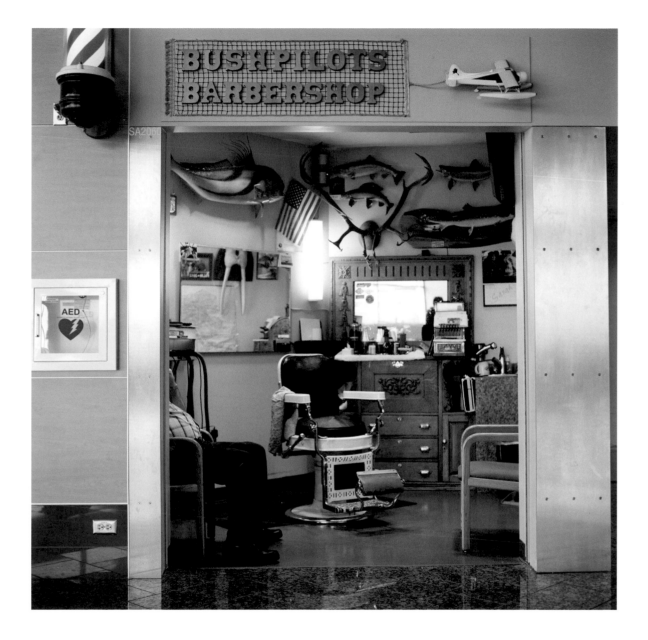

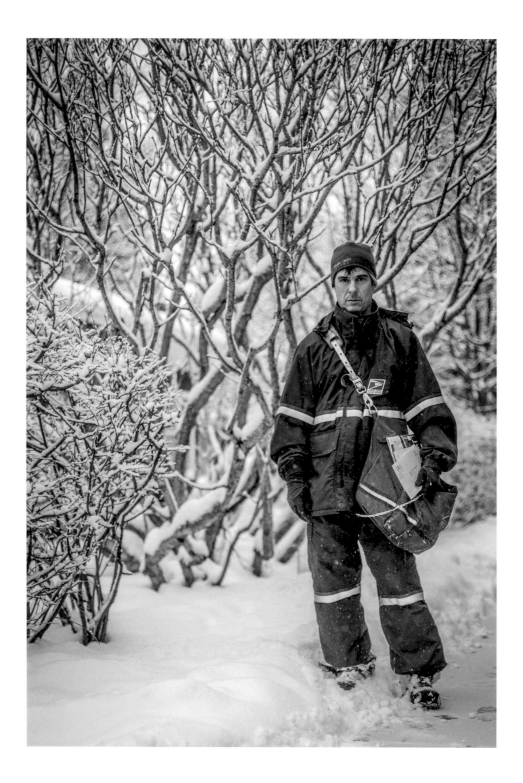

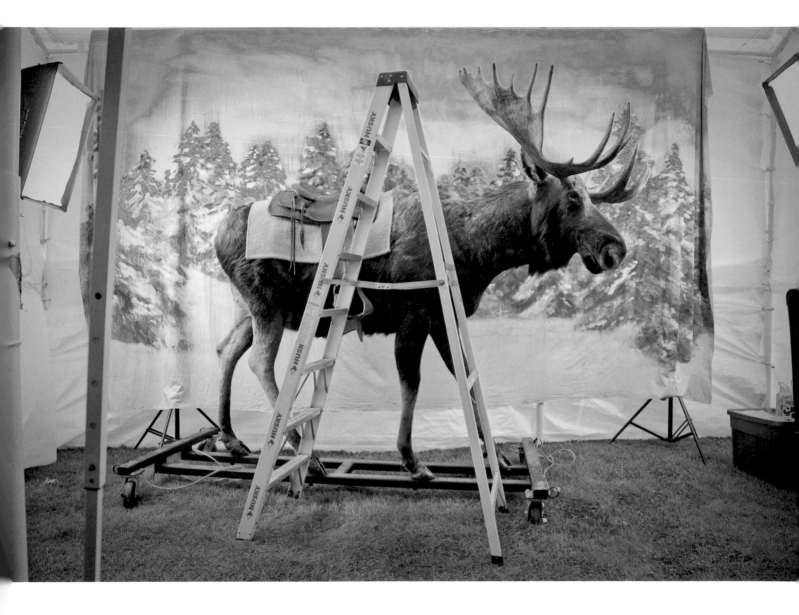

(*Opposite*) Bill Hanek.
Anchorage, Alaska.
Courtesy of Clark Mishler.

(*Above*) Alaska Landscape No. 3
at State Fair. Palmer, Alaska.
Courtesy of Clark Mishler.

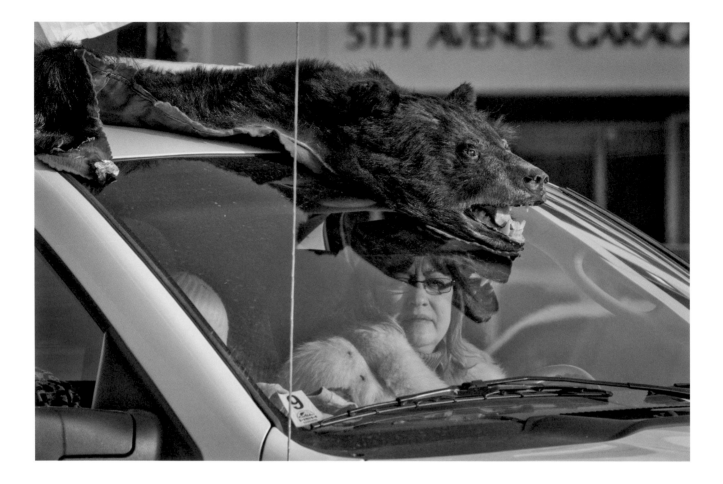

(*Above*) Automobile decoration during
Fur Rendezvous parade. Anchorage,
Alaska. Courtesy of Clark Mishler.

(*Opposite*) Barrow whaling captain
Freddie Tuckfield. Anchorage, Alaska.
Courtesy of Clark Mishler.

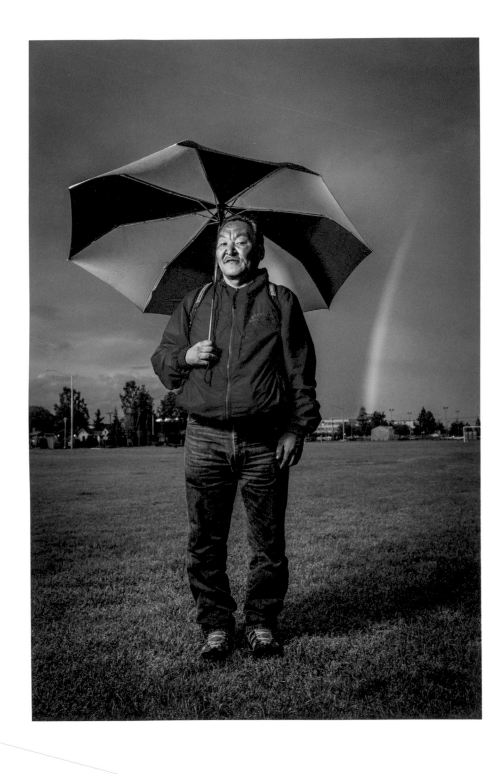

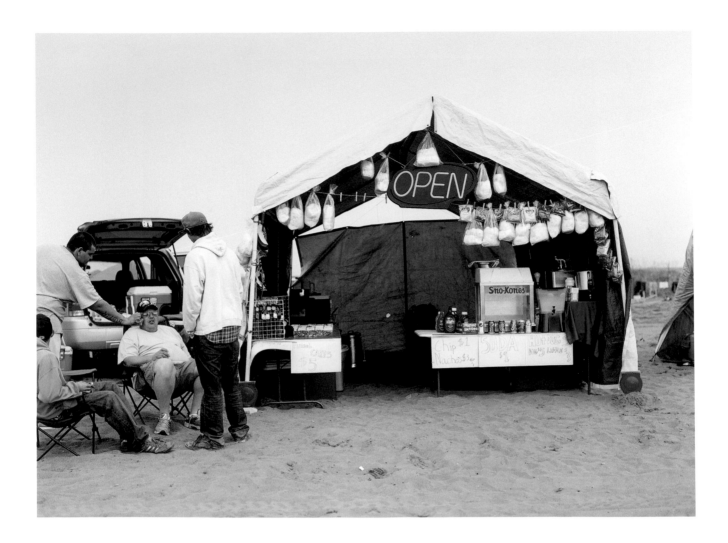

(*Above*) A temporary concession stand
on the Kenai River. Kenai, Alaska.
Courtesy of Oscar Avellaneda-Cruz.

(*Opposite*) Yup'ik dog house. Kwethluk,
Alaska. Courtesy of Clark Mishler.

(*Above*) Dipnetting on the
Kenai River. Kenai, Alaska.
Courtesy of Oscar Avellaneda-Cruz.

(*Opposite*) Office decoration.
Anchorage, Alaska.
Courtesy of Clark Mishler.

Home, or something like it.
Alaska, 2014. Courtesy of
Acacia Johnson.

THE MAGICAL REALISM OF
NORWEGIAN NIGHTS

Karl Ove Knausgård

It was in the late '80s that I saw the northern lights for the first time. I was 18 and had moved to an island in the far north of Norway to take a job as a teacher in a little school in one of the small villages up there. The village was located in the shadow of a steep, barren mountain chain, looking out on the Atlantic Ocean. Fewer than 300 people lived there, and almost all of them were involved in fishing, either as fishermen on small vessels, or as workers in the fish warehouse. It was an exposed place. One night a roof was ripped off and a camping trailer was overturned by high winds; some of the buildings had been fastened to guy wires. Everything came from the sea: the wind, the clouds, the rain, the waves and the fish, which were at the center of village life. Few of the houses had gardens; there was no buffer between civilization and nature. When you opened the door, it felt as if you were stepping out into nature, and that left its mark on the people who lived there. The social life was different from what I was used to; it was more raw and much more direct, but also warmer and more inclusive. Maybe because that's all there was—a few clusters of buildings near the sea—and those who lived there were dependent on one another.

A decade later I wrote a novel set in that place, and what stayed with me—aside from the odd social reality, in which, after only a few days, I became mercilessly entangled—what settled as a memory in my body was the light.

Oh, that Arctic light, how concisely it delineates the world, with what unprecedented clarity: the sharp, rugged mountains against the clear blue sky, the green of the slopes, the small boats chugging in or out of the harbor, and onboard, the huge codfish from the depths, with their grayish-white skin and yellow eyes staring vacantly, or on the drying racks, where they hung by the thousands, slowly shriveling for later shipment to the southern lands. Everything was as sharp as a knife. And then came the fall and with it the dark that closed around the day, which got shorter and shorter. Soon it lasted only a few hours, as if caught between two walls of darkness moving closer and closer until everything was night. Except for a faint pulse of bluish light in the middle of the day, it was dark all the time, and living and working in that kind of darkness, a sort of eternal night, does something to a person's relationship to reality; it becomes dreamlike, shadowlike, as if the world has come to an end. That's when the northern lights appear, that's when these great veils of light are drawn across the sky, and even if you know what the phenomenon is and why it occurs, the sight is still mysterious, immensely foreign. The first time I saw it, I was sitting in a car with a friend. We stopped and got out and stood there, staring, in the middle of the wilderness, spellbound like animals caught in a spotlight.

The northern lights compel your eyes upward. They're impossible to ignore. A simple phenomenon,

rays striking the atmosphere, no more mysterious than the beam from a flashlight—yet the lights convey a sense of being at the very edge of the world and looking out at the endless, empty universe through which we are all careening.

For those who lived on these islands, the light was part of their everyday life. The sun was another matter.

After months of total darkness, the moment when the sun appeared for the first time was almost reverential, and during the spring and summer, when all darkness vanished and the sun shone in the sky both night and day, at times as red as blood, the mood in that tiny community was elated; people went out at night, stayed awake and drank. It was amazing, but it also felt

dangerous, because the division between night and day is a border, perhaps the most fundamental one we have, and up there it was abolished, first in an eternal night, then in an eternal day.

Translated from the Norwegian by Tiina Nunnally.

Tom, New Year's Eve.
Baffin Island, Nunavut, 2014.
Courtesy of Acacia Johnson.

MIRRORLAND

Freya Rohn

I.
On a trail of bouldered snow
we take a bridge over the river—
force of habit, when the ice is now
as strong as the span we walk

 walking across
an act of deference to melt, to the unseen
spring we believe in only because of the
logic of the earth's swing.

To see it, you feel it can never
change—the haze of icelight and hoarfrost
of neverness.

II.
I've flown across the North in the not night—
the skinless light flattening
ice and land into one joinery of noon.

The long night is more soot-footed,
noticed than the north light—
Light and we think: *illuminating, life-giving,
the way forward*

but it is this light: *unignoreable, unrelenting,
unshadowed*—the hard beak of *un*-
tapping at the window, wanting in.

Sheets of foil cover my windows against
that light—a gilded plea for shade,
offering to an ungowned night

craving each bruise of shadow
that gives small life
to thoughts too shy for spotlit
windows, rotting before they are ripe.

III.
And then, the night antlers into the corners
of day until it saturates, warming—leaving
you restless for an older intimacy

 with hibernation
or pressing for rebellion, seeking out
murmurs of light—a gash

of sun in grounded snow
that blinds, giving over to spindrifts and cover
a slow army against the wreck of dark

IV.
At the bridge, I stop and listen for what is below
testing for what I know (but still doubt):
that the river's pulse is not wholly stilled

 the stillness
a trick—like the light shinedying
across the horizon in a show
of weak memory.

V.
High latitude plays with expectation: the *-ight*
of both *light* & *night* mirroring
the other—a reflex with one
consonant between

the call & response in a faith of opposites—
glassed foil on one side
the bright reflection of the other

a test for how much can stay knowable
—the beat of flood beneath ice
shadow in a rush of light—

even though it feels as if there could never
be enough strength
for cold to flame into burn
for leaf to happen again
for night to outgrow shade

we look at a lockjam of ice
and believe in the strong quiet blood
still moving beneath.

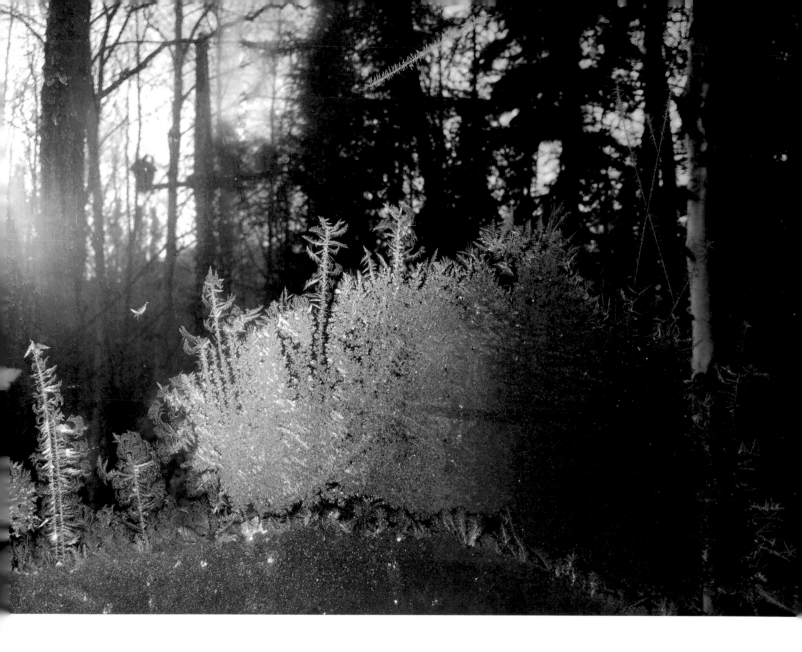

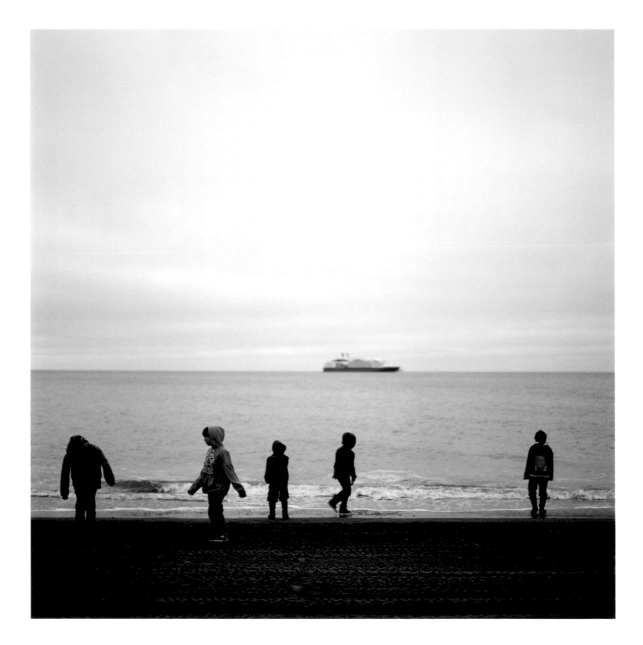

Barrow, Alaska, 2014.
Courtesy of Brian Adams.

TWO IF BY SEA

Elizabeth Bradfield

What I know is not clean or tidy. It is incomplete and skewed by how I came to know it and who taught me and the self I hauled along in my learning.

I work as a naturalist on expedition ships, and since 2009 that work has taken me annually to Arctic Canada and the Norwegian Arctic of Svalbard. For a month in the summer I live aboard a midsize ship as one of a dozen or so expedition staff, traveling with one hundred tourists on voyages that last anywhere from eight to eighteen days.

Here's a job description: Drive passengers to shore in a Zodiac and lead a hike, pointing out the low-hunkered flowers or polar bear tracks. Give illustrated talks about botany or wildlife or history to help deepen the experience of what we've seen or might yet see. Listen to the talks of other naturalists to find new ways of understanding and speaking about this place in all its complexities. When traveling from one landing to another, stand out on deck, sometimes alone, and scan the shore and waves and ice for wildlife—in part to find something and in part to serve as an example/exemplar of seeking. Join guests for cocktails in the evening as we, the expedition staff, give a bit more information about what's been encountered—sometimes light and silly, sometimes digging into questions and issues that trouble the North. Do paperwork, haul gear, teach people to properly use binoculars, clean boots, lend

a hand, offer camera tips, show up eager for the next thing, whatever it is.

"Expedition ships" are a specific category of cruising vessel. They carry 120 passengers or fewer, small compared to the 2,500-plus passenger ships that regularly land in Southeast Alaska towns like Skagway and Ketchikan. They carry guides on board—ornithologists, ecologists, naturalists, and educators—who pride themselves on offering deep information as part of the joys of travel. They strive to provide hands-on experiences of place and get people out on animal trails and beaches in areas that are not groomed for easy access. Most expedition ships carry a fleet of eighteen-foot inflatable Zodiacs, boats used to duck into small harbors, explore rugged coasts, and bring people ashore. Sometimes, they set aside days of their itineraries to stop and explore places not known to the crew aboard. There is no rock-climbing wall. The food is very good; the bar is well stocked. Often the wake-up call for the first landing of the day is at 6 a.m. If, at the dinner hour, whales or bears are spotted, the meal is delayed. It's rigorous luxury, muddy-boot decadence.

As a naturalist, my experience of the Arctic is like that of a hummingbird at a flower: I dip in. It feeds me. I head south at the end of my contract not having sampled everything, but drinking deeply from what I have reached. I return, if I'm lucky, the next year. A different

flower. A different sweetness. A moment of disorientation or surprise at what, each time, is different.

Conflicting truths must be stated: I love my work. On a boat in the North, looking and sharing, I feel more alive than nearly anywhere else. I also have deep ambivalence about the value and the impact of Arctic tourism and my role in it. I am a guide and an expert, shaping people's experiences. My knowledge of the Arctic is shallower than spring runoff, when the seasonal thaw just begins to consider beginning. We are careful of our footprints on tundra and attempt to instill and enforce respect for the land. We burn diesel to reach these places, burn gas to get ashore in our Zodiacs, and on some ships, we burn paper and boxes and other garbage. All this becomes part of the remote air we came here to breathe.

"Last-chance tourism," the boom in Arctic travel is called. Before the ice melts. Before the polar bears drown. Before the walrus before the bearded seal before the musk ox before the drilling before the homogenization and Facebook-ization. It is a deep irony that climate change is at once allowing, even prompting, tourism and erasing what people came to see. The lessening of sea ice has made it possible for ships' glossy brochures to promise that visitors can traverse the famed Northwest Passage, that destinations previously accessible only ephemerally and unpredictably can be regularly reached by ships.

Disaster has spurred Arctic visitation from "southerners" before. I am thinking specifically of the disappearance of Sir John Franklin in 1845 and Lady Jane Franklin's subsequent huge effort to muster ships to

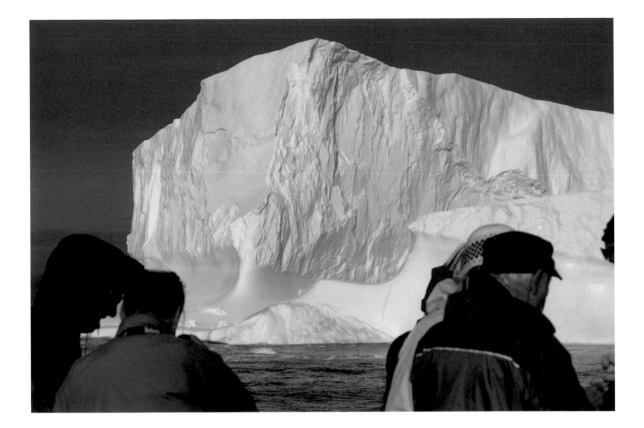

find him (the fact that there were hordes of navy captains at loose ends without a war is part of this story, too). Franklin's calamity kicked off a surge of European presence, mapping, and exploration that changed both the global sense of the Arctic and the Arctic itself.

When did Arctic cruise tourism begin? The year 1892 saw the first cruise to the Svalbard Archipelago; however, expedition cruises to Arctic Canada began only in 1984, when the MS *Explorer* voyaged through the Northwest Passage. Since then, the annual number of cruises in Arctic Canada has bumped up and down and now seems to be hovering at twenty-some ships a year—carrying about 2,500 passengers.[1] This is a tiny number compared to the roughly 9,000 expedition cruise passengers that visited Svalbard in 2009 (altogether, in 2009, some 29,000 ship passengers

(*Opposite*) Polar bear on sea ice in Svalbard, viewed from the deck of the ship. Courtesy of Elizabeth Bradfield.

(*Above*) Iceberg viewed from the ship, Davis Strait. Courtesy of Elizabeth Bradfield.

146

visited Svalbard, but only a fraction of those ships are considered "expedition cruises").[2]

Still, ship-based tourism in the Arctic is nothing like that in Antarctica, another "last-chance" destination, where the number of ship-borne visitors increased by 344 percent in the first decades of the twenty-first century.[3] The foremost reason is that there are many different Arctics: the Russian, Alaskan, Eastern Canadian, Greenlandic, Icelandic, and Norwegian Arctic are wildly different in their politics, climates, societies, and management. In Antarctica, a single treaty reigns supreme. Even though there are complications surrounding the Antarctic Treaty, Arctic tourism regulations are vastly more complex and less centralized, and records are less certain still. And, by any measure, visitation is nowhere as great in the Arctic as in its southern counterpart.

A shore excursion in Qikiqtarjuaq, on Baffin Island, means a walk through a place that has been home to people for centuries, if not millennia. It means loose dogs crowding the shore, walrus meat curing on a front porch, satellite dishes, and a guide who has stepped out of her everyday life to shepherd you through her town, a role that she might be called upon to inhabit anywhere from zero to four times a year. If you're lucky, it means a cultural demonstration in the community center, kids in town gathering to share throat singing and their prowess in Arctic Games sports. You may have been the only ship that season to visit, and it's clear that you're walking into people's daily lives, that you're perhaps both a welcome change of routine and an intrusion. Perhaps even a germ procession bringing colds and viruses to shore from our floating incubator.

A trip ashore in Svalbard rarely involves a community, and the cultural sense of time there is shorter. Svalbard has never had an indigenous population, unlike most of the rest of the North. "Old" is a Norwegian polar bear hunter's hut from the early 1900s. Your ship has planned its itinerary, shared it with a database used by other ships in the area, coordinated so that you won't overlap, and when you go ashore there are guidelines to follow regarding where you can walk, what you can touch. You are *managed* in a way that feels more park than home.

My window has been narrower than that of many. Let me show some of what I have seen from my narrow window, what I am still learning. Let me map some of my voyages and the routes that led me there.

(*Opposite*) Walrus harvested in Nunavut. Courtesy of Elizabeth Bradfield.

(*Below*) A nesting long-tailed jaeger in Svalbard. Courtesy of Elizabeth Bradfield.

147

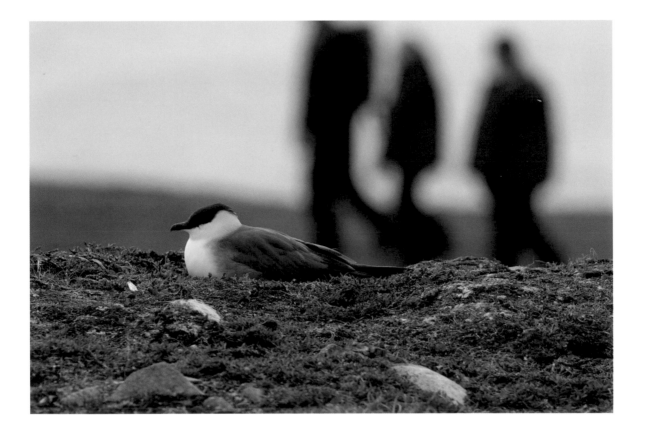

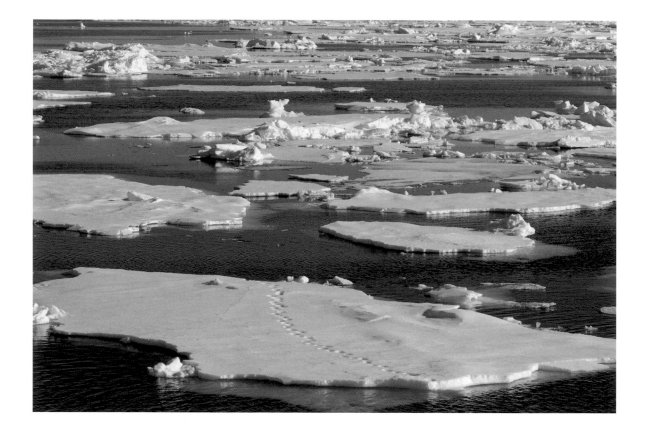

148

Arctic Dreams

"Sitting high on a sea cliff in sunny, blustery weather in late June—the familiar sense of expansiveness, of deep exhilaration such weather brings over one, combined with the opportunity to watch animals, is summed up in a single Eskimo word: *quviannikumut*, 'to feel deeply happy.'"

What possessed me, at twenty-one years old, to underline that passage in my now-ratty copy of Barry Lopez's *Arctic Dreams*? I clearly remember sitting behind the snack bar of the *Sightseer II* with the book on my knees, sneaking paragraphs between orders for Pepsi and hot dogs from customers on a Seattle Harbor Tour trip. I was careful in my underlining, precise. There are marks related to my love of boats, like the specific definition for "civilian twilight" in a footnote

Polar bear tracks across sea ice, Svalbard. Courtesy of Elizabeth Bradfield.

on one page, and new words that thrilled me, such as *subnivean,* which I underlined twice. In pen.

I was a child of the soft, forested Pacific Northwest. My family didn't go to the mountains in winter even though they were only a few hours' drive away, so I knew little of true cold or snow. We looked to the sea, to boats, and some particle in me, perhaps ferrous and responsive to the magnetism of the earth, was pointing north. I knew if I just followed the coast beyond the familiar islands of British Columbia, I'd eventually find shores without highways hemming them, ice that transformed the water into a different mode of travel.

I remember the quality of light on the water that year I was twenty-one: the deep green of Bainbridge Island passing to port, the yellow fug of pollution low to the northern horizon on still days. I don't remember how or why I got a copy of *Arctic Dreams.* Its arrival is a blank on the map. A melted bit of sea ice.

That book has been with me now for nearly twenty-five years. Packed and unpacked as my books moved from my college apartment in Seattle to my parents' garage when I boxed up everything to go work and live on a ship. Port Townsend to Boston to Cape Cod to Alaska and back to Cape Cod. I haven't reread it, but I haven't been willing to let it go. The book connects me to a time when I felt the possibilities of the future acutely, and some part of me knew even then that it was significant. A stone in the river that allowed me to cross to a different shore.

Lopez wrote about his deep exhilaration from a bluff above Lancaster Sound, in Arctic Canada. About 74°N. I've been there, at the top of Baffin Island, looking across to Devon Island. And I've looked south from Devon, too. But I want to explore another time ashore.

Ashore on Baffin

My first shore landing in Arctic Canada was not what anyone had planned: not me, not the expedition leader, not the captain, not the guests. Just days before I had boarded the Russian-crewed *Lyubov Orlova* in Kuujjuaq, a community in Nunavik, the northern part of Quebec.[4] It was mid-August. I was working for Cruise North, a now-defunct expedition company run by the Inuit-owned Makkovik Corporation. We sailed (no sails were employed . . . but it's not very romantic to say we "dieseled," and no one likes to say "cruised," a word that carries a tinge of the hormonal teenage prowl) out of the Koksoak River, then dropped Zodiacs at Monumental Island and Akpatok Island to look for bears and walrus.

The *Orlova* was not a fancy ship. She was old and battered. Faded photographs of the starlet for whom she was named were bolted to the wall in the lounge, which felt slightly brothel-like in its dimness, its red upholstered banquettes.

The general atmosphere, however, was one of delight: here we were. Heading farther north than most of us had ever been. In the land of polar bears and borealis.

All the same, after a couple of days, an antsy thrum pulsed the corridors: When would we go ashore? When? When could we walk in cottongrass and over prostrate willow? When could we touch it—the land, the place, the Arctic? Looking east, a shore landing seemed unlikely. Ice rafted against the coast of Baffin Island, a dull white that rumbled out several miles from shore. Our itinerary said—what did it say? I can't remember, because we didn't get there.

In the night, one of the seamen became ill. His gut. Pain. The ship's doctor, a burly hulk of a man who lined his office ledges with huge containers of protein powder and who had the most delicate hands, feared appendicitis.

Meet one of the difficulties of ship-based tourism in Arctic Canada: medical facilities. Major emergencies were beyond the scope of the *Orlova*'s facilities. And we had a cruise to run, passengers to carry to places they'd paid to visit. The captain and the expedition

149

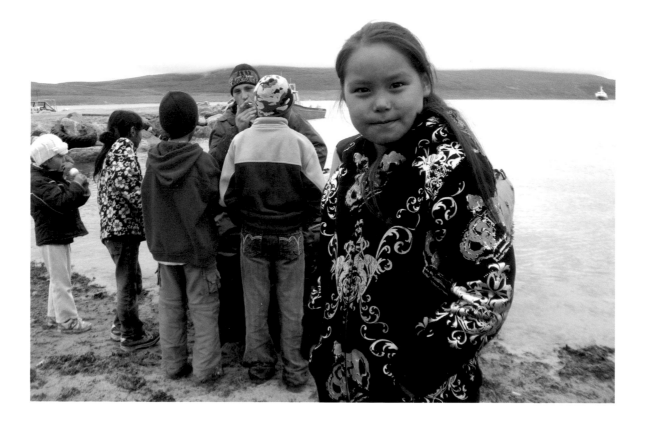

leader conferred: we would put the sailor ashore with a translator in Kanngiqtugaapik (also known as Clyde River), where there was a local health clinic with a nurse and transportation options to a bigger facility should it be necessary. Someone called the mayor to see if we could land. The expedition leader scrambled to arrange something ashore beyond an amble through town.

One of the things I came to love about Arctic Canada is that many communities are not polished for view. Because visitation by ships is so erratic and infrequent, there are no signs to direct visitors, no shops of souvenirs, nothing other than what pleases the community to make for itself.

In Kanngiqtugaapik, the land that looked so inviting from a distance was a bit bleak. We were too close to see the sweeping contours of geology and tundra,

and the harbor was full of the junk of any harbor's daily use: beached boats, oil drums, boxes, sheds, engines under repair, winter gear laid aside for the summer, red plastic gas containers. We set ashore. It was an invasion.

In Nunavut, 95 percent of the population is indigenous.[5] Communities are small. The capital of the territory, Iqaluit, has a population of 6,699, according to the 2011 census. Clyde River has a population of 820, and here we were, 130-some tourists and crew members clogging the streets, piling out of Zodiac after Zodiac in our boots and bulky jackets.

Curtains moved as we passed, and the streets were conspicuously absent of adults. But kids were out and about in force. Some studiously ignored us while others grinned back at our grins and walked with us, curi-

ous. I watched wonderfully kind and comfortable passengers crouch and chat and ask to take pictures that they then showed the kids on the back of the camera, a now-universal conversation opener. The kids giggled, grinned, and wanted to take pictures of their own. Others passengers were less comfortable, and I even saw something like pity on a few faces. Pity for the dirt roads, which are much more sensible in a place where most of the year they're covered by snow; pity for the listing snow machines on tundra, useful again in a few months. And always with pity is a tinge of judgment, superiority. Or maybe it wasn't pity, but deep confusion: how is this to be understood?

Dirt roads, low prefab homes with tanks for water and oil, bikes sprawled around. We saw caribou hides and skulls of polar bears set out to cure. A grinning

(*Opposite*) Landing party at Clyde River. Courtesy of Elizabeth Bradfield.

(*Below*) A home in Nunavut. Courtesy of Elizabeth Bradfield.

151

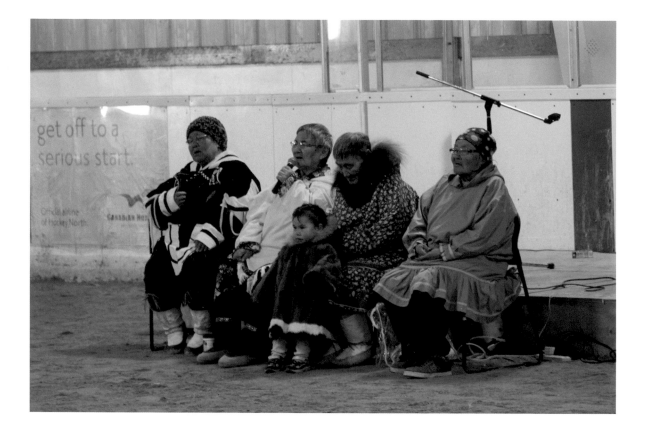

boy who must have been about eight said proudly that one of the skulls was his. His first bear. For those who had come because they feared the world would lose polar bears, perhaps within their lifetime, this was another reality to consider. And I am not outside of this story. I was watching, grappling, trying to merge what I'd learned in books and conversations with this present moment, full of its contradictions and surprising specificities. Trying to be a bridge, acknowledging distances while making them crossable. I resorted to squatting by a ditch and calling people to take a close look at the cottongrass growing there—it was beautiful. Fluffy and bright and uncomplicated. I knew what to say about it.

The deputy mayor, a youngish man with a wide smile who met us wearing baggy jeans and a ball cap,

had been able to muster up enough people to give a cultural demonstration. We gathered in the gymnasium-cum—community center. He welcomed us and described the town's plans for bringing in wind and solar energy as well as a school to, as he put it, "teach Inuit who have forgotten to be Inuit" how to enjoy being out on the land by gaining the skills taught in six-month courses on engine repair, hunting, and harvesting.

Then he passed the microphone to two girls. They faced each other. The younger, who must have been about eight, knelt on a stool to get her mouth at the right height. Both girls wore sneakers, silver glittery headbands, and black hoodies—it wasn't a costume, but they looked like a team. They moved sound between their breath and bodies: throat singing. The sound was high and gruff, breathy and fierce. They

went on, staring at each other, singing, until they broke into laughter, which is how most throat singing I've seen in Nunavut ends. Kids jumped around the edges of the room, climbing on parents and older siblings who were there to watch, too. The girls stepped aside and a group of young men put some hip-hop on a boom box and showed us their dance moves. They had recently won a regional competition. From popping and floor spins to Arctic Games events like the Kneel Jump, One Foot High Kick, and Knuckle Hop, the segue was easy to make.

Some passengers loved the chance to peek behind the curtain of more polished presentations and see how traditions lived in this community. Some were disgruntled at the hip-hop routine. It was not what they'd come to the Arctic to see. But here we were. Kids followed us out into the streets. The expedition leader told us not to give them money or candy.

Our presence was both a boon and a burden. It was a chance to display cultural pride in traditions that are still very much alive. It was like being put on display, exhibited as a curiosity. Interviews conducted by researchers in Pond Inlet (a fairly frequent ship stop) and Cambridge Bay (rarely visited) reveal that residents feel tourism is "beneficial to local carvers," helps "rekindle the craft industry," and through cultural demonstrations gives an opportunity to "keep the traditions of our ancestors alive." They also feel that ships "turn our kids into beggars" and "scare off the meat," meaning the narwhals that are hunted there for subsistence.[6] We felt all this in our visit. We felt all this in most communities we visited and left.

Antarctic of the North: Svalbard

My first trip to Svalbard, the archipelago of islands five hundred miles north of Norway, came after I'd worked a few seasons in Nunavut. How do I convey the dif-

153

(*Opposite*) In the community center of Gjoahaven, Nunavut. Courtesy of Elizabeth Bradfield.

(*Above*) The endemic Svalbard poppy. Courtesy of Elizabeth Bradfield.

ference? Start with Svalbard's history: no indigenous population, first discovered (most likely) in 1597 by Dutch explorers whose reports almost immediately kicked off a rush of commercial whaling that nearly wiped out bowhead whales in the area, a small year-round population and pulses of tourism in both winter and summer, the public infrastructure and wealth of Scandinavia.

In a town on Baffin Island, the co-op (which is the general store) has everything—groceries, socks, frying pans, fishing gear. In a back room, there are often some carvings, sealskin mittens, and other locally made goods. Things for daily living and a few things for tourists. In Longyearbyen, the main community of Svalbard, there are cafés, galleries, and specialty stores. The gear shops are shiny, designed as if in any urban mainland center, and packed with expensive backpacks and jackets and pants. The grocery store has whole aisles of branded shot glasses, tea towels, and hats. In Nunavut, some communities have museums and cultural centers designed for outsiders, but most don't. In Longyearbyen, there are a few museums, and the exhibits are beautiful and the experience rich—a lot of money and time was spent on design, construction, and upkeep. It's the display of a community that knows that tourism is its backbone.

Svalbard is part of the Kingdom of Norway, but it is run by a governor and seems in many ways a land apart. I worked on one ship with a Polish woman who had lived in Longyearbyen for several years; she explained that the Svalbard Treaty gives most people free access to and residence in Svalbard, no visas or work permits required. Svalbard reminds me of Antarctica, where the Antarctic Treaty governs a vast realm with the baseline understanding that it is a place apart, a place not for extraction and political manipulation but "for the good of all." It's more park than country or home.

There are benefits to being a park. Parks protect places of great beauty or diversity, and the wildlife

and scenery of Svalbard are stunning. Parks are managed. Like in Antarctica, expedition travel in Svalbard is regulated and organized. In addition to being under the jurisdiction of the *sysselmann*, or governor, of Svalbard, most expedition ships in Svalbard are members of AECO, the Association of Arctic Expedition Cruise Operators, founded in 2003. Ostensibly, AECO's reach extends to all places north of 60° latitude, but on the ground its presence is felt much more in Svalbard than in Arctic Canada.

I remember going ashore in Ny-Ålesund, a community established because of its coal deposits, a jump-off point for famed explorers such as Roald Amundsen, and now a year-round research station and fairly frequent ship stop. An old train from the coal era sits on a bluff there, silhouetted against the peaks on the other shore, going nowhere but perched as if aware of its quaintness. It *is* quaint. I took a picture, knowing that my nephew would love this northern cousin of Thomas the Train. Arctic terns nest in the hollows between the old rail ties. Even the industrial history of Svalbard is shaped and presented as a point of interest. The *Cruise Handbook for Svalbard* describes "numerous cultural remains of technical and industrial importance" in Ny-Ålesund.[7]

On the shore opposite Ny-Ålesund, we wandered up along a mossy slope, trying to politely forbid guests from walking across its tempting green, knowing eyes from across Kongsfjorden could be on us. As in Antarctica, ships in Svalbard follow site guidelines that direct visitors to avoid tender moss beds and historic buildings. Companies submit their itineraries to a central database, and landings are coordinated so that they are spread out. Impact is monitored. Rangers keep an eye out to make sure that ships are following wildlife-viewing guidelines. Despite a slight hiss of "Disney" to such behind-the-scenes management, these orchestrations protect the land, the animals, and also the experiences of people traveling to Svalbard. And the

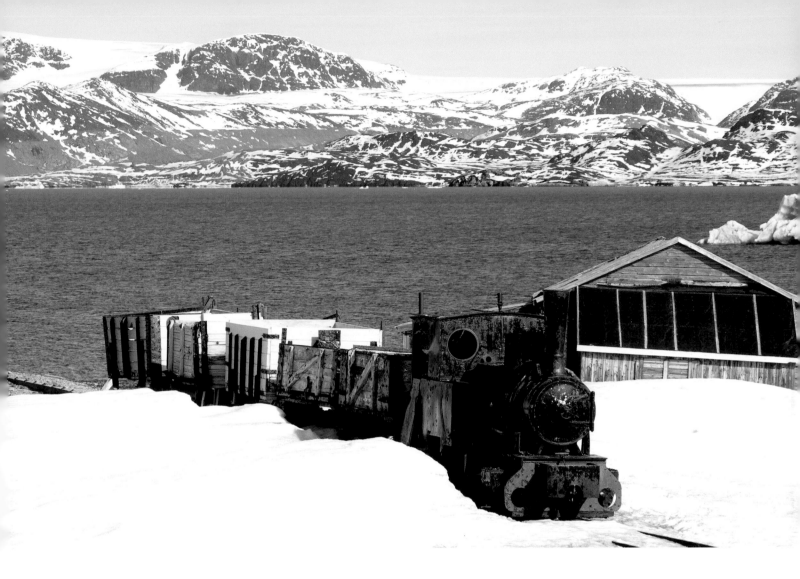

The train in Ny-Ålesund.
Courtesy of Elizabeth Bradfield.

best-laid plans still go awry: landings are canceled due to high winds, fog, or polar bears on shore.

What is wild? What is an expedition? And what is better for visitors, to see the infrastructure that protects and provides for their experience, or to keep all that hidden and allow them to feel, for a bit, that they are part of a world apart? What will better inspire them toward deeper conservation and awareness when they return? I don't have answers to these questions. I waffle.

156

(*Above*) Jason Annahatak, who began working on ships as a trainee and became an expedition leader, with the author. Courtesy of Marie-Josee Desbartes.

(*Opposite*) Walrus haul-out in Svalbard. Courtesy of Elizabeth Bradfield.

Ways of Seeing

On board the *Orlova* were a half-dozen Inuit "trainees," young men and women from communities in Nunavut and Nunatsiavut (plus a few outliers who grew up in Montreal or Toronto) hired into an ersatz apprenticeship. They learned about the expedition travel trade as they worked as boat drivers, bear guards, assistants to the hotel manager. Really, though, we learned from each other. We studied each other.

They watched me talk about the ecological adaptations of tundra plants and the circumpolar distribution of various species. I asked them whether they harvested bistort seeds, and how. We both were there to help passengers experience this place. It was tricky, though, to navigate toward respect and camaraderie, and to avoid what Seth Kantner in *Ordinary Wolves* calls "Native worship." To them, I know that we southern naturalists, American and Canadian alike, seemed over-talkative, over-solicitous, jumping in with words for plants and geological formations sometimes before questions were even asked, pointing at things and naming them aloud rather than studying them and allowing attention to follow. To passengers, the less forthcoming nature of the trainees could seem standoffish, shy, or even rude.

I remember one day when the cultural difference clarified in a way that caught me completely off guard, and that I have thought of often since: we were loading passengers into Zodiacs in rough seas, a big swell bobbing the little rubber boats alongside the ship's gangway. A gap would open, and the step from ship to boat would be dangerous if ill-timed. I was driving, throttling my Zodiac in place at the gangway, and K. was helping people make that step. I didn't think he was being careful enough. He looked casual in his attention, almost neglectful, not braced and outstretched, not springing at the first sign of hesitation.

Later, we talked about it. I said that on the ship he needed to be more obviously attentive, to show the passengers that he was caring for them. He explained that, for him, it would be a sign of disrespect to assume his elders (and all of the guests were his elders) could not take care of themselves. So, how to bridge that gap? Which way to step across the divide in this situation? Could the passengers, who came here to learn about the culture, have access to this private moment between us without it feeling exploitative? We sat in the Zodiac and laughed at each other.

I remember how M. loved to teach throat singing, even to men, who traditionally do not sing. How E. demonstrated her skill at the One Foot High Kick with triumph and challenge. How S. hated to give presentations on Inuit culture but was so very good at it, even nervously hesitating her way through the PowerPoint presentation we'd fine-tuned together. I remember D.'s sharp eyes. He could spot anything.

One day, he spotted a herd of walrus in the water. Walrus. We all wanted to see them, so the ship slowed and we dropped Zodiacs and loaded them up with passengers. I was driving near D. His glee was palpable. He was *hunting*, and there was a difference between his pursuit and mine: a casualness, a different set of concerns. He didn't think about the stress to the animals that our approach created, because when he was hunting he wouldn't think that way. These were game animals, not Arctic icons to be approached worshipfully. The walrus swam along, hefting their heads up out of the water, goggling us with red bulging eyes, snorting. At first it was thrilling to see them respond,

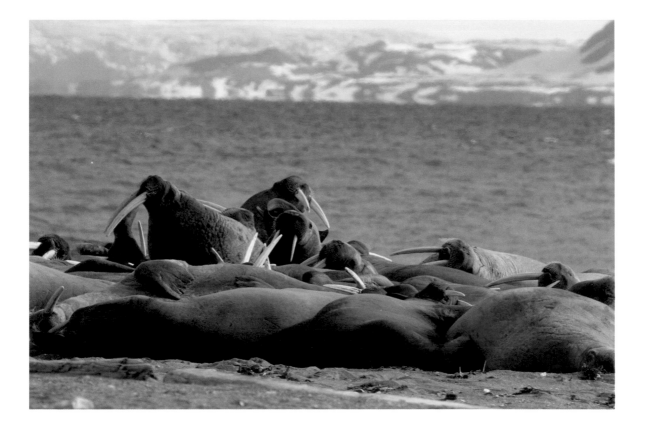

to chase, and then a sour feeling crept into our pursuit. If we had been hunting, that would be one thing, but we were indulging ourselves and our curiosity and we set that desire above the welfare of the animals for a while, pushing the boundaries further than we should have until something caught all of us out there in Zodiacs: shame, awareness, empathy—I'm not sure what to name the muddle that gathered. We watched them round a point and headed back to the ship.

Expedition cruising can engender a sense of superiority; because the ship is small, because education is a part of the focus, because itineraries are subject to ice distribution and landings to tide or fog or the presence of bears, it feels more principled and perhaps genuine than travel on a big ship. But we leave our footprints on shores that the bigger ships just cruise by. We burn our trash and fuel just as they do—more of it than land-based travelers, who contribute to an on-the-ground economy of the places where they eat, sleep, and explore. And there is always pressure when bringing people to a place: you want to show them the best of it. The most amazing, closest, wildest encounter with a fox/bear/whale/fossil. People on expedition cruises have paid, after all, a lot of money to be told what to do and where to step.

The job of everyone on the ship is dependent upon their satisfaction, their continued desire for the type of travel small ships offer. Sometimes, I relish the moment when, after standing for hours on deck with binoculars, someone walks up and asks me what I've seen. Sometimes I answer, "Nothing!" with great and perhaps perverse cheer. Other times I'll answer, "Fulmars, razorbills, and water," or "fog," knowing they want to hear about whales or bears or other charismatic megafauna.

But I *would* like to be the one who spots a polar bear on a shore or ice floe, who finds something that the ship can nudge toward. The reality is that there is a lot of water out there. A lot of shore. And only through time and attention can that scale truly make itself felt. *Not finding something has come to feel as important to me as finding it. It allows vastness, a sense of how precious the encounters are that we come upon.

Although wildlife in the North is "patchy" in its distribution, in some places amazing encounters with wildlife can be almost guaranteed. Seabird colonies, for example, or walrus haul-outs. Places where animals regularly congregate and where people can see them. These islands of plenty are phenomenal. We gawk, naturalists and passengers alike. We are unified in our wonder. At these times, when we are quiet and watching and experiencing the lives of these creatures carrying on around us, when they are unconcerned with our presence, when we get it right, I feel that perhaps I've helped people to connect with the place and, beyond that, to care for it. Maybe they will hold that spark of connection and carry it into their lives back home. Maybe they'll take one step further in their care, attention, and stewardship.

Or not. Even wonder can get boring for some people. Wildlife in the wild, after all, is not edited. The months that filmmakers spend to get thirty seconds of dramatic footage become apparent, as does the odd proximity that zoos afford. "Can't we wake it up?" the rumbling begins. "Make it do something? Can't we get closer?" One survey of Arctic ship travelers revealed that, of those who did not feel the trip met their expectations, "25% were disappointed with the amount of wildlife seen (specifically polar bears, whales and narwhales)."[8] If an honest conversation can follow such reactions, the cost of fuel and emissions and noise and presence seems a little bit more worth it. If not, then are we just helping people "collect" places as another item that can confer status? And what is my responsibility as a participant in one of our many flawed systems with great potential?

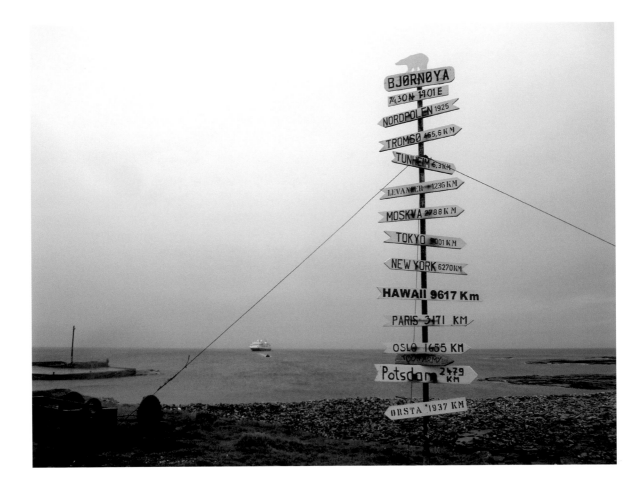

Alone at Last

For Barry Lopez, me, and the passengers, the gift of the Arctic is space and solitude. The vista is wide, treeless. Often, no structures are visible on shore, no other boats on the water. Not many contrails cross the sky once you get far enough north. Ships with spotty satellite Internet connections, cell phones out of service. The Arctic is the opposite of the urbanized daily life visitors have left, perhaps even its antidote. Yet to travel in a place that is fragile—to travel to a place *because* it is imperiled—is an act fraught with paradox.

Bear Island, Svalbard, with a sign showing distances to various cities. Courtesy of Elizabeth Bradfield.

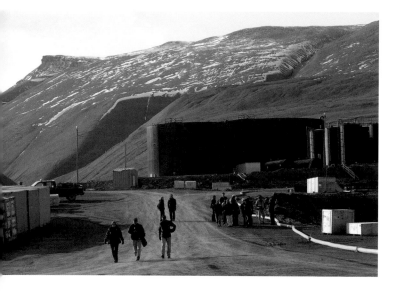

160

(*Above*) Refueling at the commercial port, Baffin Island. Courtesy of Elizabeth Bradfield.

(*Opposite*) A shipwreck on Beechy Island, the last known site of Sir John Franklin's crew. Courtesy of Elizabeth Bradfield.

The poet Denise Levertov once said, "Accuracy is the gateway to mystery." And the facts underpinning our observations of the Arctic, of course, grow more complicated the more deeply we look. Consider Bjørnøya, or Bear Island, a small outpost in the Barents Sea. Only a handful of people running a meteorological station live there, and few ships stop to visit their side of the island. Bear Island supports tens of thousands of breeding northern fulmars, black-legged kittiwakes, little auks (or dovekies), common guillemots (or murres), thick-billed guillemots (or murres); hundreds of breeding Atlantic puffins and black guillemots; as well as other migratory birds. Walking the tundra or puttering along the bird cliffs in a Zodiac, it feels utterly wild. Untouched, even. However, high concentrations of PCBs have been found in Arctic char sampled from Lake Ellasjøen. Although it is more than five hundred kilometers from any known point source for organic toxins, Bear Island, like other Arctic places, receives fallout from airborne pollutants.

Here, the naturalist faces another dilemma: what is the proper balance of wonderment and reality check? It is important to revel in wildness, to connect with and viscerally sense the value of places beyond real estate or extraction. And it is important for visitors to consider how their daily lives in lower latitudes affect this remote place.

But does it work? Does my work in the ecotourism industry trigger these connections? Does it make a difference? A 2010 survey showed that a trip to the Arctic did leave travelers with a sense of climate change and inspired 71 percent of them to make changes to their lifestyles because of those observations.[9] I cling to statistics like this.

One thing is true: ships mean infrastructure. In Longyearbyen, the port is centralized and organized. Logistics such as refueling and resupplying produce are fairly easy. Elsewhere, though, it's less seamless.

I remember a day spent in Nanisivik, on the north end of Baffin Island. It was an ugly stop, no doubt about it—industrial and without much in the way of wildlife—but we needed fuel, and Nanisivik is one of the few deepwater ports in Nunavut. We made the best of it and hiked up the gravel road and onto a river bar where dwarf fireweed was splaying out its feathery seeds, waiting for wind to spread them. We turned our backs to the rusting fuel tanks and bent to examine the tracks of Arctic fox in fine silt.

as making movies himself. I have become Facebook friends with people living in Pond Inlet. He made recordings of throat singing, as have I. He brought boys north to give them a floating education. No doubt he told the same stories about cottongrass that I do. I am critical of Mac, as he was known, and I recognize some of myself in him.

Capillary Action

There is more to say about animals, people, waterways, and lands, and there are no tidy endings. So I want to end the way I began: with longing.

To explore my own fascination with the North, I have been tracking another southerner who traveled north: Donald B. MacMillan. Living in south-central Alaska and working in the Arctic made the Arctic concrete, not just a destination belonging to others. More familiar, and also more complex. It was no longer distance and discovery that moved me, but the concept of a storied land. I wanted to write into the high latitudes differently, with a sense of the complex dynamic between people, history, and wildness.

The idea began to develop of investigating place through a conversation between myself and MacMillan, the Arctic and Cape Cod (where he was born and where I now live), his time and mine, and all the awarenesses that radiate from those points. It would be an intimate dance, a wrestling match of cultures, a frustrated love song. Donald B. MacMillan made thirty voyages to the High Arctic, while I have not yet made ten. He traveled north during a time of great technological change, similar, in a way, to our own. He was the first to bring color film and motion pictures to the north, showing movies from the deck of his schooner as well

CAPILLARY ACTION
—for Arctic explorer Donald B. MacMillan

A straw, a string lowered
into surface
tension
and the liquid climbs as far as it can.

Consider our ring of latitude, Mac,
(your Gulf of Maine, my Puget Sound)
as water settled to its level
in the globe's great bowl.

The coasts are a thread
pinched above us at the pole.
We can't help being drawn.

Tears are pulled this way,
ducts glazing the eye.
O Lacrymosa,

said Mozart, giving in.
Sentiment, passion, biological lube—
all equip us to squint north.

162

Notes

1 Adrianne Johnston, Margaret Johnston, Emma Stewart, Jackie Dawson, and Harvey Lemelin, "Perspectives of Decision Makers and Regulators on Climate Change and Adaptation in Expedition Cruise Ship Tourism in Nunavut," *The Northern Review* 35 (Spring 2012): 71, http://journals.sfu.ca/nr/index.php/nr/article/view/239, accessed February 15, 2016.

2 Numbers taken from Pat T. Maher, "Expedition Cruise Visits to Protected Areas in the Canadian Arctic: Issues of Sustainability and Change for an Emerging Market," *Tourism Review* 60, no. 1 (2012): 55-70.

3 GRID-Arendal, "Tourism in the Polar Regions," 2014, http://www.grida.no/publications/tourism-polar/, accessed February 27, 2015.

4 Nunavik is the northern region of the province of Quebec. Although not currently independent, it is on its way toward an autonomy similar to that of Nunavut or Nunatsiavut.

5 Nunavut is a Canadian territory established in 1999, the lands of which were formerly part of the Northwest Territories. It comprises much of northeastern Canada, including Baffin Island.

6 E. J. Stewart, J. Dawson, and D. Draper, "Cruise Tourism and Residents in Arctic Canada: Development of a Resident Attitude Typology," *Journal of Hospitality and Tourism Management* 18 (2011): 95–106, doi: 10.1375/jhtm.18.1.95.

7 Norwegian Polar Institute, *Cruise Handbook for Svalbard*, http://cruise-handbook.npolar.no/en/kongsfjorden/ny-alesund.html, accessed February 27, 2015.

8 Pat T. Maher, "Expedition Cruise Visits to Protected Areas in the Canadian Arctic: Issues of Sustainability and Change for an Emerging Market," *Tourism* 60, no. 1 (2012): 64.

9 Ibid., 65.

Musician Jonathan J. Bower and
his son Sam. Anchorage, Alaska,
2012. Courtesy of Brian Adams.

SUMMIT

Robert Macfarlane

A snowy owl taking flight from the quartz and granulite summit of Ben Hope, set on a meridian course north, would bank out over the Pentland Firth, pass to the east of the Faeroes, cross the Arctic Circle, and enter the Greenland Sea. It would fly above the pack ice that locks the channel between Spitsbergen and Greenland. It would pass, as all things meridian must, over the Pole. From there, without changing direction, it would fly south past the ice-bound island of Vrangelya in the Chukotse Sea. Only after many hours would it reach ground as high as Hope again: a nameless peak in the mountains of north-western Siberia, where the temperature is so cold that steel splits and larch trees shower sparks at the touch of an axe. As I drove east to the mountain from Kinlochbervie, I imagined Ben Hope and this nameless peak rhyming in their altitude, across thousands of miles of cold space, each northering towards the other.

I had been told that if you climb Ben Hope on the summer solstice, and spend a clear night on its summit, you will never lose sight of the sun. The combination of elevation and northerliness means that the uppermost rim of the sun never dips fully below the horizon. A truly white night. In the autumn, too, it was said to be a fine place for watching the aurora borealis, which shimmered like aerial phosphorescence, green and red. But I was most drawn to Hope in its winter

moods. For several years I had wanted to climb it when snow was on the ground, and spend a cold night on its summit: the sense of polar space opening out beyond me, the scents of berg and frazil washing down off the invisible Arctic Ocean.

Hope is a mountain which holds the solstitial opposites of north: it knows both the affirmation of the never-vanishing sun and the indifference of the eighteen-hour night. There could be, I thought, no other place in Britain or Ireland where you could better feel a sense of "bigness outside yourself," in Stegner's phrase. That "bigness" had been there on Rannoch Moor and at Sandwood, and I had felt a chronic version of it in Coruisk. But I wondered if, once I began to move south, it would fall away, become unlocatable.

I drove through sleet, then sunshine, then squalls, with raindrops the size of berries pelting on to the windscreen. No weather system remained dominant for more than an hour. By early afternoon I was at Hope's south-western foot. Clouds bearing cargoes of snow pushed past to the north-east. Snow was falling lightly over Foinaven, to the west across moor. The sky above me was clear, a pale winter white. I looked up at Hope, remembering its shape from the maps I had studied.

The geography of Hope is exquisite: a steep summit cone, shapely and symmetrical when seen from

Thompson Pass, Alaska, 2007.
Courtesy of Brian Adams.

the sea. A sharp curving north ridge, on which per-egrines nest, forms a glacis protecting the mountain's northern approach, and keeps secret the watery land on Hope's eastern flank—a region of fourteen lost lochs and lochans. To the south, the mountain's long plateau-ridge, the Leitir Mhuiseil, streams out, taper-ing for three miles, trimmed on its western flank with a band of silver-grey schist and flashed here and there with quartz.

I started up Hope as the day's light began to dim, feeling excited, almost jaunty, to be out there alone. Following a stream-cut, I passed big boulders worked by the water into curious shapes. As I climbed, the view over the surrounding landscape opened. Hundreds of empty miles of watery land radiating out in each direc-tion, big peaks here and there—Klibreck, Loyal, hold-ing snow in their eastern corries—and Loch Hope lead-ing the eye north, past the mountain's cliff ramparts, and out to the spaciousness of the Firth.

Reaching the upper brink of the Leitir Mhuiseil, I saw three deer standing watchfully on the ridge's rim. They observed my approach, then turned in synchrony and rode their long legs off and out of sight. I sat by a stream, and drank handfuls of cold water. Westwards, the late sun was breaking through the cloud cover here and there, so that the day's light fanned slowly upon the moors. I could see white bows of blown snow, strung by sharp straight rays of sunshine, and I counted four separate storms spaced across the earth. To the east, though, night was coming: the edges of that world were in a cooling blue of shadow and dusk and chill.

Hope did not give itself up easily. The ascent was nearly from sea-level, and the huge summit cone, crag-bound, was steadily steep. By the time I reached the top, the air around me was dark and gritty, and the wind colder. The summit was bare, stripped by gales

and frost-weathering. Rime ice had formed in feath-ery windrows on shattered grey rocks, which were also marked with lichens the colour of lime and tangerine. Between the rocks, snow lay in stripes and furrows, dry and granular as sand. Working quickly, with numb-ing hands, and a growing sense of worry—was this too cold a place, too hard a place, to spend the night?—I moved rocks to clear a lozenge-shaped space of rough flatness, and arranged them into a low curving wall, a foot or so high.

That night the winds began a slow swing from west to north, bringing snow showers scattering against the canvas of my bivouac bag, and raking the sum-mit rocks with hail. A moon was up there somewhere, breaking through the cloud cover. It was far too cold to sleep. I lay like a compass needle, head to the north, on my front, looking towards the sea, watching patches of silver open and close over the distant waters, trying to keep warm.

At two o'clock, still sleepless, I left the shelter, crossed back to the main top, and began to pace out the reach of the mountain's curving summit plateau. The cloud cover had thinned. Moonlight came and went in squalls. Each rock wore a carapace of ice, which cracked and skittered off in shards at the slight-est contact. Little hail drifts had built up in the lee of the rocks; otherwise the wind had stripped away all the unfrozen snow. The air smelt bright.

I walked out to where the mountain's eastern ridge began, and from there looked down into the lost lochs, which were holding moonlight like snow. Moving across to the south-western tip of the plateau, I sensed more than saw the massive complex of Foinaven miles away, its snow-shires flashing silver, the rest of its black bulk invisible in the dark. The cold was pressing, constant, and I began to shiver; not a surface tremble, but a deep convulsive shaking. In that deep winter darkness, my

167

sunny East Anglian beechwood felt suddenly hugely distant, the landscape of another continent or era, not just another country.

This was one of the least accommodating places to which I had ever come. The sea, the stone, the night and the weather all pursued their processes and kept their habits, as they had done for millennia, and would do for millennia to follow. The fall of moonlight on to water, the lateral motion of blown snow through air, these were of the place's making only. This was a terrain that had been thrown up by fire and survived ice. There was nothing, save the wall of rocks I had made and the summit cairn, to suggest history. Nothing human. I turned east and south, straining to see if there was any flicker of light in the hundreds of miles of darkness around me. Even a glimpse of something lit, however distant and unreachable, would have been reassurance of a sort. Nothing. No glimmer.

There could have been nowhere that conformed more purely to the vision of wildness with which I had begun my journeys. I had been drawn here by a spatial logic, a desire to reach this coincident point of high altitude and high latitude. But now I could not wait to leave it. It was an amplified version of the discomfort I had unexpectedly felt at the Inaccessible Pinnacle in Coruisk.

If I could have safely descended from the summit of Hope in the darkness, I would have done so. The comfortless snow-shires, the frozen rocks: this place was not hostile to my presence, far from it. Just entirely, gradelessly indifferent. Up there, I felt no companionship with the land, no epiphany of relation like that I had experienced in the Black Wood. Here, there was no question of relation. This place refused any imputation of meaning.

All travellers to wild places will have felt some version of this, a brief blazing perception of the world's disinterest. In small measures it exhilarates. But in full form it annihilates. Nan Shepherd found this out on the Cairngorm plateau, another bare, stripped, Arctic zone. "Like all profound mysteries, it is so simple that it frightens me," she had written of the water that rises on the plateau. "The water wells from the rock, and flows away. For unnumbered years it has welled from the rock, and flowed away. It does nothing, absolutely nothing, but be itself. One cannot know the rivers till one has seen them at their sources; but this journey is not to be undertaken lightly. One walks among elementals, and elementals are not governable."

Musicians speak of the "reverberation time" of a note or chord: the time it takes that sound to diminish by a certain number of decibels. The reverberation time of that black and silver night on Hope would be endless for me. Standing there, I knew that the memory of it might fade but it would never entirely disappear. I wondered if there would be any such places south of there, or if this was to be in some way the end of my journeys.

At some point, the winds dropped, and the temperature rose by a degree or two. I returned to the shallow stone shelter and was able at last to sleep, for perhaps two hours, little more, longing for dawn and escape from the summit. When I woke at first light, cold to the core, the air was windless. My rucksack was frozen, the canvas rigid and pale as though it had been fired in a kiln. I found and kept a fragment of quartz granulite, irregular in its shape: sharp-edged, frost-shattered. Then I set off down the mountain, and it seemed as I did so that descent in any direction from that summit would be a voyage south.

60 minutes, Dettifoss, 2011.
Courtesy of Olaf Otto Becker.

Goose Lake.
Anchorage, Alaska, 2011.
Courtesy of Brian Adams.

THIS IS THE NORTH I KNOW

Julie Decker

A personality persists in this rugged land, with its incongruous desert plains, temperate forests, and coastline that runs and runs and runs. From outside, the personality is blank, muted, quiet, cold—a whisper against a southern drawl. But from here we are charmed by the breaks in character, the surprises that come from the ironies in the whispers and the shouts of Nature, cast against the strains of man, piling futile infrastructure in a place too large to house it.

The North I know is not the white nothingness, nor the black of oil. It is the charcoal grays of walks along the beach in rubber boots, of the silt that prevents a solid switch from land to ocean, and the crust of gravel and dust on the streets and trails. It is the tongue-tied twists of trees that defy the permafrost, the two roads that snake from here to there as if it were possible to get from here to there, and the harsh sun on the horizon that makes sunglasses absurd.

I've grown up to the versus—man versus nature, development versus environment, rural versus urban, but they never had much song. The score was always the tones in between; the place I knew was both ugly and beautiful, the people torn between resistance and desire.

When I was young, our urban yard was a dance of chickweed and daisies. Voles ate holes in our toys. A moose walked away with our swing set when it tangled in his branches. The residential roads were as dirty as our cars. Prostitutes roamed two of the four main streets, defining the thoroughfare between bars named after frontier ideals. *The Tonight Show* arrived a week late, the political jokes slightly stale. But it beat the arrival time for the fruit and vegetables at the supermarket. It was its own kind of savvy.

We grew up proud of our otherness and constantly trying to prove we were every bit as mainstream. We wore *Flashdance* legwarmers over our moonboots. We laughed at the North unless we went South, where we'd brag about the glories of the edge.

This edge is Alaska, the state that makes the United States an Arctic nation. Our otherness is in the personality of this place—that embrace of the stain of man against the lustrous backdrop of aurora skies and landscapes punctured with towering mountains, carved raw with rivers and pocked with pingos. Our personality comes from centuries of adaptation—from chosen and forced ingenuity, technology born of necessity; it's to survive or depart. We are both ubiquitous and nowhere; we are everywhere and distinctly not. Coping is what bonds and binds us—community is born from shared experiences. The experiences here are not so luxurious—did you make it or did you not; have you migrated south or learned the slow burn of managing to get by? But in sharing the cold we remain loyal to each other—loan the chains, tug the cars, share the food and the tips and the adaptations. We share the smirk

Abandoned hotel near Fairbanks, Alaska.
Courtesy of Julie Decker.

Bear Cove, Alaska.
Courtesy of Julie Decker.

of having survived where others threw in the towelette.

We argue here of whether we are more a Cinderella state, or an empowered Northern nation, or a teeming gateway to the Pacific Rim. We declare status as both a byway and a destination. We laugh at the stories of happenstance—the declarations that it was Alaska or bust, and then the boom came. Or the declaration of Alaska as a temporary state, tried on for the bragging rights of exoticism or candor; the intangible rewards that come from living so close to environmental extreme. For it was cold here once.

The cold is more temperamental now; it teases us. In its age its ice has thinned and calved. It has quit fighting us in some places, relaxed into the apocalyptic sun of the ozone. It shrugs at us. It brings less wind and snow. The weather has drifted elsewhere, lazy now perhaps. It wreaks havoc elsewhere instead, where they have only heard of the Arctic but do not wish to go there. It is in these other more southern places that the cold storms and dumps snow in cataclysmic batches, getting the labor over with quickly, rather than bringing it in the planned stages of its younger years, when the cold was youthful and sprite. The cold had muscles then. It exercised relentlessly. It was strong enough to hold villages and predator mammals of its namesake white.

The cold prompts a presence. It's difficult to be distracted when it is cold and icy and when the challenge of transportation is not the timetable, nor the tracks. The cold is shared. Shelter shields, but not forever. To thrive we have to get from here to there and back again. Northerners don't take this for granted. Our roads end where the population spreads. Airplanes usurped the roads, laughed at the ground. Distance is relative. It's a long day's drive between Alaska's two largest cities, with the highest peak in North America thrown in between. Its arrogance is welcomed, along a flat path otherwise interrupted only by coal and the railroad. We share the road—travelers north and south, residents and tourists. Like we share the cold. We are not rich in choices.

Our riches come from the land and we argue over ownership and use. We argue about what's over and under the land. We treasure it, guzzle it, laud it, protect it, count it, divvy it up, and ask for it back. We have a lot of land and a lot of riches. It's what the North shares.

People come to the North from all places south. Ecotourists now, in addition to the trip-of-a-lifetimers. Motorcoaches and ships, cruises and charters. There are mountains to postcard, animals to pull alongside, culture to replicate, and places to fish. Hip boots replace fruit at the supermarket. The rivers' edges become hooked and bloodstained. Brown bears patrol for the easy shavings of mania. We are seasonal, though spring and fall are shortened for efficiency. This is a land of abundance, except for people. We cluster and then disperse.

Land is silent unless you put your ear to the ground. Wind is harsh unless you use it to smell. Sun is glaring unless it's the first sign of spring or the hint of cold. The land is untouched unless you've touched it. People are passive unless you listen. This is not a place untouched. Man has walked this place long before I touched it. I feel ownership but don't own it. People were not discovered, only places and only then to its foreigners.

The North is now burdened with self-awareness. The "outside" is looking in. We are connected, at the center. We are up here but we are everywhere. What happens here no longer stays here; people talk about it. We are fierce and fiercely proud; we invite attention but blister at it. The BBC is in Barrow filming subsistence whalers; cultures have collided. Artists are in western Alaska watching the coastline. Scientists drill for core samples and change is measured. Sarah Palin shouts "Drill, Baby, Drill" until it's shrill.

Subsistence is more than a belief. Success in this environment has always meant understanding the give

and take with the environment. Respect is hard fought. Survival is not a notion. Failure is tangible. You use the best tools available if you adapt—even if that means guns and snow machines.

The North is one place and many places at the same time. Circle the Arctic Circle from Anchorage to Reykjavik or Helsinki, or traverse from Arctic Alaska to Siberia or Svalbard, and it's familiar—the angle of the sun and the weight of the air. The sky is the same umbrella, the people have the same sense. The farther north you go, the more the buildings are utilitarian and design is a trickle.

It's not difficult to see what the artist sees. For a time, a century and more ago, the idea of landscape was shipped east and south as those explorers who portrayed it went farther west and north. Romanticism was sought. Landscape became a subject for commodity. Now the stories of the North are nostalgic for the romantics, replaced by urgency, fear, calls of calamity. Today, the perspective of the landscape is told in film and into microphones. The North is a television star. Reality bites.

The landscape is evidence. It beckons science and research. Study me, it says. Mark my time. Glaciers recede, tundra buckles, permafrost puddles, the edges of the cragged coast disappear. Life in and around and under the sea ice is underestimated; it is not just frozen plates. It does not symbolize an absence of life; it is abounding with it. It has long been how life thrives. Beyond the polar bear.

I once took a cruise ship back home rather than away from it, hitching a ride on the deck of a state ferry, sleeping bag on the deck with nomads looking for a cheap ride north that was faster than the Alcan Highway. I remember porpoise chasing the boat as I stared over the side. I dropped my Raggedy Ann doll into the ocean. My dad told me the porpoise would play with it. It was their toy. The ocean was hopeful then. Today it is plastic. Core sea ice samples are dotted with flakes

of the man-made; the landscape is what is consumed. Now I see advertisements for cruise ships to Longyearbyen and Barrow. Take a number to view the geysers in Iceland; book a stay at the Canadian hotel on wheels for polar bear viewing. Northerners nod at one another in recognition. This is not our frenzy.

This is no longer the story of the reindeer. It is our story. The early warning system of the villages has sounded. Our musk oxen are trinket mittens, and scarves and narwhals are on t-shirts. But we know their myths. We do not want to be the land of the lost. We are not a dead or dying culture. It's beautiful here.

This is my borrowed land, but it has consumed me. In my story, I feature it as the hero. The North changes you. The cold defines, seeps in. A personality forms not from one but from many. It's a shared story, more poignant when it's familiar. It's the insider who stands in the cold, clad in REI jacket with a coffee cup in hand, taking a photo or two on the iPhone. The post of the landscape on Facebook is for relatives, not for friends on the inside. We know the intimacy of synthetic hand warmers stuffed in multiples into mittens and socks. We remember when it was too cold for kids to cry and too cold for small talk. My childhood recounts a carnival in the pitch-dark, pitch-perfect cold of February, dewy cotton candy sticking to chapped lip, clutched tightly with a mittened hand, fingers curled far inside.

Men in furs are the fashion of stereotypes. The Iditarod is not what makes this the land of endurance. The authentic is composed of idiot strings and honey buckets. It is pristine here, but it is also torn by alcohol, disease, and abuse.

There are sounds of the North, like the quiet of the snow. As a child I knew acutely the sound of the blades of a runner sled my father pulled, the feel of my mitten as it dragged into the snow mixed with dust on the road, and the patterns—little diamonds and parallelograms—that were drawn from snow that fell back to the road off studded snow tires that had passed

175

176

Footprints in snow.
Anchorage, Alaska.
Courtesy of Julie Decker.

Ghost.
Anchorage, Alaska.
Courtesy of Julie Decker.

by—Firestone and Goodyear snowflakes. Our husky, Nooka, trotted alongside, white fur against white. I remember when she was stolen to provide practice for dogfights. It's the nature of the insider to protect the story, to be the one to tell it. We claim the protected right to comment upon the ridiculous qualities of our place and its people. We tout the need to earn the right to call it home. To be part of the inside means knowing the charm and the blatancy of the Birdhouse and Skinny Dicks. You have to remember when there were no breweries and pizza joints. You have to know the buzz and the lull.

We reject the "Outside" for our individualism, but offer no explanation for the line outside Olive Garden or the giddy teasers of Krispy Kreme and Whole Foods. We gear up at Cabella's. We think we make the brand and allow others to borrow it. We self-identify as Levi's—tough enough to know what's fun. Don't just try this place on for size: these are jeans of a lifetime. Today, the adventure of the North is captured by Go-Pros and webcams.

We are not victims of the future; we are participants in it. The visual cues of environmental change are no longer mysterious. It is hyperreal up here. We are alert, with eyes open and ears listening. Up here we no longer clear the snow. We watch Al Roker on the flat-screen as he speaks of the Polar Vortex. That is our vortex; we did not intend to send it your way. This weather was brought to you by the Arctic. It has sponsored change.

The environment is the main character in our story. Without it we are everywhere. This North belongs to the indigenous, to the people that came here and stayed and who have learned to thrive. The North no longer cloaks itself in the personality of the frontier. It is not the edge but the center.

The North is the personality we have formed. It is not barren; within it resides laughter and languages.

The map of the North is international. We are a land of logistics and massive infrastructure on stilts above half-frozen soil. We are dotted with shipping containers. Our ceremonial spaces are fewer and farther between. We build for education and hospitals and sewers. We are a place of military strategy, the resting place of Wiley Post, the landing strip for FedEx and presidential stopovers. We are a nod to the Cold War. We were tagged with roads to nowhere. But here everywhere is nowhere and it's important to get there. It's not efficient to take longer to get to nowhere. And we are a place of expediency, evidenced in architecture and the boom and bust.

It's hard to get rid of our junk here. It has to go by plane or boat. It costs more. Recycle, reuse—we have known of the *R*s for a long time.

We no longer sell our story. We own it, shape it, tell it. This is the place that I know. I've lived to see a time when we empower the voice of the insider and redefine the Northerner. It's both fragile and powerful up here. We have targeted our landscape with viewfinders at roadside stops. We are buying a paved stairway to the wilderness. We have tamed ourselves but not the environment. There is no tour bus to the future. The answers are less traveled; the questions are more frequent. The shared sense of place and responsibility is growing.

Perched up here, it's an incredible view of both the past and the future. It is strange to be at the center when you are at the top of the world. We look to Northerners to teach us how to adapt. It is no longer romantic and this is not reality TV. The wilderness is less than wild. Access can be bought online. Knowledge is downloaded rather than passed on.

The stereotype of the North is no longer the explorer or the cabin beneath the aurora. We are not fiction nor fantasy. We are in a pivotal place at a pivotal time. McCandless and London and Service and Kent

Snow-covered wood in the woods.
Courtesy of Julie Decker.

came seeking the mystique. They had stories of isolation. They exported the myth and we clung to it.

Today, the gold has been mined. We have invested and developed and speculated. Today, this landscape and its impact are not isolated. Today, the North is not a frontier; it is the starting place. It is the testing ground. It is populated and pivotal. The horizon is no longer painted in misty pink and blue. It is a different kind of poignant. Optimism is a choice. Fools are made of lesser things.

The North is embedded in my memories. It has shaped my perspective. I am not a curiosity seeker in this place, but I wonder what the curiosity in this place will reveal. The view from up here is both beautiful and profound.

North is relative to all points above and below. It is defined by where you stand. From here, it is both magnetic and true.

Why do we long to wend forth
through the length and breadth of a land,
Dreadful with grinding of ice,
and record of scarce hidden fire . . .

No wheat and no wine grows above it,
no orchard for blossom and shade;
The few ships that sail by its blackness
but deem it the mouth of a grave;
Yet sure when the world shall awaken,
this too shall be mighty to save.

—**William Morris**

CONTRIBUTORS

Writers

Simon Armitage is a graduate of Portsmouth University in the UK, where he studied Geography. As a postgraduate student at Manchester University, his MA thesis concerned the effects of television violence on young offenders. Until 1994 he worked as a probation officer in Greater Manchester. Armitage has published several limited-edition pamphlets with small and local poetry presses. His first full-length collection of poems, *Zoom!*, was published in 1989. Further collections are *Xanadu*, *Kid*, *Book of Matches*, *The Dead Sea Poems*, *Moon Country* (with Glyn Maxwell), *CloudCuckooLand*, *Killing Time*, *Selected Poems*, *Travelling Songs*, *The Universal Home Doctor*, *Tyrannosaurus Rex versus the Corduroy Kid*, and *Seeing Stars*. Armitage also writes for radio, television, and film, and is the author of four stage plays. He has published two novels, *Little Green Man* and *The White Stuff*. His other prose work includes *Gig: The Life and Times of a Rock-Star Fantasist* and the best-selling memoir *All Points North*. His nonfiction book *Walking Home* was short-listed for the 2012 Portico Prize.

Elizabeth Bradfield is the author of the poetry collections *Once Removed, Approaching Ice,* and *Interpretive Work*. Her poems have appeared in *The New Yorker, Orion,* and elsewhere. Founder and editor in chief of Broadsided Press, she lives on Cape Cod, works as a naturalist on expedition ships in the Arctic, is the cur-

rent Poet-in-Residence at Brandeis University, and is on the faculty of the low-residency MFA program at the University of Alaska Anchorage.

Berit Ellingsen is a Korean-Norwegian writer who lives in Norway and writes in English. Her fiction has appeared in numerous literary journals, and she has also published poetry and popular science articles. She is the author of the short story collection *Beneath the Liquid Skin* and two novels, *Une Ville Vide* and *Not Dark Yet*. Ellingsen divides her time between Norway and Svalbard in the Arctic.

Karl Ove Knausgård is a Norwegian writer whose six-volume autobiographical novel, *Min Kamp* (2009–11; *My Struggle*, 2012–), proved to be a runaway best seller in Norway and also captivated a large and growing number of English-language readers. Knausgård made his publishing debut in 1998 with the novel *Out of the World*, for which he was awarded the Norwegian Critics Prize for Literature, the first time in the award's history that a debut novel had won. His second novel, *A Time for Everything*, won a number of awards and was nominated for the Nordic Council's Literature Prize and the IMPAC Dublin Literary Award.

Judith Lindbergh was born in Worcester, Massachusetts. Her published work, ranging from travel and

cultural pieces to short fiction and poetry, has appeared in numerous magazines and journals, including *Archaeology Magazine, The World & I, Scandinavian Review,* and the Canadian literary journal *Other Voices.* Lindbergh is also an accomplished photographer, and her images of Greenland and Iceland have been exhibited at venues including the Cathedral of Saint John the Divine and the Edward Hopper House. Several are included in *Vikings: The North Atlantic Saga,* published in conjunction with the Smithsonian National Museum of Natural History's two-year traveling exhibition of the same name. Lindbergh also presented an excerpt from her first novel, *The Thrall's Tale,* as a special event at the Smithsonian. She lives in New Jersey with her husband and two sons.

Barry Lopez was born in New York, grew up in Southern California and New York City, and attended college in the Midwest before moving to Oregon, where he has lived since 1968. He is an essayist, author, and short-story writer, and he has traveled extensively in remote and populated parts of the world. He is the author of *Arctic Dreams,* for which he received the National Book Award; *Of Wolves and Men,* a National Book Award finalist for which he received the John Burroughs and Christopher Medals; and eight works of fiction, including *Light Action in the Caribbean, Field Notes,* and *Resistance.* His essays are collected in two books, *Crossing Open Ground* and *About This Life.* He contributes regularly to *Harper's, Granta, The Georgia Review, Orion, Outside, The Paris Review, Manoa,* and other publications in the United States and abroad. His work has appeared in dozens of anthologies, including *Best American Essays, Best Spiritual Writing,* and the "best" collections from *National Geographic, Outside, The Georgia Review, The Paris Review,* and other periodicals. His most recent books are *Home Ground: Language for an American Landscape*, a reader's dictionary of regional landscape terms that he edited with

Debra Gwartney, and *Outside,* a collection of six stories with engravings by Barry Moser.

Robert Macfarlane took up his post as fellow in English at Emmanuel College, Cambridge University, in 2002. After completing his BA at Pembroke (1994–97), he spent two years studying at Magdalen College, Oxford, and a year teaching at a university in Beijing, before returning to Cambridge for his PhD. In 2006 he was appointed to a university lectureship in post–World War II literature in English. Macfarlane's research and writing interests include the nature-writing tradition, travel writing, originality and plagiarism, the relations of ecology and literature, the Anglo-American novel since World War II, contemporary poetry, and Victorian environmentalism. He is well known, both as a critic and as a writer. His first book, *Mountains of the Mind: A History of a Fascination*, won the Guardian First Book Award, the Sunday Times Young Writer of the Year Award, and a Somerset Maugham Award, and was filmed for BBC4. *The Wild Places*, a travelogue exploring the histories and landscapes of "the wild" in Britain and Ireland, won a number of prizes in Britain and North America, including the Boardman-Tasker Prize for Mountain Literature, and was adapted by the Natural History Unit for BBC2. *The Old Ways*, the third and final book in a loose trilogy of works about landscape and the imagination, was published by Penguin in 2012. Macfarlane also writes regularly on literature, travel, nature, and the environment for the *Guardian* and *The Times Literary Supplement*, among other publications.

Ted Mayac Sr. is a King Islander (Ukiovokmiut) born at King Island in the spring of 1936. Ted witnessed and experienced the true subsistence lifestyle of the King Islanders. He saw a way of life dedicated to respect, harmony, and honor emphasized in the King Island village life. Over time, Ted began to understand and

validate the teachings and admonitions of the King Island customs and traditions. Ted has become an acknowledged teacher and a resource person for Native Alaska history and traditions. At the present time, Ted is actively involved in the King Island Corporation and King Island Tribal affairs. He is a member of the Alaska Native Heritage Center Inupiak Cultural Committee. He has been influential in the preservation and archival activities of King Island history and culture.

Craig Medred is the author of *Graveyard of Dreams: Dashed Hopes and Shattered Aspirations Along Alaska's Iditarod Trail*. He was the outdoor editor of the *Anchorage Daily News* for twenty years and now writes for the *Alaska Dispatch*.

Carol Richards is Inupiaq (Eskimo), with family from Kotzebue, Alaska. She earned a BA in German from Seattle University and a BA in graphic design (with honors) from the Art Center College of Design in Pasadena, California. She has taken courses at the Writer's Studio through Stanford's continuing education program and graduate-level courses in creative nonfiction at the University of Alaska Anchorage. She also participated in the Sirenland Writers' Conference in Positano, Italy; in 2015, she worked with Pulitzer Prize—winning author Anthony Doerr. She has attended the Wrangell Mountains Writing Workshop in McCarthy, Alaska, and the Kachemak Bay Writer's Conference in Homer, Alaska. In 2015, she was awarded a writer's residency at Hedgebrook, which accepts forty writers each year. Her writing has appeared in the *Alaska Quarterly Review* and *Best Creative Nonfiction* (vol. 2), and received a notable mention in the *Best American Essays* anthology.

Freya Rohn is originally from Portland, Oregon, but has since made her home in northern places including Scotland, Norway, and Alaska. She has an MFA from the University of Alaska Anchorage, where she was a recipient of the Jason Wenger Award for Poetry. Her poems have appeared in *Cirque* (under the name Kirsten Anderson), *Sugarhouse Review*, the *Colorado Review*, *Catamaran Literary Reader*, and the *Bellingham Review*, where her poem *After a Death* was nominated for a Pushcart Prize. She lives in Anchorage, Alaska, with her husband and son.

Eva Saulitis was trained as a marine biologist and received an MS and an MFA from the University of Alaska Fairbanks. Beginning in 1986, she studied the killer whales of Prince William Sound, Kenai Fjords, and the Aleutian Islands, and she was the author or coauthor of numerous scientific publications. Her essay collection, *Leaving Resurrection*, was a finalist for the Tupelo Press Non-Fiction Prize and the Foreword Book Award. A poetry collection, *Many Ways to Say It*, was published in 2012, and a memoir, *Into Great Silence: Discovery and Loss among Vanishing Orcas*, was published by in 2013. Her latest poetry collection, *Prayer in Wind,* was published in 2015, and her book of essays *Becoming Earth* will be released in 2017. Her essays and poems have appeared in numerous literary journals. She lived in Homer, Alaska, where she taught creative writing at Kenai Peninsula College and in the low-residency MFA program of the University of Alaska Anchorage. She continued to spend summers studying killer whales in Prince William Sound until her death in early 2016.

Bryndís Snæbjörnsdóttir and **Mark Wilson** are artists and academics who conduct their interdisciplinary and collaborative practice from bases in the north of England, Iceland, and Gothenburg, Sweden. Their often socially engaged projects explore contemporary relationships between human and non-human animals in the contexts of history, culture, and the environment. The work is installation-based, using objects, text, photography, video, and drawing. Their work

185

has been widely discussed in texts across many disciplinary fields and is regularly cited as contributive to knowledge in the expanded field of research-based art practice. Bryndís Snæbjörnsdóttir has been a visiting professor at Malmö Art Academy and Lund University and a guest teacher at the Icelandic Art Academy and University of Iceland. Mark Wilson is currently associate professor of fine art at the University of Cumbria, UK.

Photographers

Brian Adams is an editorial and commercial photographer based in Anchorage, Alaska, specializing in environmental portraiture and medium-format photography. His work has been featured in both national and international publications, and his photographs documenting Native Alaskan villages have been showcased in galleries across the United States. His first book of photography, *I AM ALASKAN*, was published in 2013 by the University of Alaska Press.

Oscar Avellaneda-Cruz was born in Colombia and moved to Alaska at the age of three. He is an award-winning photographer specializing in editorial portraiture and commercial photography. He currently lives and works in Anchorage, Alaska.

Olaf Otto Becker was born in Germany and studied communication design focusing on photography in Augsburg and philosophy and religious studies in Munich. After his studies, he worked as a freelance designer and photographer. Since 2003 he realizes his own self-assigned projects and is a regular contributor to the *New York Times Magazine*. Since his first book *Unter dem Licht des Nordens* was released in 2005, he has published four additional volumes of his photo-

graphic work. His works are presented internationally in museums, galleries, and exhibitions.

Michael Conti is a photographer and video artist based in Anchorage, Alaska. He earned a BFA from the University of Alaska Anchorage and an MFA from the Art Institute of Boston and has received numerous awards for his photography and video. He received a project award from the Rasmuson Foundation in 2006 and was a Connie Boocheever Fellow from the Alaska State Council on the Arts in 2011. He presently teaches photography, video, and color at the University of Alaska Anchorage.

Tiina Itkonen has exhibited her photographic work at international venues including the 54th Biennale de Venezia, 17th Biennale of Sydney, Danish National Museum of Photography, Kunstmuseum Wolfsburg, Ludwig Museum, and the New York Photo Festival. Her works are included in collections such as the Moderna Museet (SE), DZ-Bank Collection (DE), Statoil Collection (NO), Fundacio Foto Colectania (ESP), Helsinki City Art Museum (FI), as well as in numerous private collections throughout Europe, the United States, and Asia. Since 1995 Itkonen has traveled regularly to Greenland to photograph the polar landscape and people. Itkonen's first book, *Inughuit*, a selection of photographs of Greenland's Polar Inuit, the world's northernmost people, was published in 2004 and her second book, *Avannaa*, containing photographs of Greenland's landscape, was published in 2014. She currently lives and works in Helsinki, Finland.

Acacia Johnson is a photographer and artist from Anchorage, Alaska. Her photographs depict the landscapes of the circumpolar North. A recent graduate of the Rhode Island School of Design, Johnson has spent several years living in Norway and has exhibited her

work internationally. Her work is included in collections at the Rhode Island School of Design Museum and the Smithsonian Museum of American History. She also works as a seasonal expedition guide and photography lecturer in Greenland, Svalbard, and the Canadian Arctic. Recently, Acacia spent a year as a Fulbright scholar in Canada, pursuing a project about the winter landscape of Baffin Island in affiliation with the Ontario College of Art and Design University. She is now based somewhere between Norway, Alaska, and the polar seas.

Clark James Mishler studied advertising design at the Art Center in Los Angeles and worked as a layout editor at *National Geographic Magazine* in Washington, DC, before he became a freelance photographer in 1990. After a career based in Anchorage, Alaska, Mishler relocated to California's Napa Valley.

Jeroen Toirkens studied photographic design at the Royal Academy for the Visual Arts in The Hague and has been working as an independent photographer and filmmaker since 1995. He focuses on social documentary photography and slow journalism and has published extensively in national and international newspapers and magazines. In 2011 his first book, *Nomad*, was published, and in 2013 he released his second book, *Solitude*. He lives and works in the Netherlands.

Editors

Julie Decker is the director of the Anchorage Museum in Alaska, where she also served as chief curator. She has written extensively on the art and architecture of the North. She has edited numerous publications, including *Gyre: The Plastic Ocean*, *Alaska and the Airplane*, *Wandering Ecologies: The Landscape Architecture of Charles Anderson*, *Modern North: Architecture on the Frozen Edge*, *Expanded View: Anchorage Museum*, *True North: Contemporary Architecture of Alaska*, *Quonset: Metal Living for a Modern Age*, and *John Hoover: Art and Life*.

Kirsten J. Anderson is the deputy director and chief curator at the Anchorage Museum in Alaska. She has an MPhil in archaeology from the University of Glasgow, Scotland, and an MFA from the University of Alaska Anchorage.

187

CREDITS

"Summit," from *The Wild Places,* by Robert Macfarlane. Copyright © 2007 by Robert Macfarlane. Used by permission of Viking Books, an imprint of Penguin Publishing Group, a division of Penguin Random House LLC.

"The Magical Realism of Norwegian Nights," by Karl Ove Knausgård, originally printed in the *New York Times.* Copyright © 2013 by Karl Ove Knausgård. Used by permission of The Wylie Agency LLC.

"Last Snowman," by Simon Armitage, originally printed in the *Guardian.* Copyright © 2015 by Simon Armitage. Used by permission of David Godwin Associates LTD.

"Arktikós," from *Arctic Dreams,* by Barry Lopez. Copyright © 2001 by Barry Lopez. New York: Vintage, 1986. Used by permission of Sterling Lord Literistic, Inc.

Quote from "Nord (North)," by Rolf Jacobsen, in *Night Open.* Translated by Olav Grinde. Buffalo, NY: White Pine Press, 1995.

Quote from "The Word-Hoard: Robert Macfarlane on Rewilding Our Language of Landscape," by Robert Macfarlane, originally printed in the *Guardian,* February 27, 2015.

Quote from *Moominland Midwinter,* by Tove Jansson. Translated by Thomas Warburton. New York: Square Fish Books, 2010.

Quote from "Iceland First Seen," by William Morris, in *British Poets of the Nineteenth Century: Poems by Wordsworth, Coleridge, Scott, Byron, Shelley, Keats, Landor, Tennyson, Elizabeth Barrett Browning, Robert Browning, Clough, Arnold, Rossetti, Morris, Swinburne.* Edited by Curtis Hidden Page. Boston: B. H. Sanborn & Company, 1910.